BRIDGMAN'S
COMPLETE GUIDE TO
DRAWING FROM LIFE

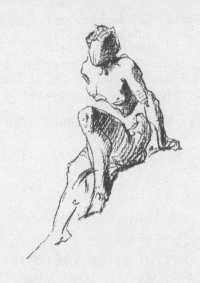

With Drawings and Text By
George B. Bridgman

Edited by Howard Simon

WINGS BOOKS
New York

This 1999 edition is published by Wings Books®, an imprint of Random House Value Publishing, Inc. 201 East 50th Street, New York, N.Y. 10022, by arrangement with Sterling Publishing Co., Inc.

Wings Books and colophon are registered trademarks of Random House Value Publishing, Inc.

Random House
New York • Toronto • London • Sydney • Auckland
http://www.randomhouse.com/

Printed and bound in the United States of America.

Library of Congress Cataloging-in-Publication Data
Bridgman, George Brant, 1864 - 1943
Bridgman's complete guide to drawing from life : with drawings and
text / by George B. Bridgman; edited by Howard Simon.
p. cm.
Originally published: Sterling Pub., 1952
Includes index
ISBN 0-517-25546-4
1. Anatomy, Artistic. 2. Human figure in art. 3. Drawing-
-Technique. I. Simon, Howard, 1903- . II. Title. III. Title:
Complete guide to drawing from life.
NC760.B825 1992
743'.49—dc20 91-38010 CIP

11 10 9 8 7

CONSTRUCTIVE ANATOMY

Copyright MCMXX by George B. Bridgman

BRIDGMAN'S LIFE DRAWING

Copyright MCMXXIV by George B. Bridgman

THE BOOK OF A HUNDRED HANDS

Copyright MCMXXVI by George B. Bridgman

HEADS, FEATURES AND FACES

Copyright MCMXXXII by Bridgman Publishers, Inc.
Revised Copyright MCMXXXVI by Bridgman Publishers, Inc.

THE FEMALE FORM

Copyright MCMXXXV by Bridgman Publishers, Inc.

THE HUMAN MACHINE

Copyright MCMXXXIX by George B. Bridgman

THE SEVEN LAWS OF FOLDS

Copyright MCMXLII by Bridgman Publishers, Inc.

TABLE OF CONTENTS

EDITOR'S NOTE

For more than thirty years thousands of art students crowded into George Bridgman's classes at the Art Students' League in New York to learn at first hand the method of drawing from life which was his personal contribution to art education and which in his own lifetime had become famous. Many of the best known names in contemporary painting and sculpture and commercial art were enrolled in those classes.

Bridgman's vivid and articulate personality brought lively interest to the study of anatomy. His beautiful drawings of musculature and bone structure have provided a truly new literature on the subject. These were anatomical drawings made not for the medical student or the doctor but specifically for the artist. How the body moves, bends, how its parts coordinate, how the hands clutch, pull, or push, are among the countless bodily movements he illustrated and analyzed.

Great artists have, in the past, illustrated the phases of anatomy that related to one or another portion of the human body. In the new "COMPLETE BRIDGMAN" it is clear that *all* of the constructive anatomy of the human figure is gathered into one volume.

Bridgman invented a terminology which graphically describes the twisting and turning of the human body. The term "Wedging" likewise is his own; it describes how one group of muscles integrates with another. By simplifying forms and giving them increased definition, he makes his particular method an easy one to remember. In a sense these drawings of the human

figure are peopled with a special kind of man, essentially Bridgman's own creation. Like the great master of the Renaissance, Michelangelo, (whom Bridgman closely studied) he does not personalize or individualize. But his immense knowledge of structure is put to work. In this book one learns to foreshorten the forms and to articulate the limbs in a direct comprehensible manner because the reasons for change of form and shape are diagrammatically and dramatically explained. Muscles actually change in shape as they react. How they move the structure by contraction and how they appear from various points of view are explained with countless other facts in precise fashion.

George Bridgman's life was devoted to making clear these complex movements of human anatomy so that artist, art student and teacher may find an inexhaustible mine of information that touches every phase of their study.

The COMPLETE BRIDGMAN is meant to be used as well as read. Nowhere can be found a more complete analysis of the hand, for instance, than in these pages. Over two hundred drawings of the hand with its enormous variety of movement and position are shown. And there are explanations, as well, of its muscles at every plane.

There are innumerable drawings both of structure and movement integrated with the text and a complete study of folds and draperies as they relate to the human form.

In this book is the heart of Bridgman's system of constructive anatomy, his life drawing and his work on the structure of head and features. The entire work of his long lifetime in art instruction and practice is included here.

It was necessary up to the present to acquire a separate book on each phase of Bridgman's art instruction. In the new COMPLETE BRIDGMAN is presented for the first time a comprehensive volume that includes all the specialized art instruction in a form that can be readily consulted and is all-inclusive.

Howard Simon

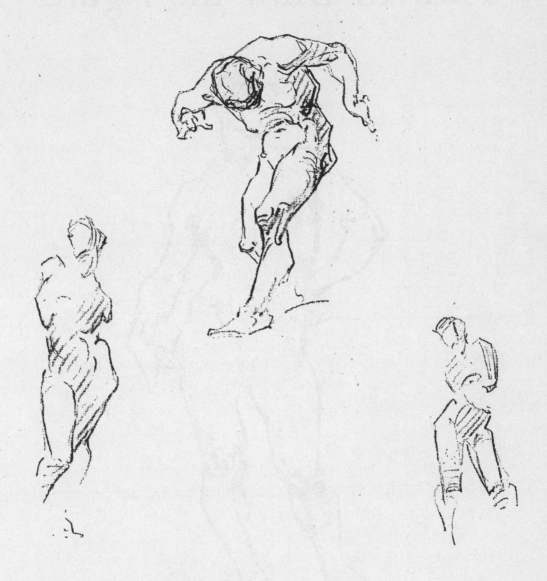

THIS is the story of the blocked human form where the bending, twisting or turning of volume gives the sensation of movement held together by rhythm. The different stages are arranged in their sequence from "How to Draw the Figure" to the "Balance of Light and Shade." Its purpose is to awaken the sense of research and analysis of the structure hidden beneath. It is hoped that the ideas conveyed in the drawing and text of this book may enable the reader to carry on to independent and better ideas.

11

How to Draw the Figure

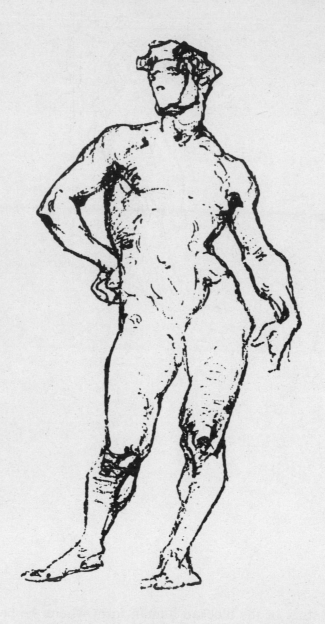

BEFORE you make a line you must have a clear conception of what you want to draw. In your mind it is necessary to have an idea of what the figure to be drawn is doing. Study the model from different angles. Sense the nature and condition of the action, or inaction. This conception is the real beginning of your drawing.

12

Give due consideration to the placing of your drawing on the paper, for balance and arrangement.
Make two marks to indicate the length of the drawing.

Block in with straight lines the outline of the head. Turn it carefully on the neck, marking its center by drawing a line from the Adam's apple to the pit between the collar bones.

From the pit of the neck make one line giving the direction of the shoulders, keeping in mind the marking of its center, which should be the pit between the collar bones.

Indicate the general direction of the body by outlining to the hip and thigh, at its outermost point, the side that carries the weight.

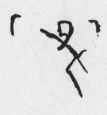

Follow this by outlining the opposite inactive side of the body, comparing the width with the head.

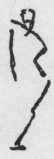

Then, crossing again to the action side of the figure, drop a line to the foot. You now have determined the balance, or equilibrium of the figure.

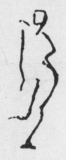

Carry the line of the inert side to the knee, over and upward to the middle of the figure.

On the outer side, drop a line to the other foot.

Starting again with the head, and thinking of it as a cube with front, sides, top, back and base, draw it on a level with the eye, foreshortened or in perspective.

Outline the neck and from the pit of the neck draw a line down the center of the chest.

At a right angle to this line, where stomach and chest join, draw another line and then draw lines to indicate the rib cage as a block, twisted, tilted or straight, according to its position.

Now draw the thigh and the leg which support the greatest part of the weight of the body, making the thigh round, the knee square, the calf of the leg triangular and the ankle square. Then draw the arms.

These few simple lines place the figure. They give its general proportions, indicating its active and inactive sides, its balance, unity and rhythm.

Bear in mind that the head, chest and pelvis are the three large masses of the body. They are in themselves immovable. Think of them as blocks having four sides, and as such they may be symmetrically placed and balanced, one directly above the other. In this case, the figure would have no movement. But when these masses bend backward, forward, turn or twist, the shifting of them gives action to the figure.

Whatever positions these three masses may assume, no matter how violently they may be drawn together on one side, there is a corresponding gentleness of line on the opposing, inert side and a subtle, illusive, living harmony flowing through the whole, which is the rhythm of the figure.

Proportions of The Human Figure

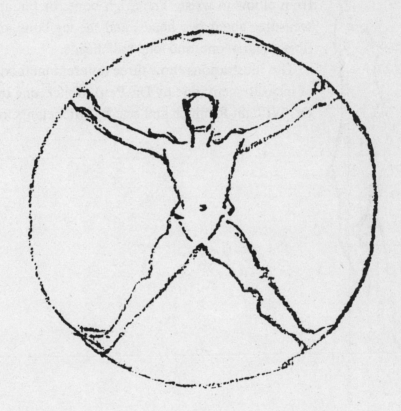

A_{LL} measurements of the human figure are divisions of the body into parts of given measurements. There are many conceptions of measuring, scientific and ideal, and they all differ.

If given proportions were used, even though these proportions were the ideal average, they would result in a drawing without character. Again, to apply these so-called canons of art, the figure must be on the eye-level, upright and rigid. The least bending of the head or body would change the given proportions visually, though not actually.

17

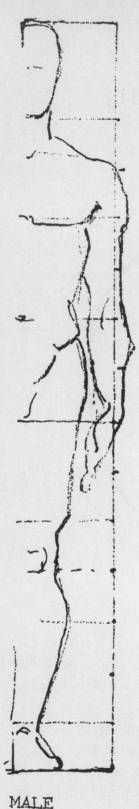

From an anatomical point of view, taking the skull as a unit, horizontally, the bone of the upper arm, the humerus, is about one and one-half heads in length. The bone on the thumb side of the forearm, the radius, is about one head in length. The forearm bone, the ulna, or the little finger side, measures about one foot from elbow to wrist. The thigh bone, or femur, measures about two heads, and the leg bone, or tibia, nearly one and one-half heads.

The illustrations show three different methods of measurement; one by Dr. Paul Richer, one by Dr. William Rimmer and one by Michelangelo.

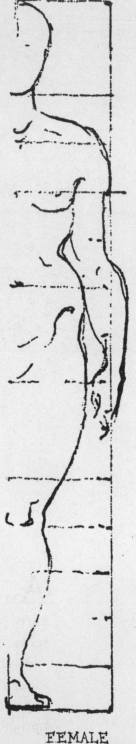

DR. PAUL RICHER
AFTER COUSIN
7½ HEADS

MALE

FEMALE

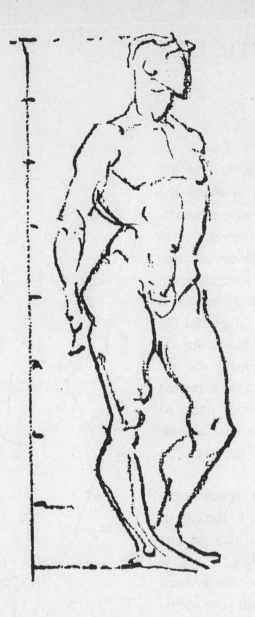

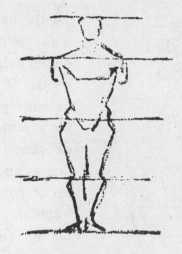

DR. WM. RIMMER

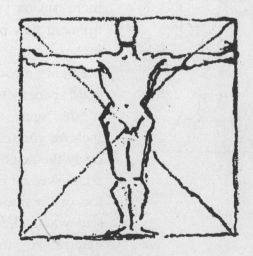

MICHELANGELO
8 HEADS

Measurements

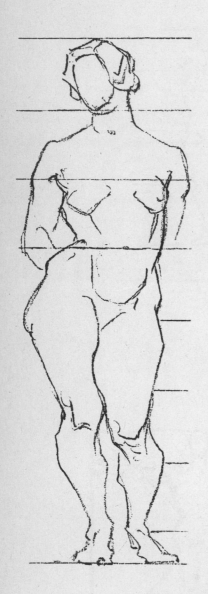

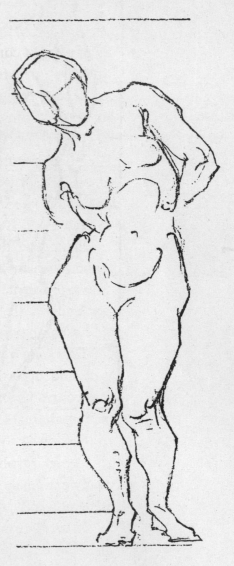

You have to measure, first of all, with your eye; and by studying the model judge the comparative measurements of its several masses. Then measure mechanically. When measuring mechanically, hold your charcoal or pencil between the thumb and fingers and use the first finger and the tip of your charcoal to mark the extremities of the measurement you are taking. Your arm should be extended to its full length and your head so tilted that your eye is as near as possible to the shoulder of the arm you are using in measuring.

From the model, the space registered from the first finger to the end of your charcoal or pencil may be one inch; but on your drawing this measurement may possibly be two or more inches. In other words, all your measurements are comparative and if the head spaces seven times into the length of the figure and registers, say, one inch on your charcoal or pencil, obviously the height of seven heads should be marked off on your drawing regardless of the size of your drawing, which size you had, in a general way, predetermined and may be anywhere from miniature to mural. The arm has

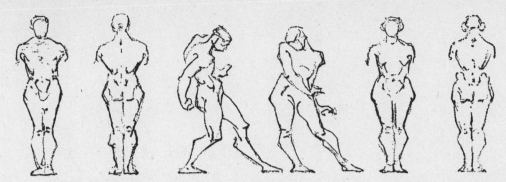

its axis at its connection with the shoulder blade. The eye, being above the arm and more forward, has an entirely different axis and radius; arms and necks vary in length. Also, in measuring, as in target practice, it is natural for some to close the left eye, others the right, and still others to keep both eyes open. So, with these varying conditions it is difficult to set down any fixed rules for the technique of measuring, your own physique and tendency to use one or both eyes are such important factors. In any case, however, you *must* keep your eye as close as possible to the shoulder, your arm extended and stiff.

On a figure, there are no marks that may be used in proving your measurements correct. Again, the model may be far above the level of the eye, causing violent perspective. Only at the eye level can the pencil be held perpendicularly. Above or below the eye level, the pencil or charcoal must take some studied and given angle, and to determine this angle accurately requires some practice. To find this angle, take a panelled wall or a vertical pole and upon it mark off six or seven spaces a foot or so apart. Then seat yourself several feet away and at arm's length, with eye close to shoulder, incline charcoal or pencil to register correctly each of the spaces you have marked off. As in revolver practice, you will become extremely accurate in judging the angle at which the charcoal should be held at different distances. This same method of angles may then be applied to measuring the figure.

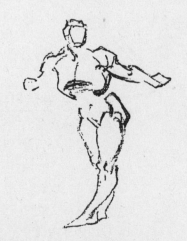

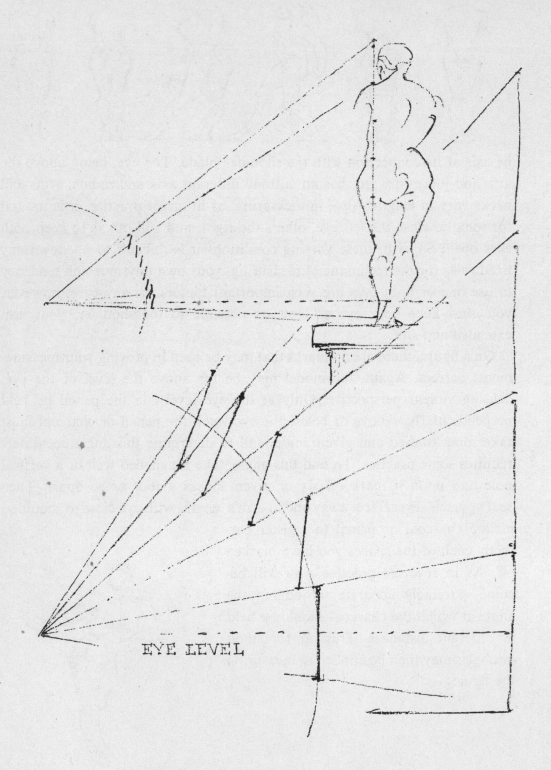

EYE LEVEL

MEASUREMENTS

MOVABLE MASSES

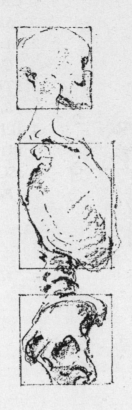

CAGE
12 inches High
8 inches Deep
10 inches Wide

HEAD
8 inches High
7½ inches Deep
6 inches Wide

PELVIS
8 inches High
6 inches Deep
10 inches Wide

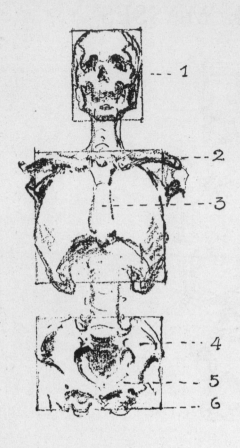

1 CRANIUM
 Skull
2 CLAVICLE
 Collar Bone
3 STERNUM
 Breast Bone
4 ILIUM
5 PUBIS
6 ISCHIUM
 Pelvis Bones

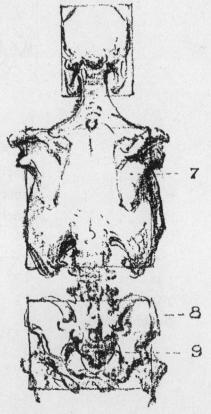

7 SCAPULA
 Shoulder Blades
8 CREST OF
 ILIUM
9 SACRUM

Wedging, Passing and Locking

THE upper and lower limbs are held in place on the cage and pelvis by mortise and tenon, called ball-and-socket joint and at elbow and knee by the ginglymus or hinge joint. The surrounding muscles, by their position, shape and size are capable of moving these joints in any manner that the construction of the joints permits.

As movement occurs, and the body instinctively assumes a position suited to the taking of some action, the muscles, by contraction, produce the twisting and bending of the masses. In so doing the muscles themselves expand, shorten and bulge, making smaller wedges or varied forms connecting the larger and more solid masses. This shortening and bulging of the muscles becomes an assemblage of parts that pass into, over and around one another, folding in and spreading out. It is these parts passing into or over each other that gives the sense of wedging or interlocking. This might be compared to the folds in drapery: where the folds change, their outline changes.

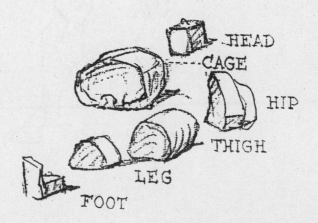

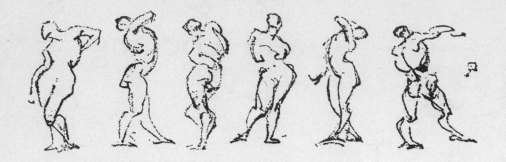

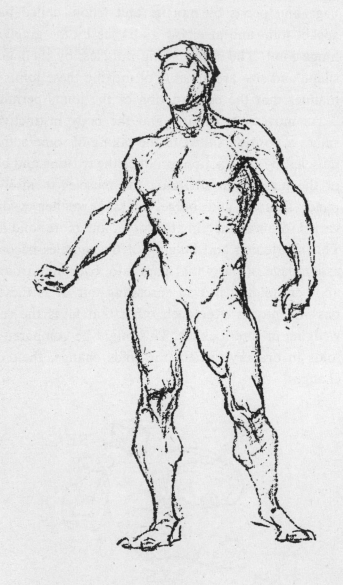

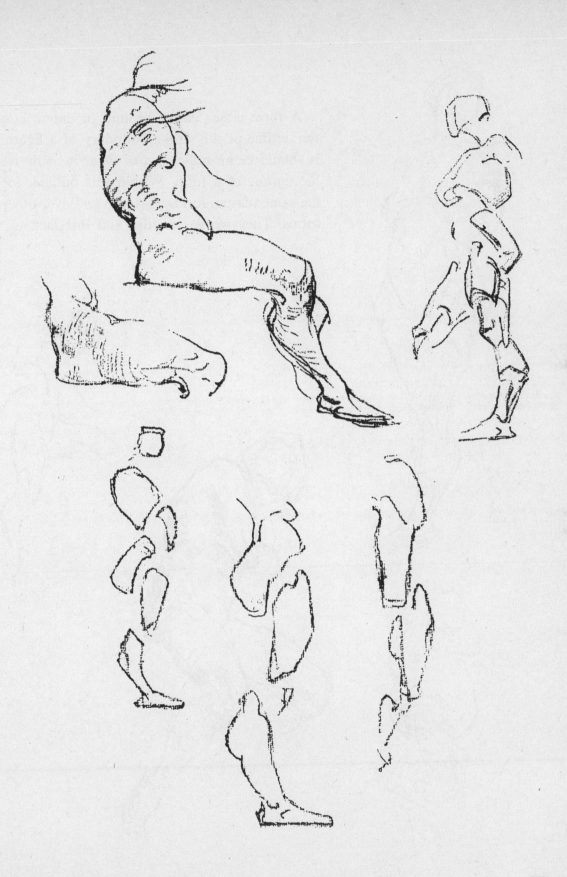

A form either passes around or enters into the outline of the visible boundary of a figure. It should be an indication of what it really is: the outline of a form. Within this outline, for the same reason, forms pass into and over other forms. They wedge, mortise and interlock.

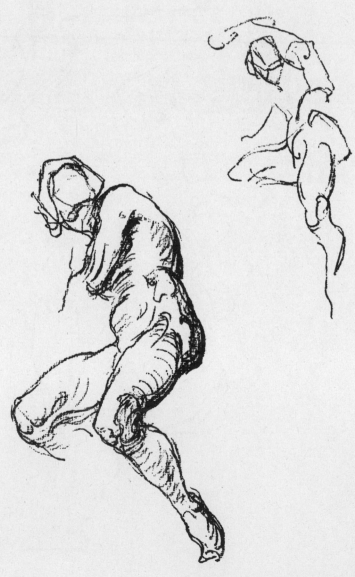

The outline of a figure may be so drawn that it gives no sense of the manifold smaller forms of which it is composed. Again, the outline of a figure may be so drawn that the sense of the figure's depth, of the wedging, interlocking and passing of smaller forms within the larger masses conveys to the mind an impression of volume and solidity.

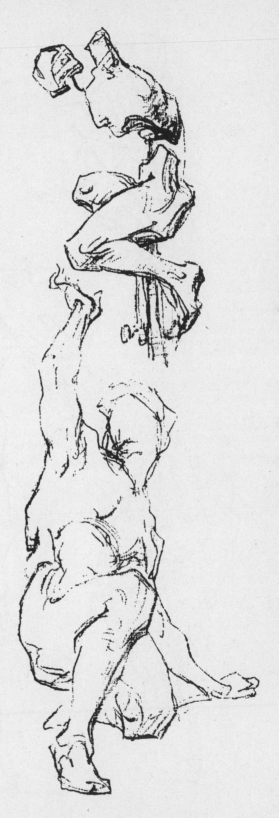

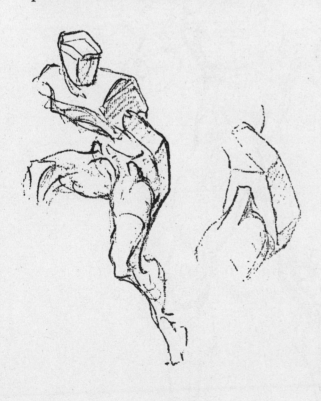

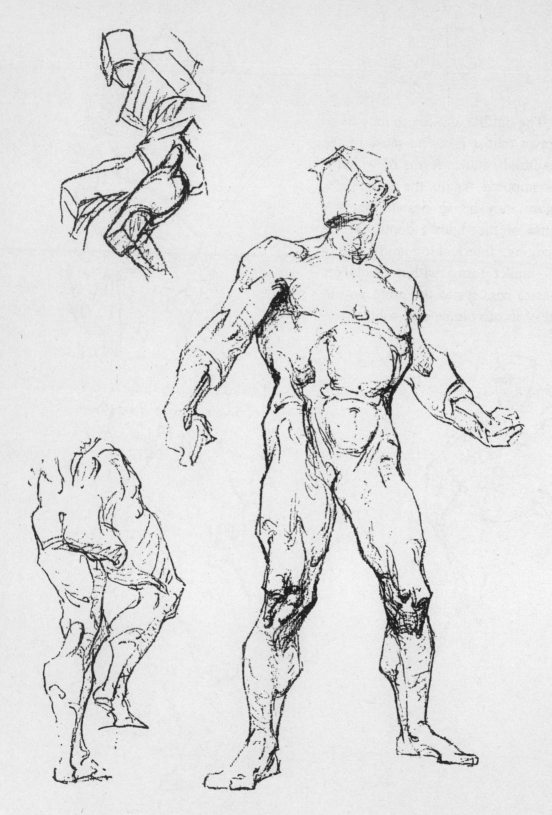

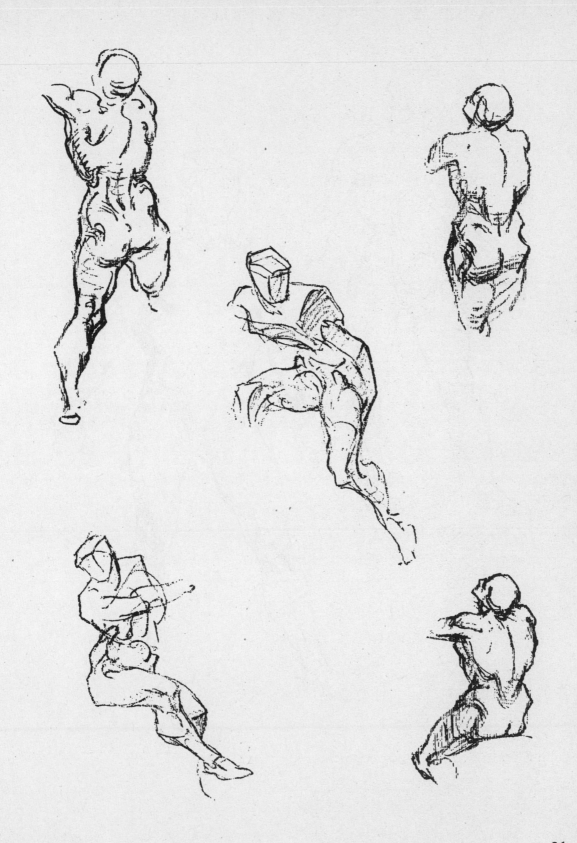

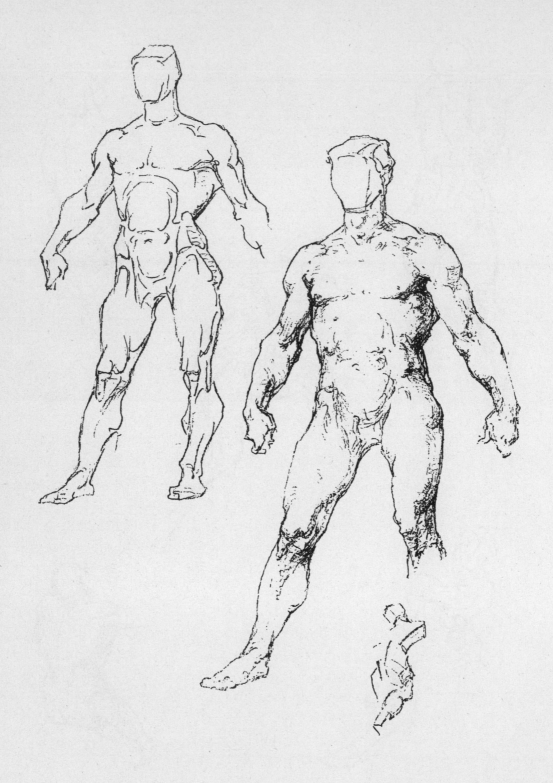

32

Balance

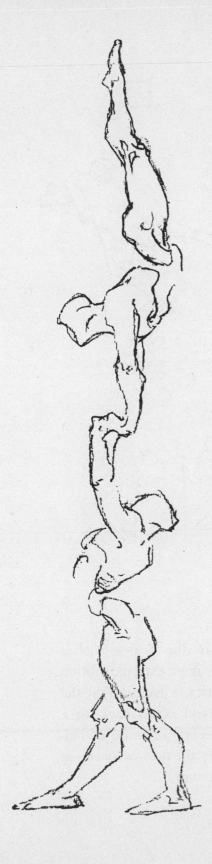

Wʜᴇɴ several objects are balanced at different angles, one above the other, they have a common center of gravity. In a drawing there must be a sense of security, of balance between the opposite or counteracting forces, regardless of where the center line may fall. This is true no matter what the posture may be. A standing figure whether thrown backward or forward, or to one side or the other, is stationary or static. The center of gravity, from the pit of the neck, passes through the supporting foot or feet, or between the feet when they are supporting the weight equally.

In a way, the pendulum of a clock when hanging straight, or perpendicular, represents a standing figure without movement. It is static, stopped. So is the clock. But start the pendulum swinging. It describes an arc, moving back and forth, but always about a fixed center of gravity. The position of the pendulum when at one or the other extreme of its swing or arc, from its center of gravity, represents the extent to which a figure may be thrown out of balance. And this position would also represent the

33

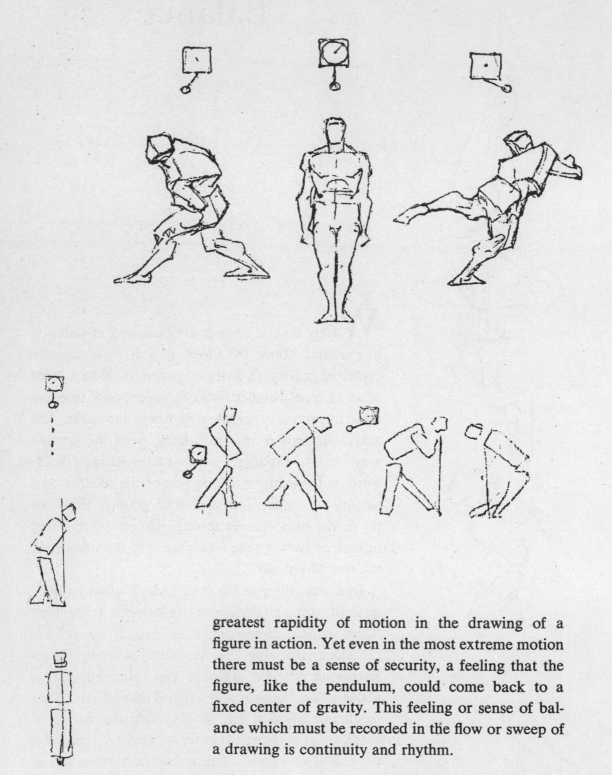

greatest rapidity of motion in the drawing of a figure in action. Yet even in the most extreme motion there must be a sense of security, a feeling that the figure, like the pendulum, could come back to a fixed center of gravity. This feeling or sense of balance which must be recorded in the flow or sweep of a drawing is continuity and rhythm.

BALANCE

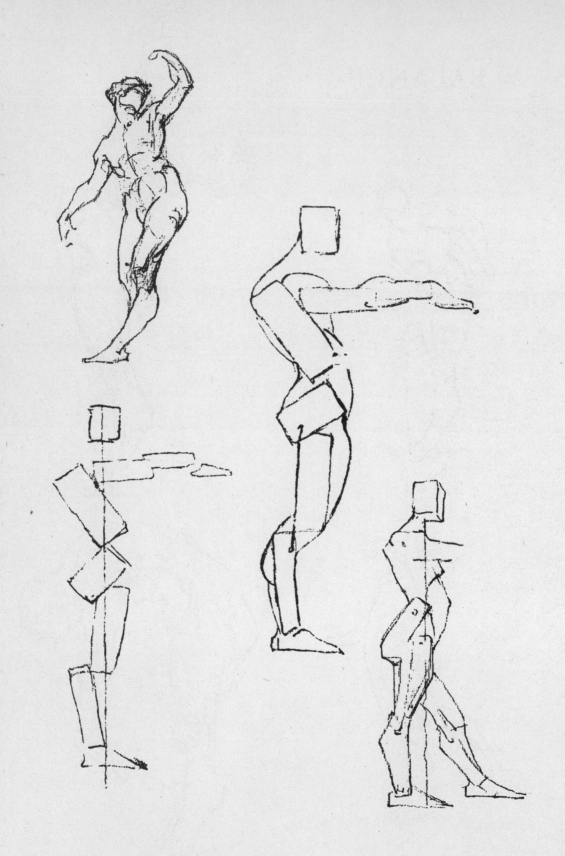

36

Rhythm

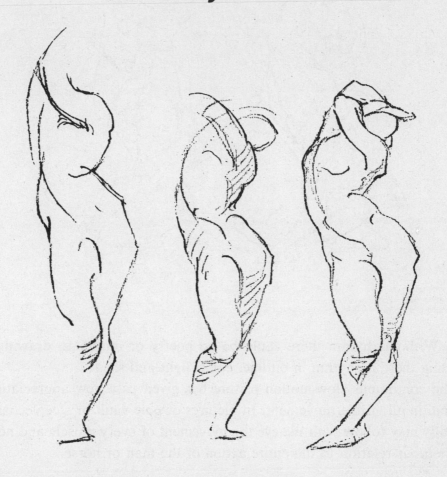

THE consciousness or idea of rhythm can not be traced to any period, or to any artist or group of artists. We know that in 1349 a group of Florentine artists formed a society for the study of the chemistry of colors, the mathematics of composition, etc., and that among these studies was the science of motion. But rhythm was not invented. It has been the measured motion of the Universe since the begining of time. There is rhythm in the movement of the sea and tides, stars and planets, trees and grasses, clouds and thistle-down. It is a part of all animal and plant life. It is the movement of uttered words, expressed in their accented and unaccented syllables, and in the grouping and pauses of speech. Both poetry and music are the embodiment, in appropriate rhythmical sound, of beautiful thought, imagination or emo-

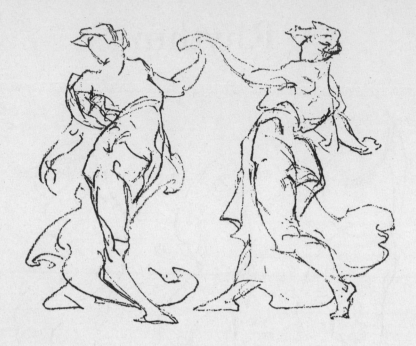

tion. Without rhythm there could be no poetry or music. In drawing and painting there is rhythm in outline, color, light and shade.

The continuous slow-motion picture has given us a new appreciation of rhythm in all visible movement. In pictures of pole vault or steeplechase we actually may follow with the eye the movement of every muscle and note its harmonious relation to the entire action of the man or horse.

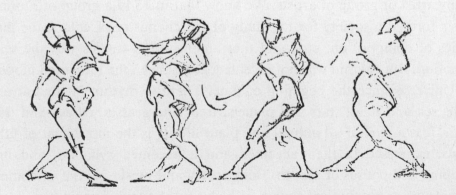

So to express rhythm in drawing a figure we have in the balance of masses a subordination of the passive or inactive side to the more forceful and angular side in action, keeping constantly in mind the hidden, subtle flow of symmetry throughout.

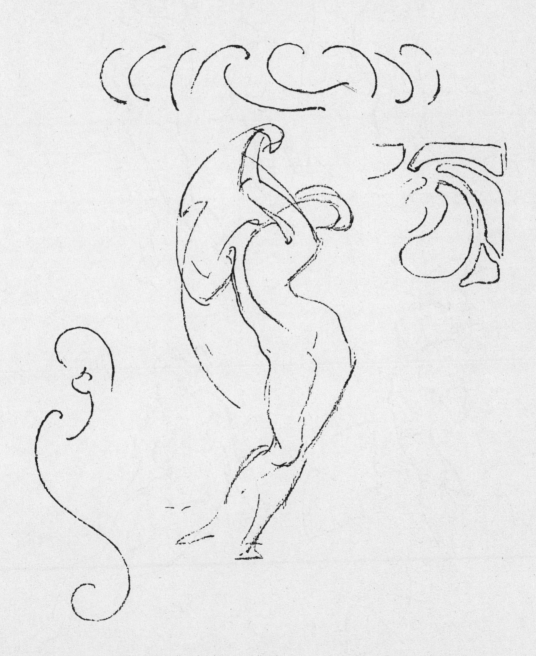

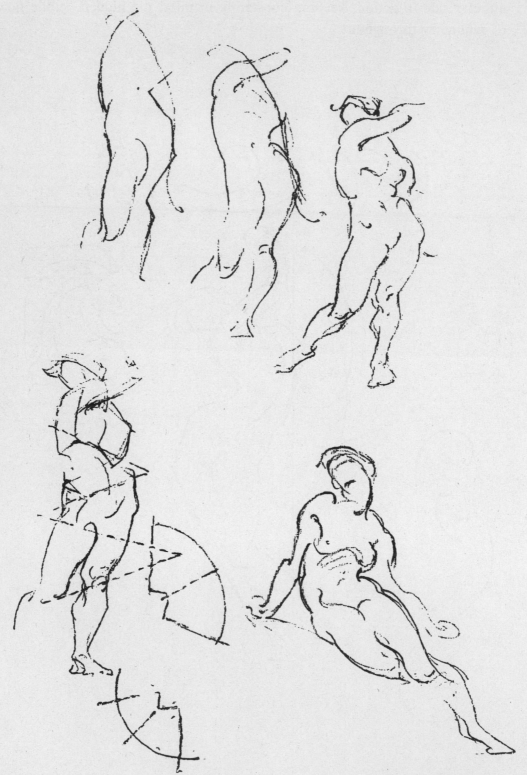

40

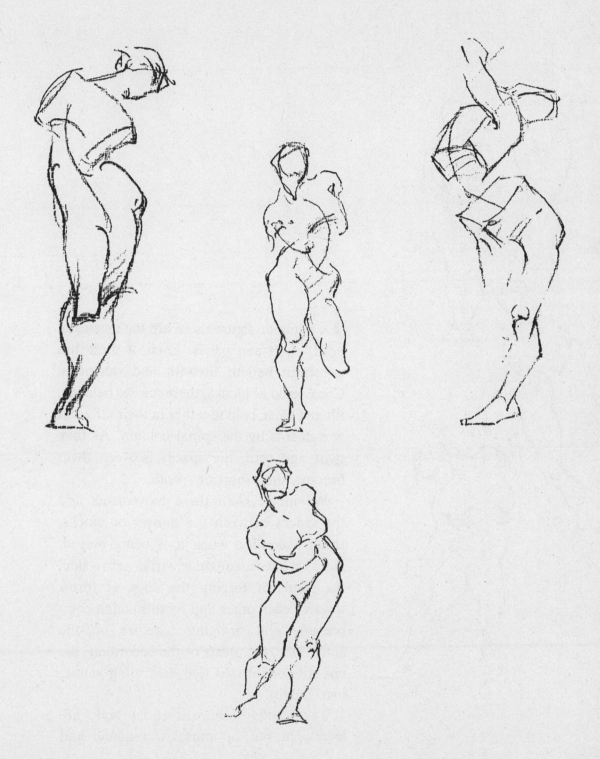

Turning or Twisting

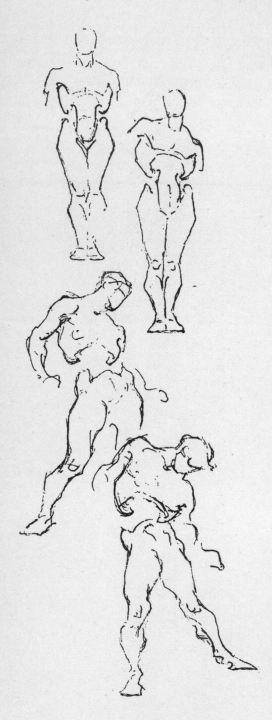

In a human figure there are the masses of head, chest and pelvis. Each of these has a certain height, breadth and thickness. Considered as blocks, these masses balance, tilt and twist, held together in their different movements by the spinal column. As they twist and turn, the spaces between them become long, short or spiral.

We might liken these movements and the spaces between the masses or blocks, to an accordion when it is being played. Here we have an angular, virile, active side, the result of forcing the ends or forms towards each other and by this action compressing and bringing together on the active side, the pleats of the accordion; the opposite or inflated side describing gentle, inert curves.

The blocks or masses of the body are levers, moved by muscles, tendons and

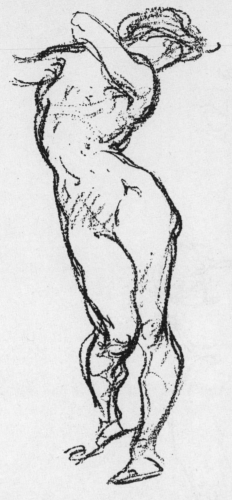

ligaments. The muscles are paired, one pulling against the other. Like two men using a cross-cut saw, the *pulling* muscle is swollen and taut, its companion is flabby and inert. When two or more forms such as the chest and the pelvis are drawn violently together, with cords and muscles tense on the active side, the inert, passive mass opposite must follow. There is always to be considered this affinity of angular and curved, objective and subjective, active and passive muscles. Their association is inevitable in every living thing. Between them, in the twistings and bendings of the body there is a harmony of movement, a subtle continuity of form, ever changing and elusive, that is the very essence of motion.

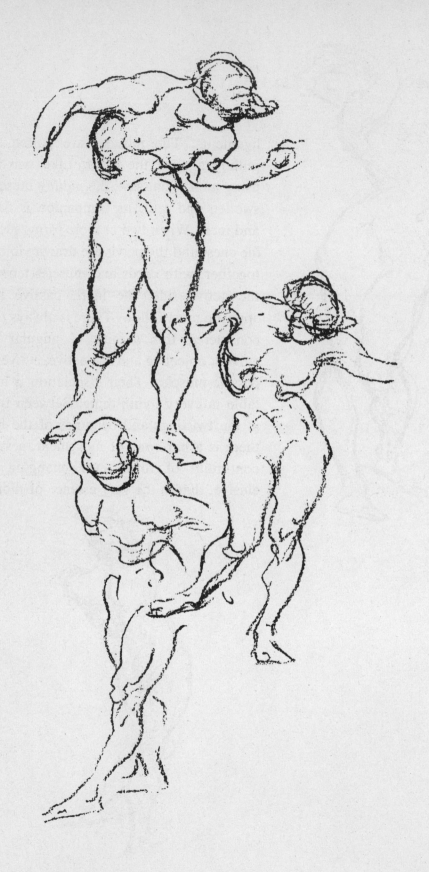

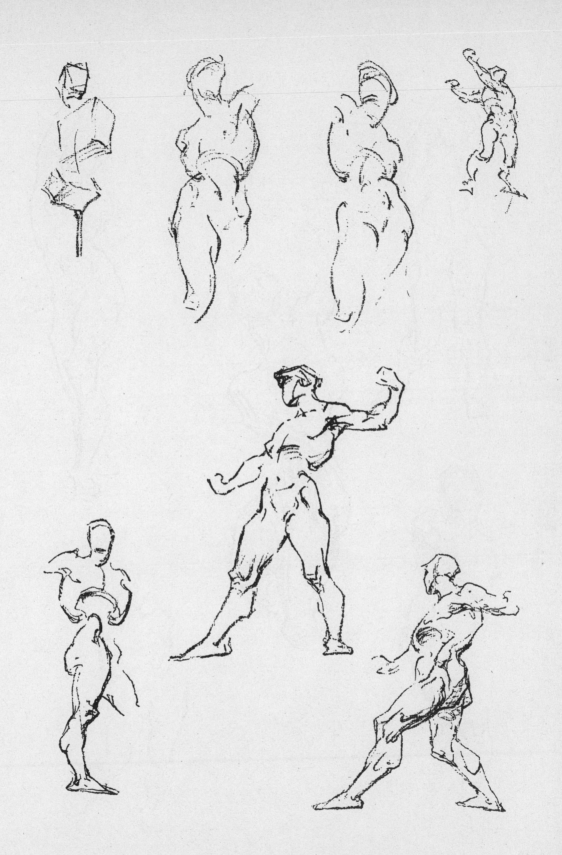

45

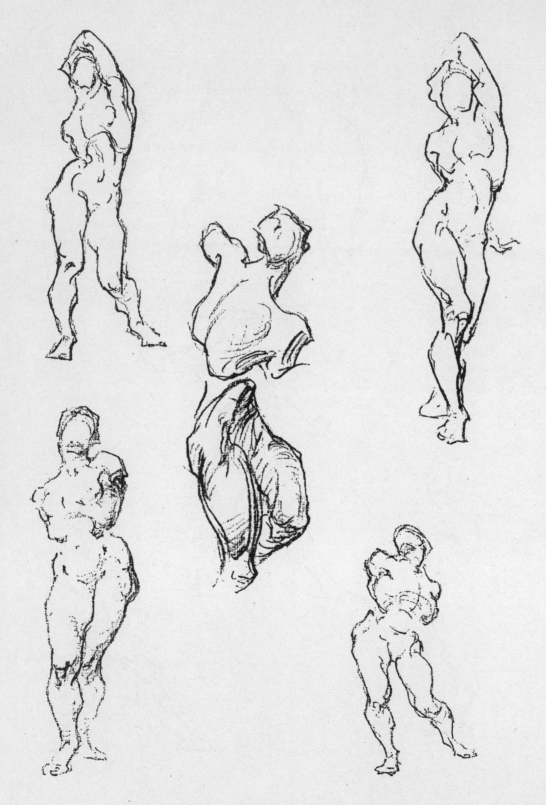

46

Light and Shade

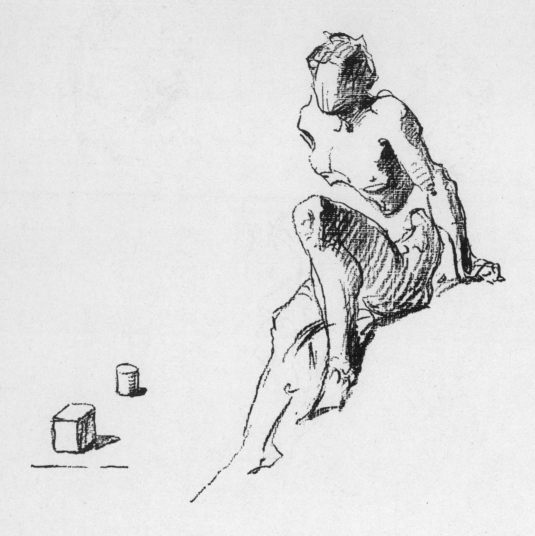

Shade with the idea that light and shade are to aid the outline you have drawn in giving the impression of solidity, breadth and depth. Keep before you the conception of a solid body of four sides composed of a few great masses, and avoid all elaborate and unnecessary tones which take away from the thought that the masses or planes on the sides must appear to be on the sides while those on the front must appear to be on the front of the body. No two tones of equal size or intensity should appear directly above one another or side by side; their arrangement should be shifting and alternate.

48

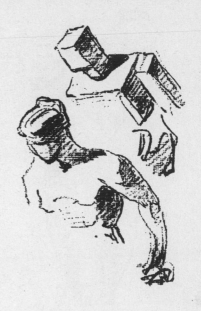

There should be a decided difference between the tones. The number of tones should be as few as possible. Avoid all elaborate or unnecessary tones and do not make four tones or values where only three are needed. It is important to keep in mind the big, simple masses and to keep your shading simple, for shading does not make a drawing.

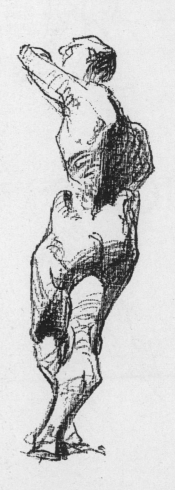

49

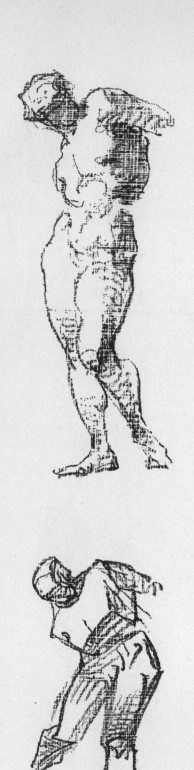

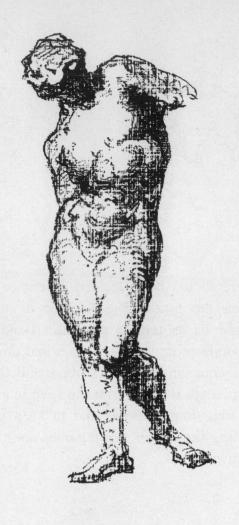

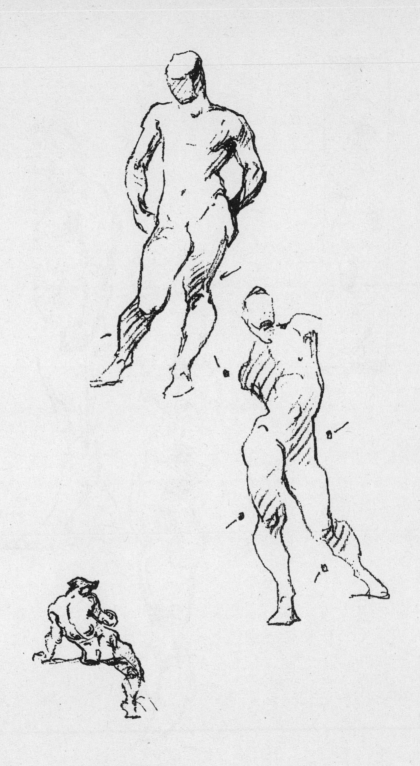

51

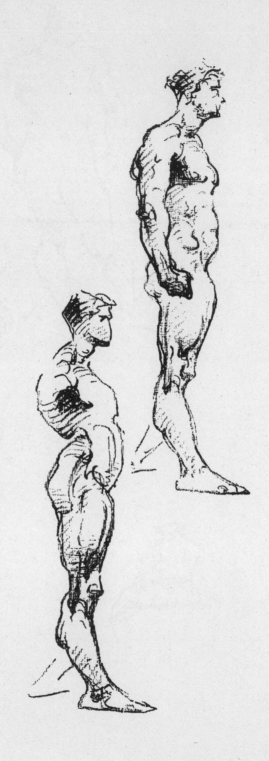

52

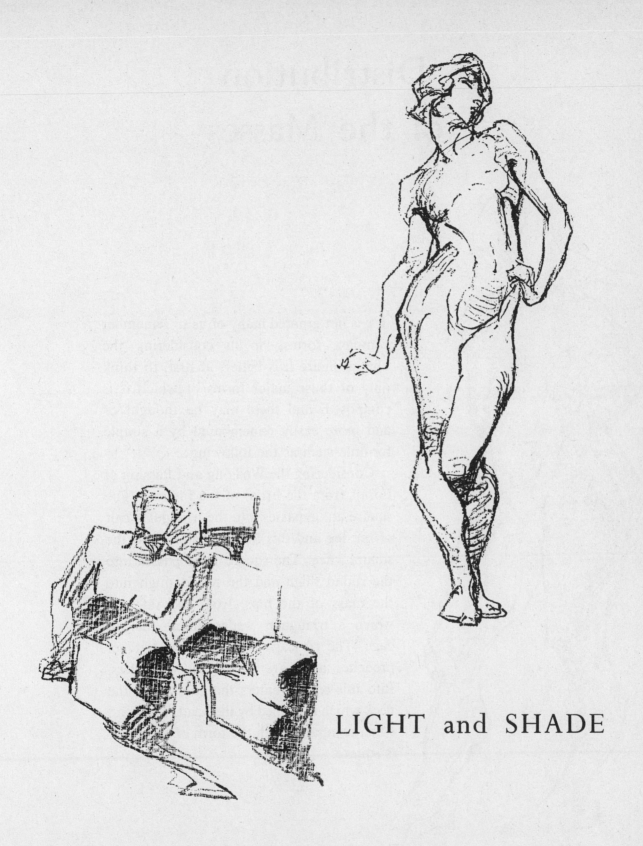

LIGHT and SHADE

Distribution
of the Masses

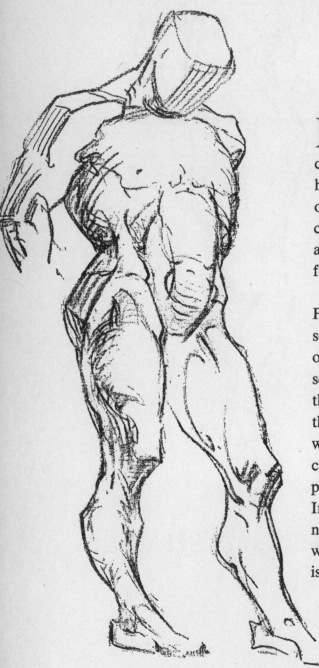

IT is not granted many of us to remember complex forms. So in considering the human figure it is better, at first, to think only of those major forms of which it is composed, and these may be thought of and more easily remembered by a simple formula such as the following:

Considering the Wedging and Passing of Forms from the Front of the Figure—The square ankle passes into the triangular calf of the leg and this in turn passes into the square knee. The square knee passes into the round thigh and the round thigh into the mass of the hips, from the sides of which a triangular wedge enters the rib cage. The rib cage is oval below, but approaches a square across the shoulders. Into this square enters the column of the neck which is capped by the head. The head when compared with the form of the neck, is square.

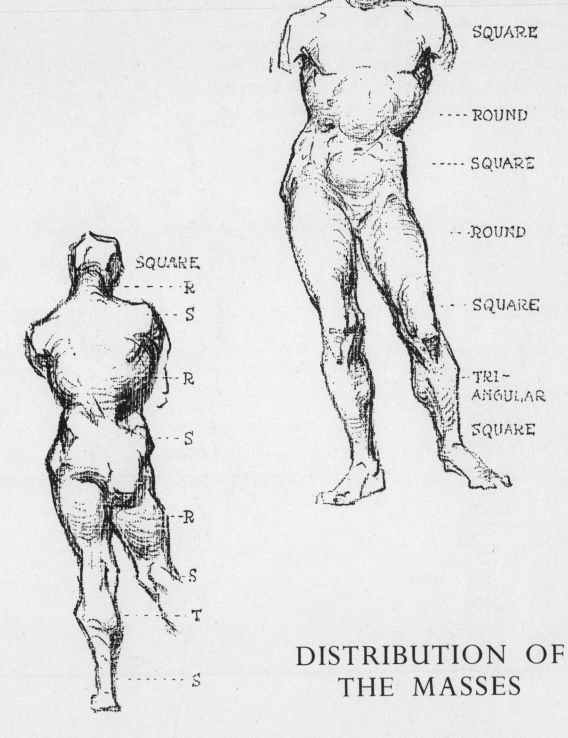

ROUND

SQUARE

ROUND

SQUARE

ROUND

SQUARE

TRI-
ANGULAR

SQUARE

SQUARE
R
S

R

S

R

S

T

S

DISTRIBUTION OF
THE MASSES

Considering the Wedging and Passing of Forms from the Rear of the Figure—The head is square, capping the round neck. The rib cage is square at the shoulders, wedging into the neck, and triangular below, wedging into square hips. The square hips rest on the round pillars of the thighs. The knees are square, the calves triangular and the ankles square.

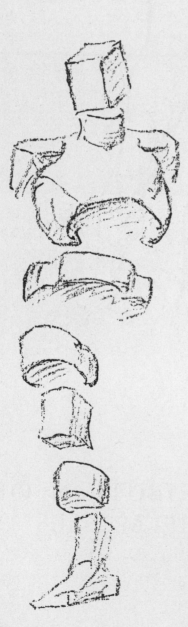
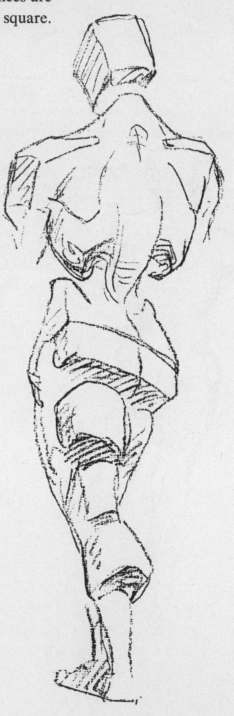

Building the Figure

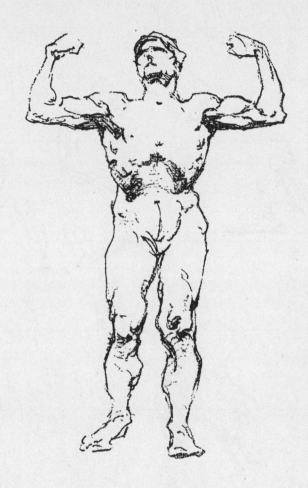

FROM a piece of lath and a few inches of copper or other flexible wire, a working model of the solid portions of the body may be constructed. Cut three pieces from the lath to represent the three solid masses of the body: the head, chest and hips. Approximately, the proportions of the three blocks, reduced from the skeleton, should be—Head, 1 inch by ⅝ of an inch; torso, 1½ inches by 1¼ inches; hips, 1 inch by 1¼ inches.

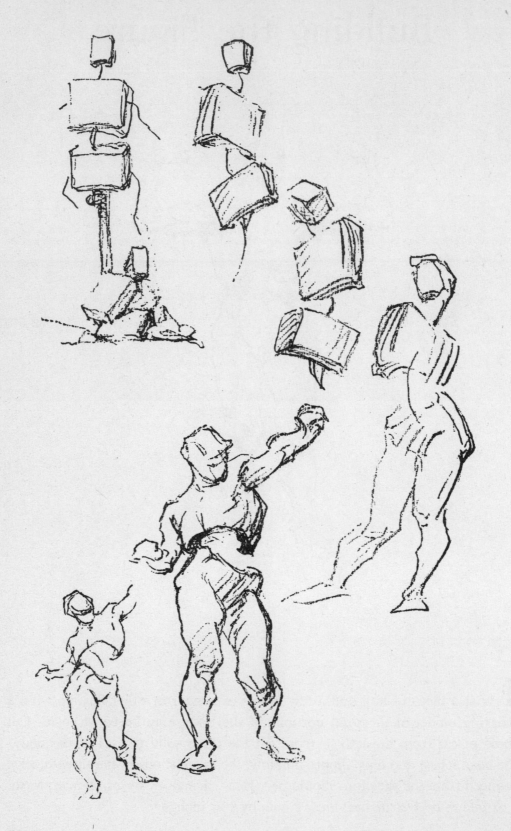

Drive two parallel holes perpendicularly through the center of the thickness of each of these blocks, as closely together as practicable. Wire the blocks together by running a strand of flexible wire through each of these holes, allowing about half an inch between the blocks, and twist the wires together.

The wire in a rough way represents the spine or backbone. The spine is composed of a chain of firm, flexible joints, discs of bone, with shock-absorbing cartilages between them. There are twenty-four bones in the spine, each bending a little to give the required flexibility to the body, but turning and twisting mostly in the free spaces between the head and chest, and between the chest and hips. The spine is the bond of union between the different parts of the body.

The portion of this wire between the head and chest blocks represents the neck. On the neck the head has the power to bend backward and forward, upward and downward, and to turn. The head rests upon the uppermost vertebra of the spine, to which it is united by a hinged joint. Upon this joint

it moves backward and forward as far as the muscles and ligaments permit. The bone beneath this hinged joint has a projection or point resembling a tooth. This enters a socket or hole in the bone above, and forms a pivot or axle upon which the upper bone and the head, which it supports, turn.

So, when we nod, we use the hinged joint, and when we turn our heads, we use the pivot or axle.

The wire between the two lower blocks represents that portion of the spine which connects the cage or chest above with the basin or pelvis below. This portion of the spine is called the lumbar region. It rests upon the pelvis or basin into which it is mortised. Its form is semicircular: concave from the front. On this portion of the spine, the lumbar, depends the rotary movement between the hips and the torso. As the spine passes upward, becoming part of the cage or chest, the ribs are joined to it.

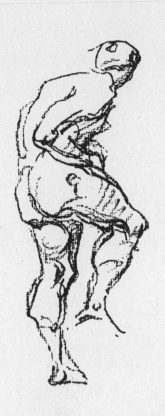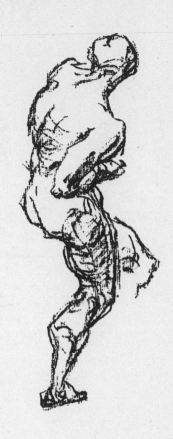

The masses of head, chest and pelvis, represented by the three blocks, are in themselves unmoving. Think of these blocks in their relation to each other and forget, at first, any connecting portions other than the slender wire of the spine.

In the little tin soldier at "attention" we have an example of the symmetrical balance of these blocks one directly over the other. But this balance never exists when the body is in action, seldom, indeed, when it is in repose. The blocks in their relation to each other are limited to the three possible planes of movement. They may bend forward and back in the sagittal plane, twist in the horizontal plane or tilt in the transverse plane. As a rule, all three movements are present and they may be closely approximated by turning and twisting the three blocks in the little model of lath and wire.

The limitation to the movement of the spine limits the movements of the three masses or blocks. Such movement as the spine allows the muscles also allow.

Mouldings

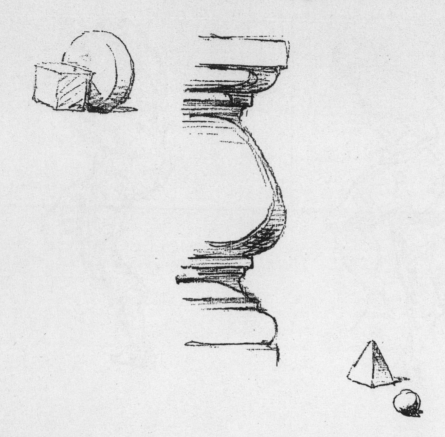

ARCHITECTURAL mouldings consist of alternate rounds and hollows, of plane or curved surfaces, placed one beneath the other to give various decorative effects by means of light and shade.

The human figure, whether standing erect or bent, is composed of a few big, simple masses that in outline are not unlike the astragal, ogee, and apophyge mouldings used in architecture. Looking at the back of the figure, there is the concave sweep of the mass from head to neck, then an outward sweep to the shoulders, a double curve from rib cage to pelvis, ending abruptly where the thigh begins, a slight undulation half way down to the knee, a flattened surface where it enters the back of the knee, another outward sweep over the calf and down to the heel; the whole, a series of undulating, varied forms. And the front of the figure curves in and out in much the same manner, a series of concave and convex curves, and planes.

The distribution of light and shade brings out these forms.

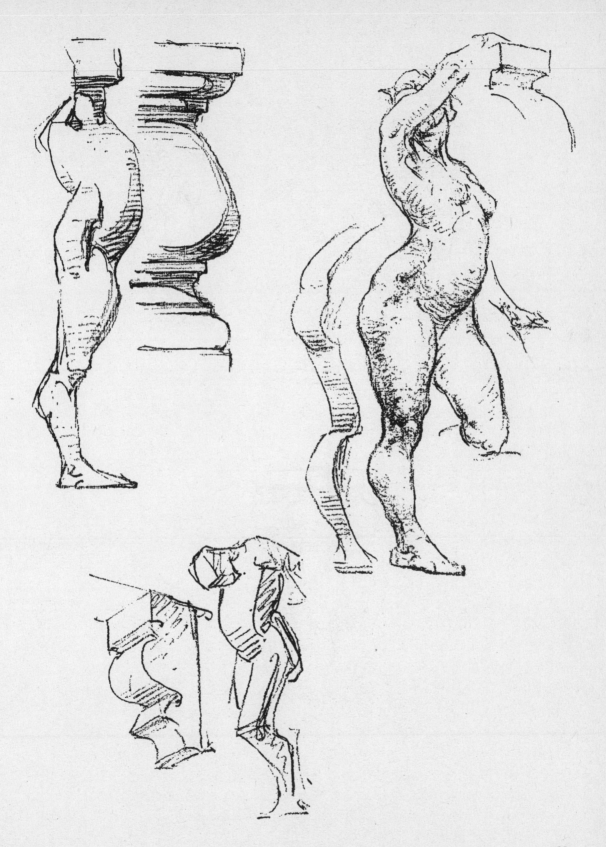

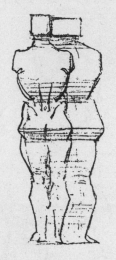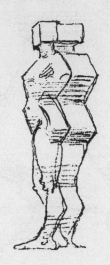

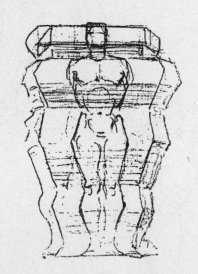

64

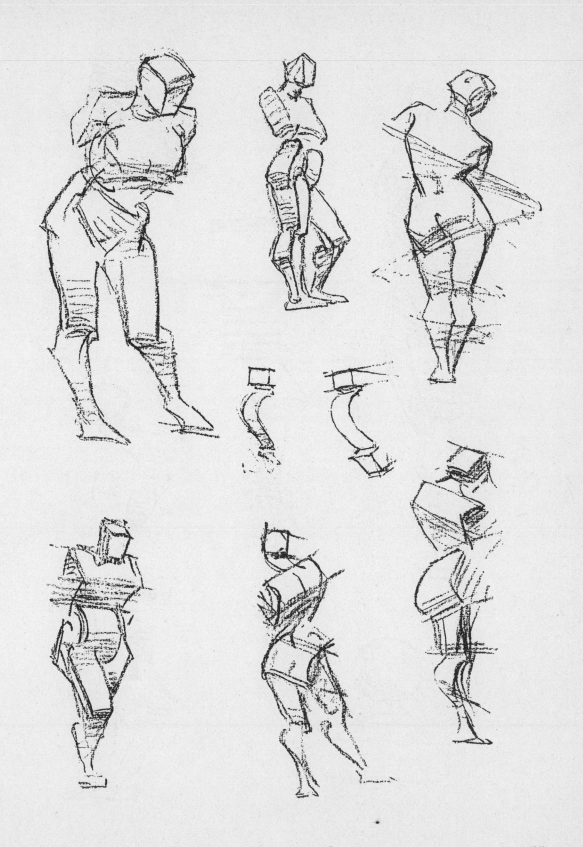

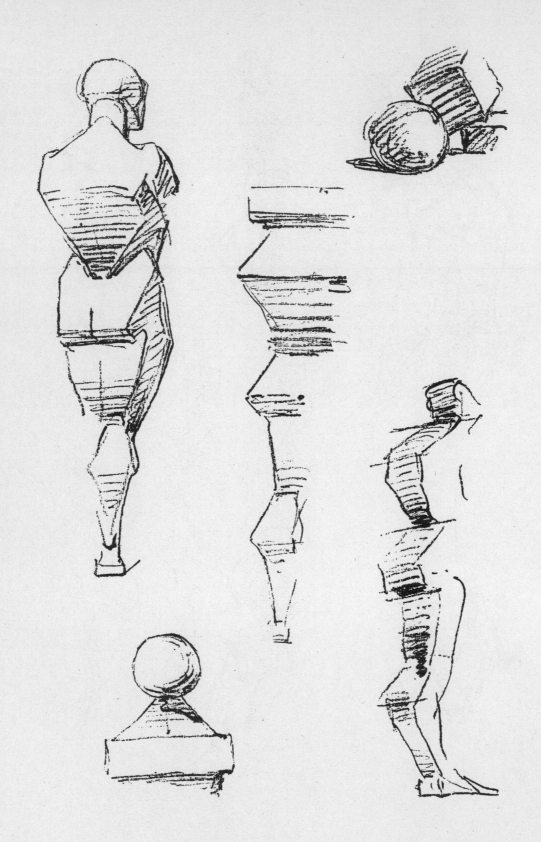

66

The Human Head

A͟T first the study of heads should be in the abstract, that is, we should forget everything that distinguishes one head from another and think of the masses common to all heads. Heads are about the same size. Each is architecturally conceived, constructed and balanced; each is a monumental structure.

By first mentally conceiving of a head as a cube, rather than as an oval or egg-shaped form, we are able to make simple, definite calculations.

The cube of the head measures about six inches wide, eight inches high and seven and a half inches from front to back. These measurements are obtained by squaring a skull on its six sides: face, back, two sides or cheeks, top and base or lower border, which is partly hidden by the neck but is exposed under the chin and jaw, and again at the back where it is seen as the lower border of the skull. Therefore the base of this cube is about seven and a half inches deep and six inches wide, and on this "ground plan" as on that of a square, any form may be constructed.

This cube may be tilted to any angle, also foreshortened, and it may be placed in perspective.

THE SKULL

THE skeleton of the head, like the cube, has six surfaces: top, base, two sides or cheeks, front and back. Its bony framework is immovable, except the lower jaw, which articulates.

There are twenty-two bones in the head. Eight of these bones compose the brain case and fourteen bones compose the face. The brain case is bounded in front by the frontal bone or forehead, which extends from the root of the nose to the crown of the head and laterally to the sides of the temples. The two malar bones, or cheek bones, are facial bones, each united to four other bones forming a part of the zygomatic arch which spans the space from cheek to ear. Above, the malar or cheek bone joins the forehead at its outer angle; below, it joins the superior maxillary or upper jawbones. The two superior maxillary bones constitute the upper jaw and cylinder that hold the upper row of teeth. They are attached above to the cheek bones and eye cavities. The nasal bones form the bridge of the nose.

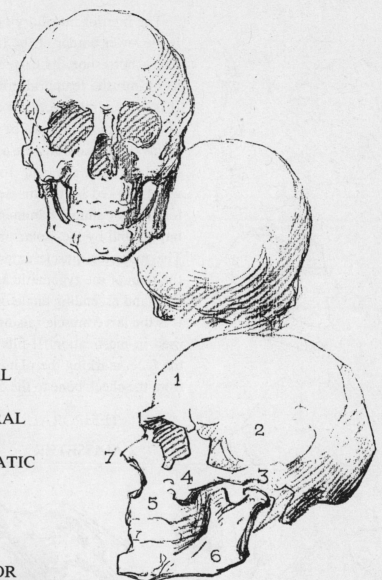

1 FRONTAL

2 TEMPORAL

3 ZYGOMATIC
 ARCH

4 MALAR

5 SUPERIOR
 MAXILLARY

6 INFERIOR
 MAXILLARY

7 NASAL

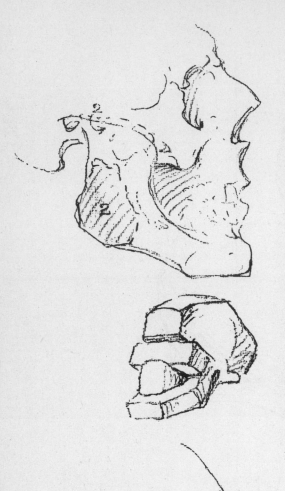

The inferior maxillary or lower jawbone is the lower border of the face. It is shaped like a horseshoe, its extremities ascending to fit into the temporal portion of the ear. It is a mandible, working on the principle of a hinge moving down or up as the mouth opens or closes, but with a certain amount of play, sideways and forward, so that when worked by the masseter muscles the food is not simply hammered or flattened, but ground by the molar or grinding teeth. The masseter muscle extends from under the span of the zygomatic arch to the lower edge and ascending angle of the lower jaw. It is the large muscle raising the lower jaw, used in mastication. It fills out the side of the face, marking the plane which extends from the cheek bone to the angle of the jaw.

1 TEMPORAL

2 MASSETER

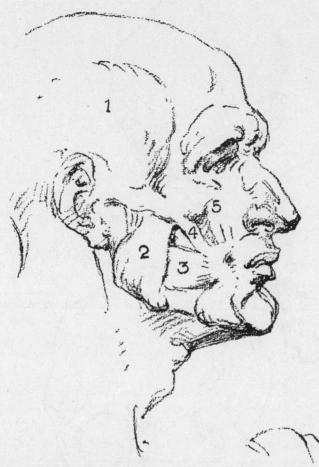

MUSCLES OF MASTICATION:

1 Temporal

2 Masseter

3 Buccinator (cheek muscle)

4 and 5 Lesser and greater
zygomaticus (muscles of expression)

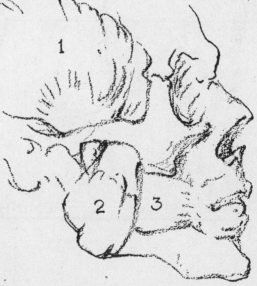

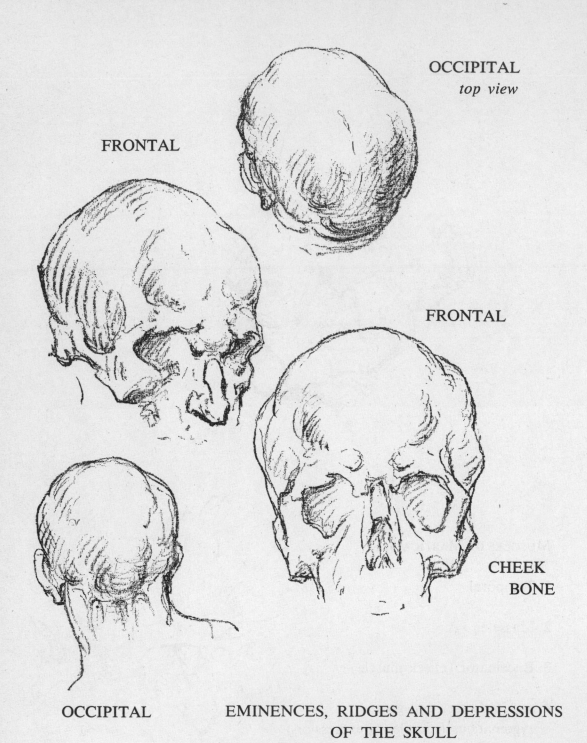

OCCIPITAL
top view

FRONTAL

FRONTAL

CHEEK
BONE

OCCIPITAL EMINENCES, RIDGES AND DEPRESSIONS
OF THE SKULL

72

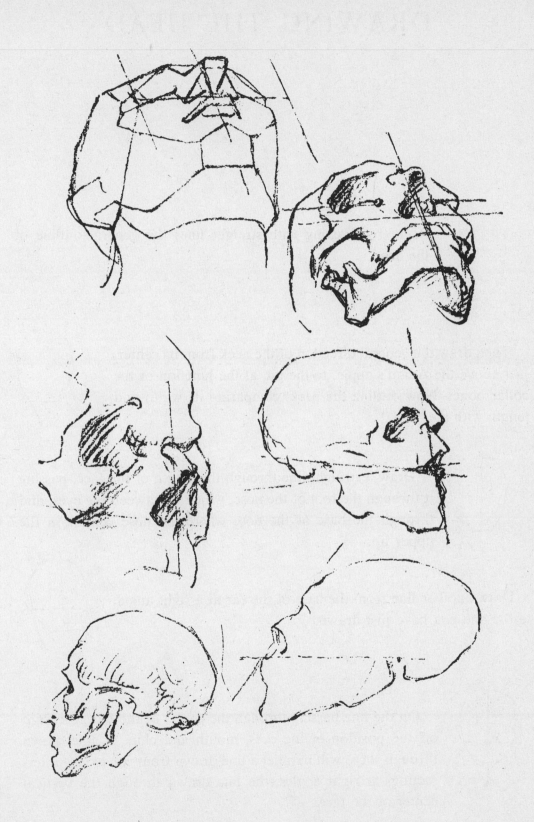

DRAWING THE HEAD

 Begin by drawing with straight lines the general outline of the head.

Then draw the general direction of the neck from its center, just above the Adam's apple, to the pit, at the junction of the collar bones. Now outline the neck, comparing its width and length with the head.

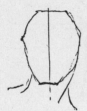 Draw a straight line through the length of the face, passing it through the root of the nose, which is between the eyes, and through the base of the nose where the nose centers in the upper lip.

Draw another line from the base of the ear at a right angle to the one you have just drawn.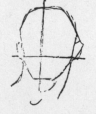

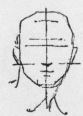 On the line passing through the center of the face, measure off the position of the eyes, mouth and chin. A line drawn through these will parallel a line drawn from ear to ear, intersecting, at right angles, the line drawn through the vertical center of the face.

74

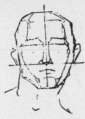

With straight lines, draw the boundaries of the forehead, its top and sides, and the upper border of the eye sockets. Then draw a line from each cheek bone at its widest part, to the chin, on the corresponding side, at its highest and widest part.

If the head you are drawing is on a level with your eyes, the lines you have just drawn will intersect at right angles at the base of the nose and if both ears are visible and the line from the ear extended across the head, it will touch the base of both ears.

Consider the head as a cube, the ears opposite each other on its sides or cheeks and the line from ear to ear as a spit or skewer running through rather than around the head.

If the head is above the eye level, or tilted backward, the base of the nose will be above this line from ear to ear. Or should the head be below the eye level or tilted forward, the base of the nose will be below the line from ear to ear. In either case, the head will be foreshortened upward or downward as the case may be and the greater the distance the head is above or below the eye level the greater the distance between the line from ear to ear and the base of the nose.

You now have the boundaries of the face and the front plane of the cube. The features may now be drawn in.

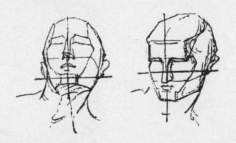

PERSPECTIVE OF THE HEAD

Pᴇʀsᴘᴇᴄᴛɪᴠᴇ refers to the effect of distance upon the appearance of objects and planes. There are to be considered parallel perspective, angular perspective and oblique perspective.

Parallel lines which do not retreat do not appear to converge. Retreating lines, whether they are above or below the eye, take a direction toward the level of the eye and meet at a point. This point is called the center of vision, and it is also the vanishing point in parallel perspective. In parallel perspective, all proportions, measurements and locations are made on the plane that faces you. So in drawing a square, a cube or a head, draw the nearest side first.

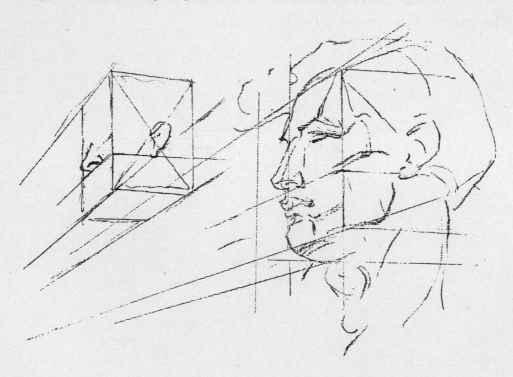

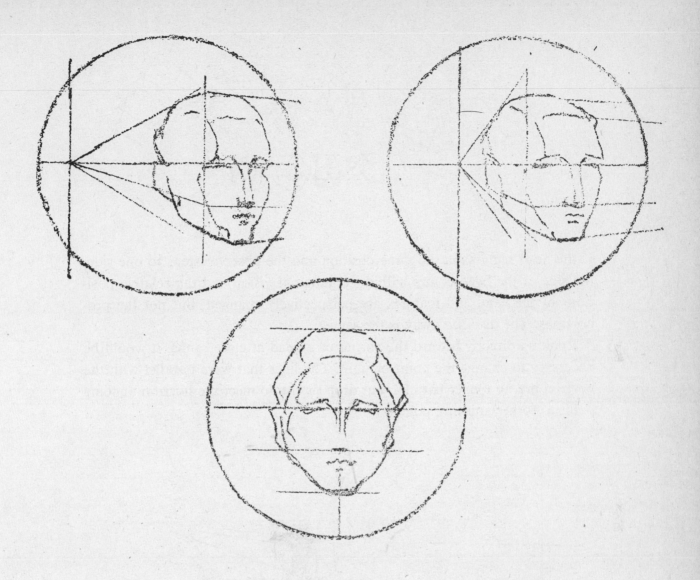

When an object is turned to right or left, so that the lines do not run to the center of vision, then the center of vision is not their vanishing point and the object is said to be in angular perspective.

When an object, such as a cube, is tilted or turned from the horizontal it is said to be in the oblique perspective.

Take a circle for an illustration. Draw a horizontal line through its center, then a line at right angles. Where they intersect place a point of sight. Should a head be placed directly in the center of this circle the center of the face would correspond to the root of the nose, on a line level with the lower border of the eyes. The horizontal line is called the horizon and is at eye level at the height of the eye. The features will parallel the horizontal line.

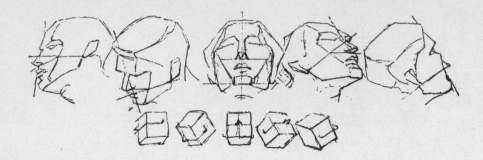

If the head remains in the same position and the observer steps to one side, the side of the head comes within the range of vision and the relative positions of the head and features are perspectively changed, but not the proportions. The distance away is the same.

Looking directly toward the corner of a head at close range, it would be necessary to change the point of sight. The lines that were parallel with the horizon are no longer parallel, but drop or rise to meet the horizon at some point to form vanishing points.

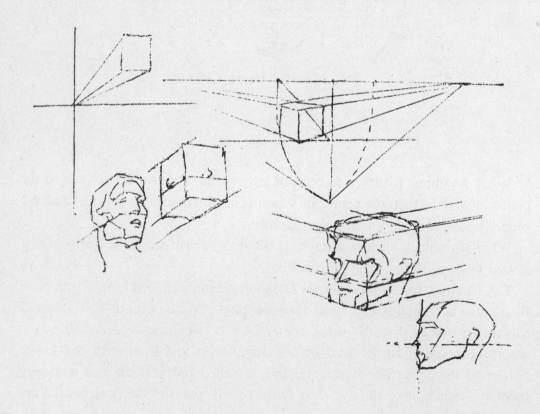

Unless a head is at eye level it must necessarily be in perspective. When a head is above the spectator, obviously he is looking up. Not only is the head in perspective, but every feature of the face; eyes, nose, mouth, ears. Like the barnacles on the hull of a ship, the features follow the lift. In the same manner they follow the upward trend, or its reverse. Everything to that is secondary. The features must travel with the mass of the head.

Perspective must have some concrete shape, form or mass as a basis. A cube or a head seen directly in front will be bordered by parallel lines; two vertical and two horizontal. These lines do not retreat, and therefore, in appearance remain parallel. As soon however, as they are placed so that they are seen from beneath, on top or from either side, they appear to converge. This convergence causes the further side of the object to appear smaller than the nearer side.

The rules are:

First—Retreating lines whether above or below the eye tend toward the level of the eye.

Second—Parallel retreating lines meet at the level of the eye. The point where parallel retreating lines meet is called the vanishing point.

As objects retire or recede they appear smaller. It is the first rule of perspective—on this, the science of perspective is built.

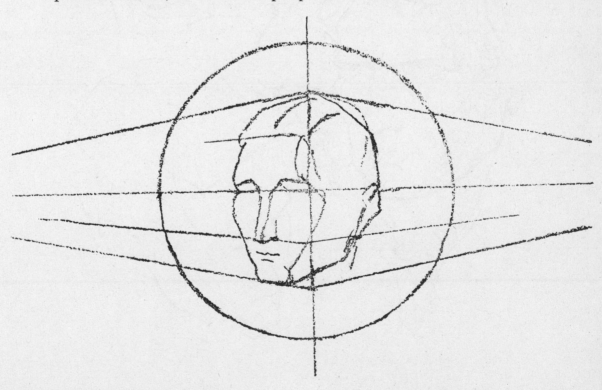

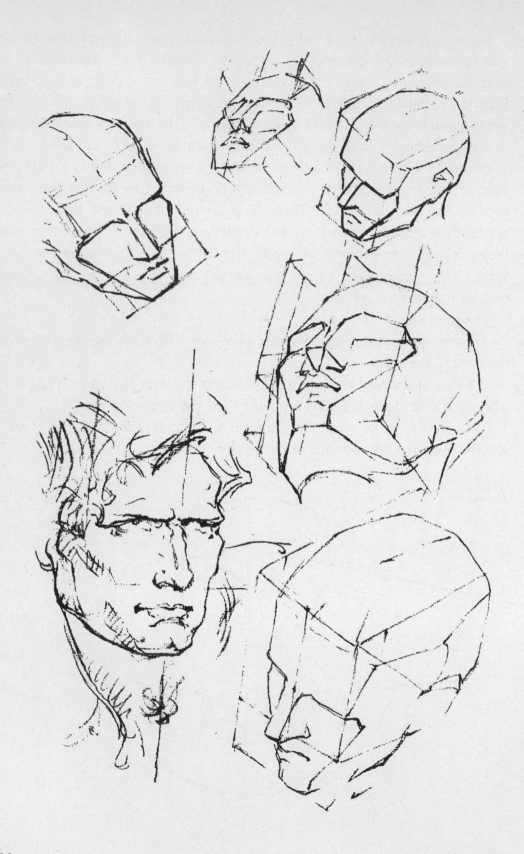

80

DISTRIBUTION OF MASSES
OF THE HEAD

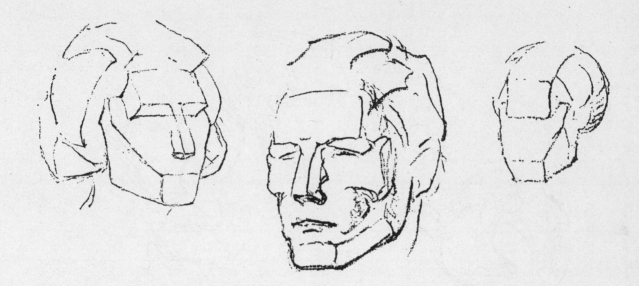

Four distinct forms compose the masses of the face. They are:

1. The forehead, square and passing into the cranium at the top.
2. The cheek-bone region which is flat.
3. An erect, cylindrical form on which are placed the base of the nose and the mouth.
4. The triangular form of the lower jaw.

From forehead to chin a face that is not flat either protrudes or recedes, curving outward or inward, alternating as to curves and squares of varied forms. In this respect a face in profile resembles architectural mouldings.

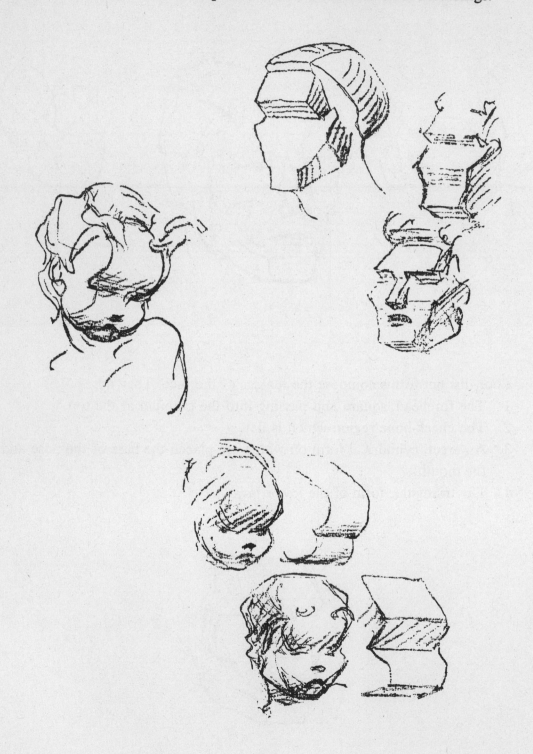

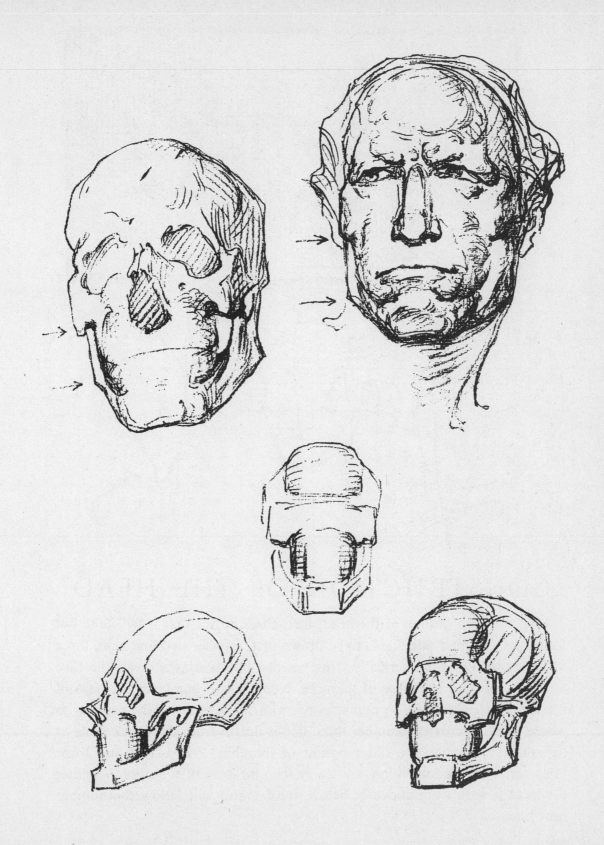

83

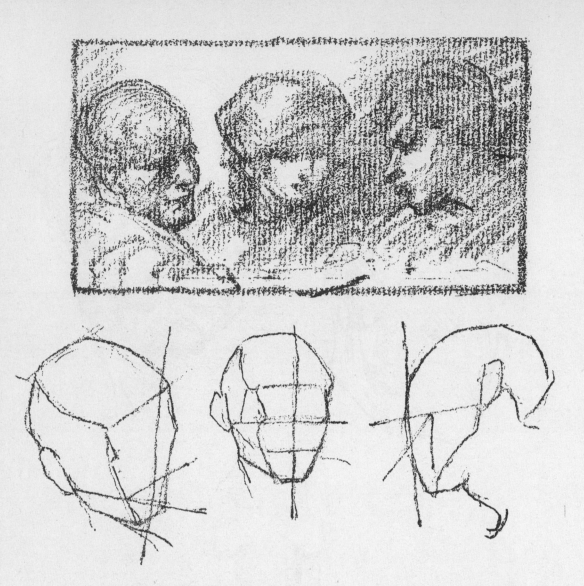

CONSTRUCTION OF THE HEAD

First draw an outline of the head, then check to see that it will take but four lines. Number one line is to be drawn first, number two line next, three and four to follow numerically. Number one line is drawn down the face touching the root and base of the nose. Number two line from the base of the ear at a right angle to number one, with no relation to the face as to where this line crosses. Number three line is drawn from the cheek bone at its greatest width to the outer border of the chin. Where two and three intersect, start the fourth line and carry it to the base of the nose. Whether the head is seen from above or below, the features will follow the number four line.

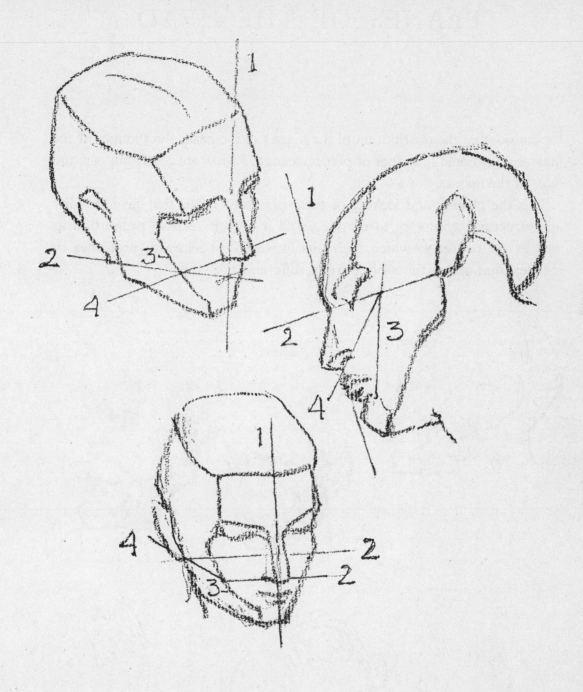

PLANES OF THE HEAD

In considering the distribution of the masses of the head, the thought of the masses must come first; that of planes, second. Planes are the front, top and sides of the masses.

It is the placing and locking of these planes or forms that gives solidity and structural symmetry to the face, and it is their relative proportion as well as the degree to which each tilts forward or backward, protrudes or recedes, that makes the more obvious differences in faces.

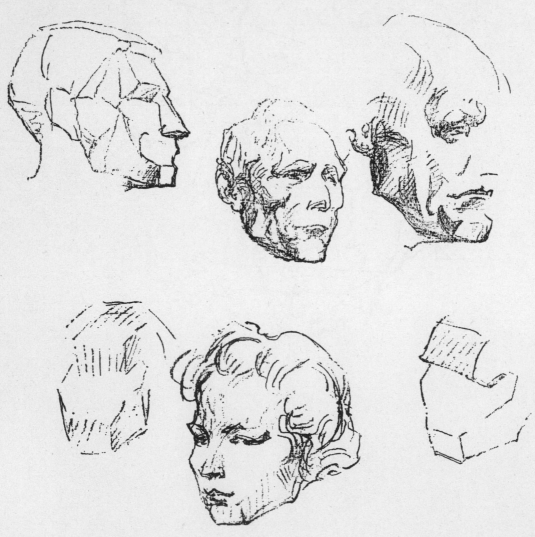

Heads in general should be neither too round nor too square. All heads, round or oval or square, would be without contrast in form.

In drawing, one must look for or suspect that there is more than is casually seen. The difference in drawing is in what you sense, not what you see. There is other than that which lies on the surface.

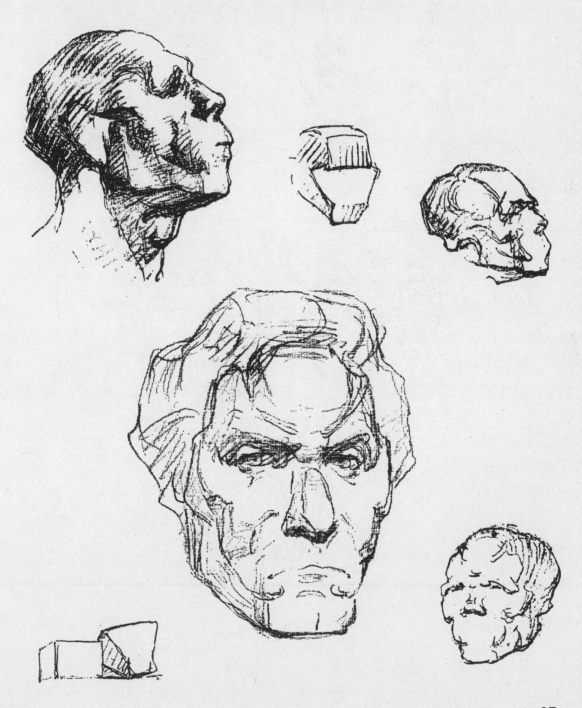

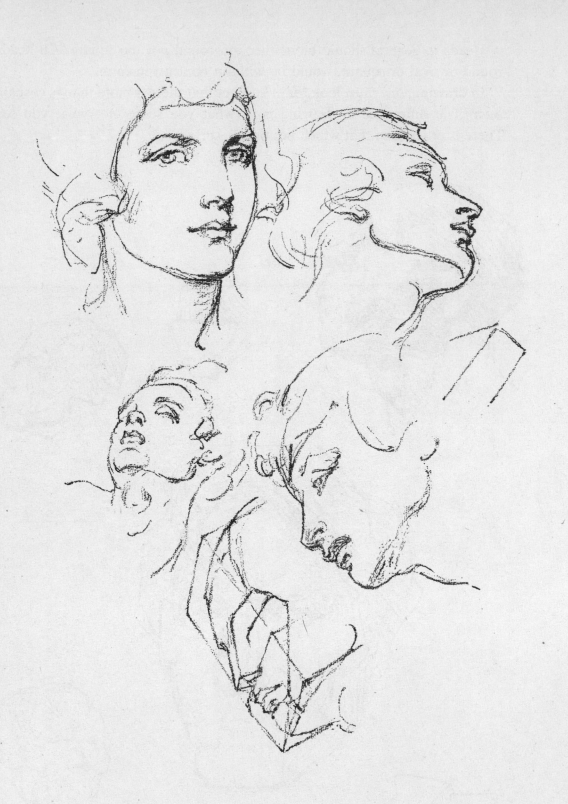

88

The front of a face is the front plane. The ear side is another plane. Spectacles are hinged to conform to the front and sides of a face.

The square or triangular forehead must have a front and two sides, making three planes.

The face turns at a line from each cheek bone downward to the outer side of the chin. There is also a triangular plane on each side of the nose; its base from tip to wings forms another triangular plane. There is also the square or rounded chin with planes running back from each side.

Border lines separate the front and sides of the forehead above, and cheek bones and chin below. Across from ear to cheek bone is a ridge separating two more planes which slope upward toward the forehead and downward to the chin.

Considering the masses of the head, the thought of the masses comes first, then the planes; after that the rounded parts of the head. There are four rounded forms on the skull. One on the forehead, two on the sides of the head, just above each ear, and one on the front of the face, extending from nose to chin. On each side, at the upper part of the forehead, are two rounded elevations termed the frontal eminences. These eminences often merge into one and are referred to as the frontal eminence.

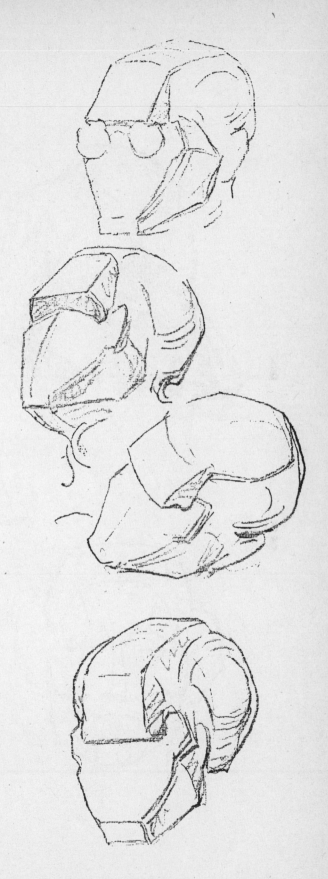

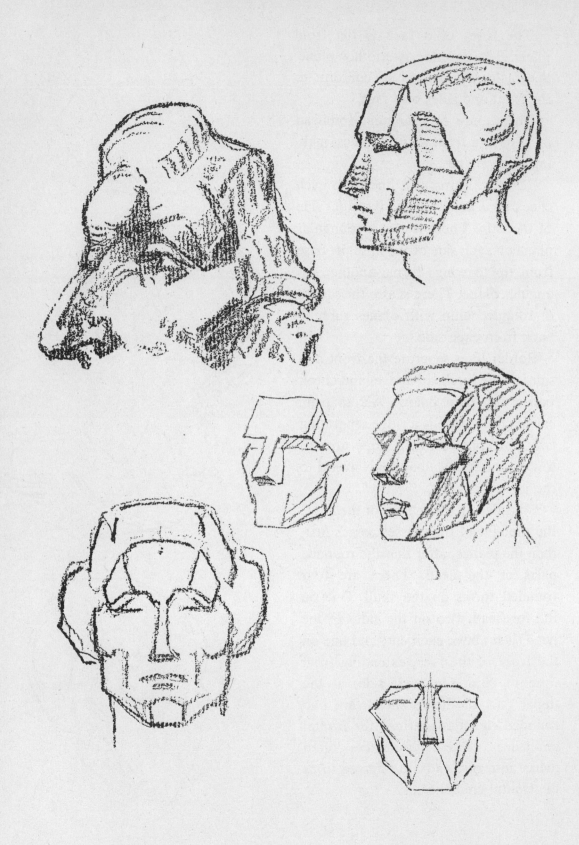

90

The plane of the forehead slopes upward and backward to become the cranium; and the sides turn sharply to the plane of the temples.

The plane of the face, divided by the nose, is broken on each side by a line from the outer corner of the cheek bone to the center of the upper lip, making two smaller planes.

The outer of these turns to become the plane of the jaw, which also is again divided by a line marking the edge of the masseter muscle, running from the outer border of the cheek bone to the corner of the jaw, and again making two secondary planes, one toward the cheek and one toward the ear.

The relations of these masses and planes is to the moulding of a head what architecture is to a house. They vary in proportion with each individual, and must be carefully compared with a mental standard.

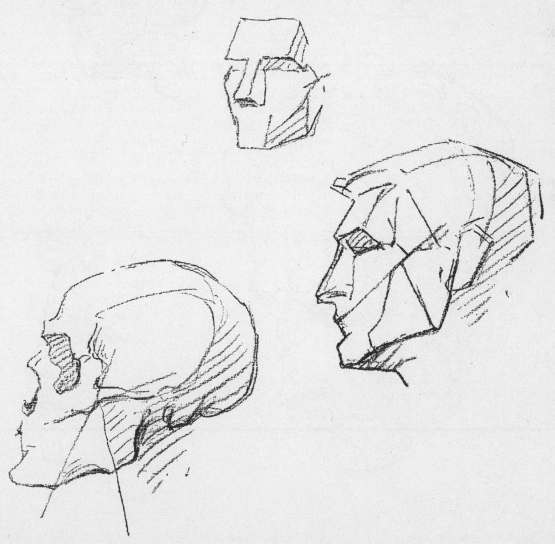

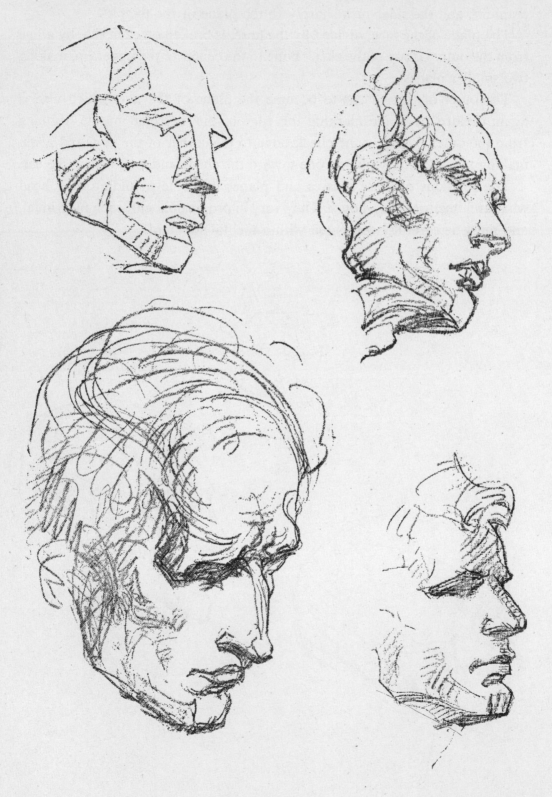

92

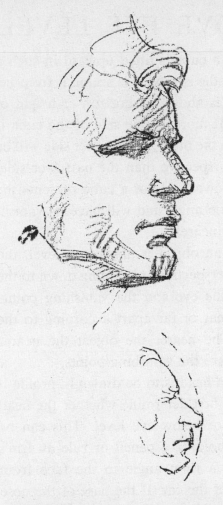

THE HEAD
IN PROFILE

In profile the masses of the head are the same—the cranium, the skeleton of the face, and the jaw.

The front border of the temple is seen to be a long curve, almost parallel to the curve of the cranium.

The top of the cheek bone is seen to be prolonged backward toward the ear as a ridge (zygoma or yoke) which also marks the base of the temple. It slopes slightly down in front.

From cheek bone and zygoma, where they meet, a lesser ridge is seen rising between the temple and the orbit, marking the back of the orbit and the first part of the long line of the temple.

Assume a profile view of a head measures eight by eight inches. Directly in front or from the back, the relative proportions would be six by eight. At three-quarters view it would be somewhere between the two measurements.

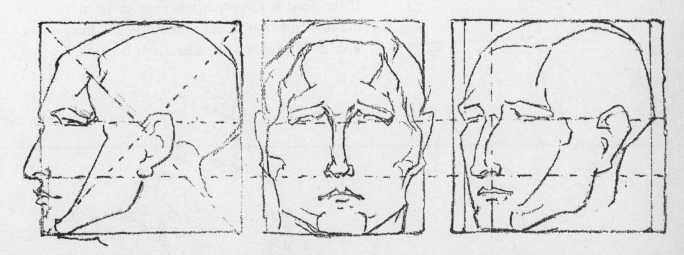

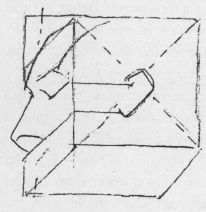

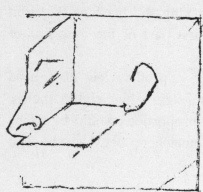

ABOVE EYE LEVEL

When a cube is tilted upward in such a way that the spectator is seeing it from beneath, it is above the horizon or height of the eye. If more of one side of the cube is seen than the other, the broader side will be less in perspective than the narrower side. The narrowest side of a cube presents the more acute angle and will have its vanishing point nearest.

When an object is above eye level, the lines of perspective are coming down to the level of the eye and the vanishing points will be near or far apart according to the angles. The nearer the object the nearer together are the vanishing points.

When a head is to be drawn in profile it is well to first determine whether the head is above or below eye level. This can be done by holding a pencil or rule at arm's length at a right angle to the face from the base of the ear. If the base of the nose shows below the ruler, then you are looking up underneath the head; therefore the head is above eye level or tilted backward. If the head is three-quarters view or front, the line from ear to ear will cut below the nose as in profile when seen from beneath.

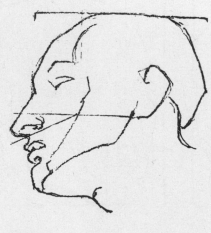

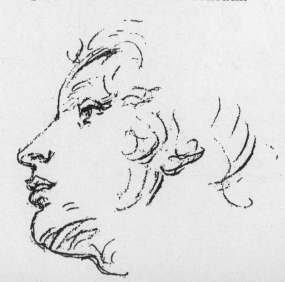

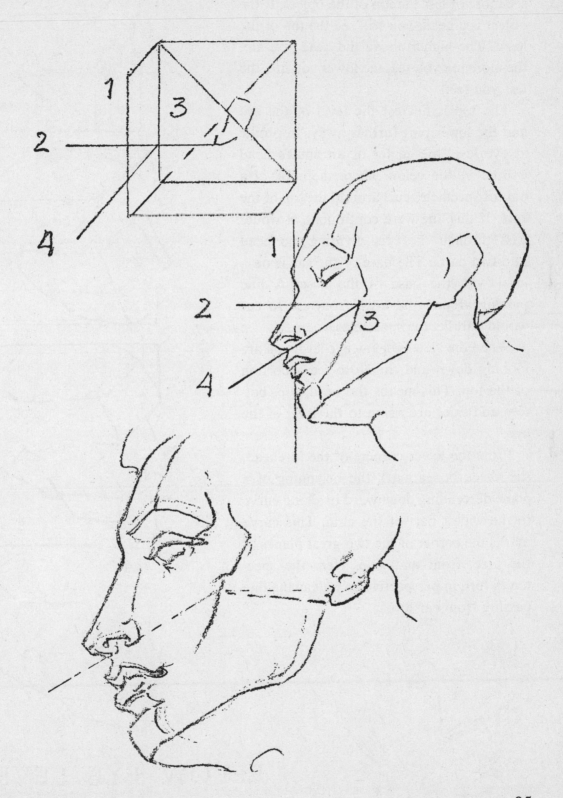

In looking down on an object you will see more or less the top of the object. If the object is a head, you will see the top of the head. The higher above the head you are, the more top you see, the lower you are, the less you see.

The top is nearest the level of the eye and the lower part further away. In profile at eye level the center of an adult's head will be a little below where the hook of a pair of spectacles curl around the top of the ears. If this line were continuous, it would pass through the eye, dividing the head into two parts. The base of the ear is on a level with the base of the nose. A line passing around the head from ear to ear would parallel the spectacles.

When the view is below eye level you are looking down and therefore see a portion of the top. This means the head, top, bottom and sides are rising to the level of the eye.

From the lower corners of the forehead, the cheek bones mark the beginning of a plane descending downward in a long curve to the widest part of the chin. This curve marks the corner of the two great planes of the face, front and side. Here the spectacles turn in perspective as well as the line passing from ear to ear.

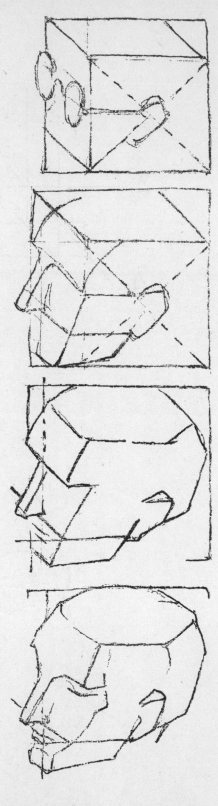

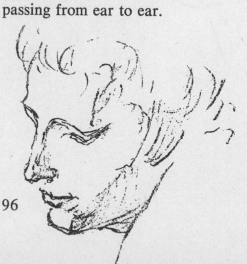

BELOW EYE LEVEL

96

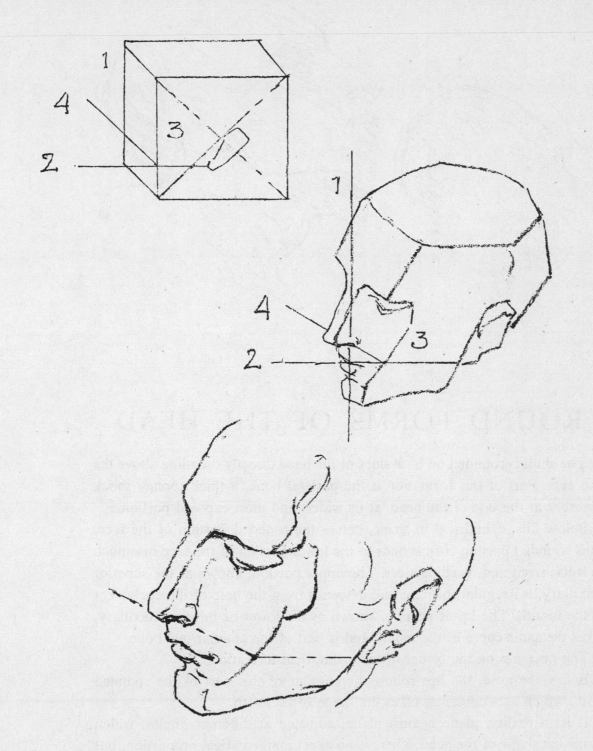

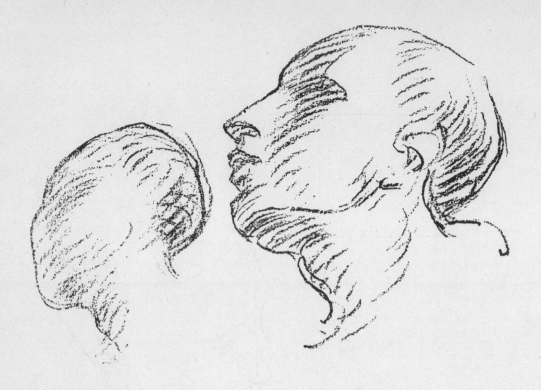

ROUND FORMS OF THE HEAD

The skull is rounded on both sides of the head directly on a line above the two ears. Part of this formation is the parietal bone, a thick spongy shock absorber at the side of the head, at its widest and most exposed portion.

Below this, cylindrical in shape, comes the rounded portion of the face. This rounded portion corresponds to the lower portion of the face inasmuch as it has front and receding sides. The upper portion, known as the superior maxillary, is irregular in shape and descends from the base of the eye socket to the mouth. The lower portion, known as the lower or inferior maxillary, takes the same curve as the mouth and is part of the angular jaw bone.

The nose lies on the center of this cylindrical formation.

Below the nose, the lips follow the contour of this part of the rounded form, which as a covering, takes the shape of the teeth.

It is in reality, plane against plane, adjusted at different angles, which forms the shape of the head. There is no exact mathematical proportion, but in perspective or from any angle, we are forced to balance truly one side with the other.

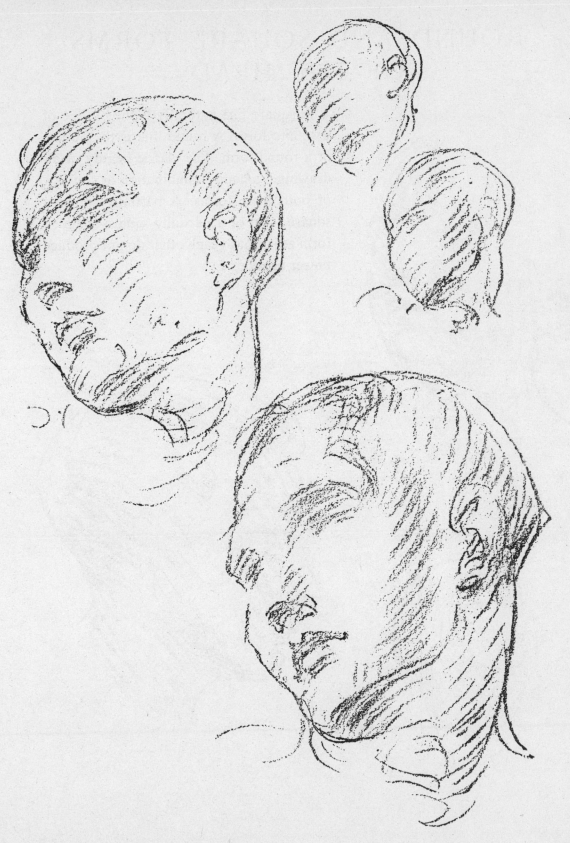

ROUND AND SQUARE FORMS OF THE HEAD

A square line naturally is the outline of a square form. A round line is the outline of a round form. The classic beauty of all drawing is a happy combination or contrast of both these forms. A partially rounded square form or a partially square rounded form adjacent to each other do not produce power or style.

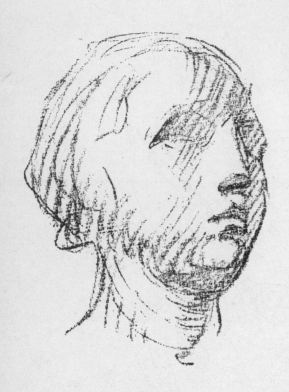

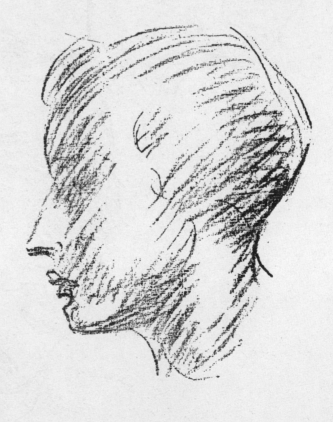

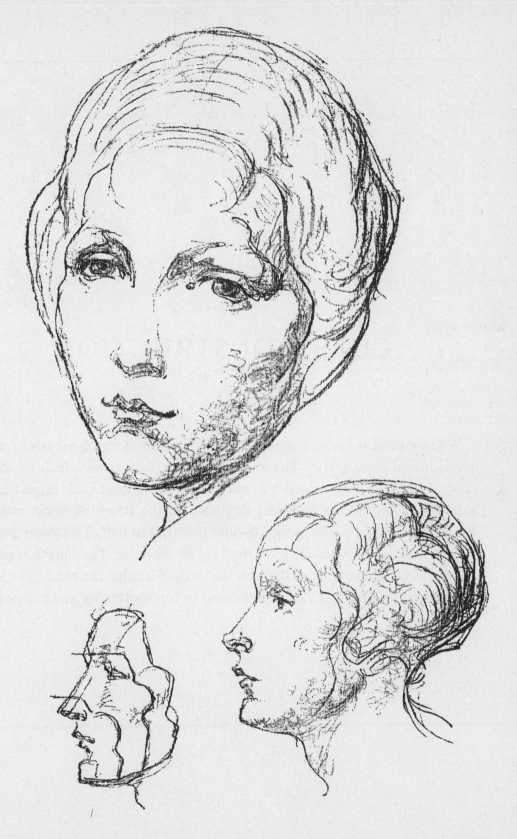

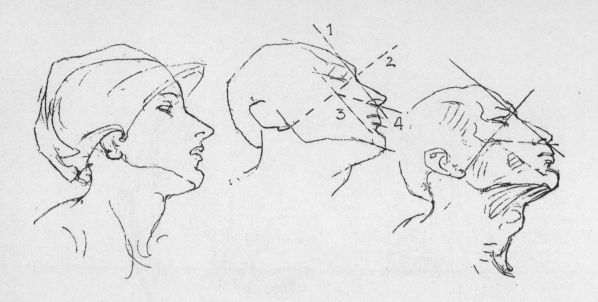

CUBE CONSTRUCTION

When a head is built on a cube there is a sense of mass, a basis of measurement and comparison. The eye has a fixed point upon which to rest. A vertical line divides the head into two parts. These are equal, opposite, and balanced. Each side is an exact duplicate of the other. A horizontal line drawn through the lower eyelids divides the head in half. The lower portion again divided in the middle gives the base of the nose. The mouth is placed two-thirds up from the chin. Built on the form of a cube, the head has a sense of bulk and solidity that easily lends itself to foreshortening and perspective.

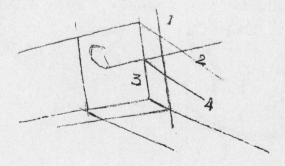

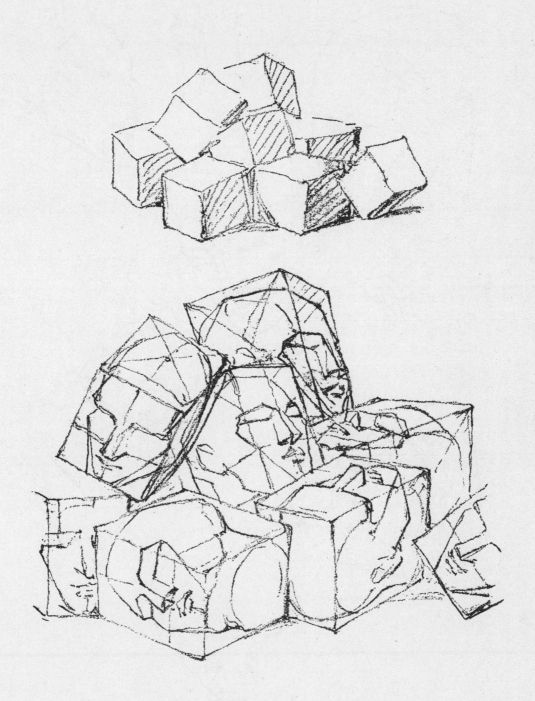

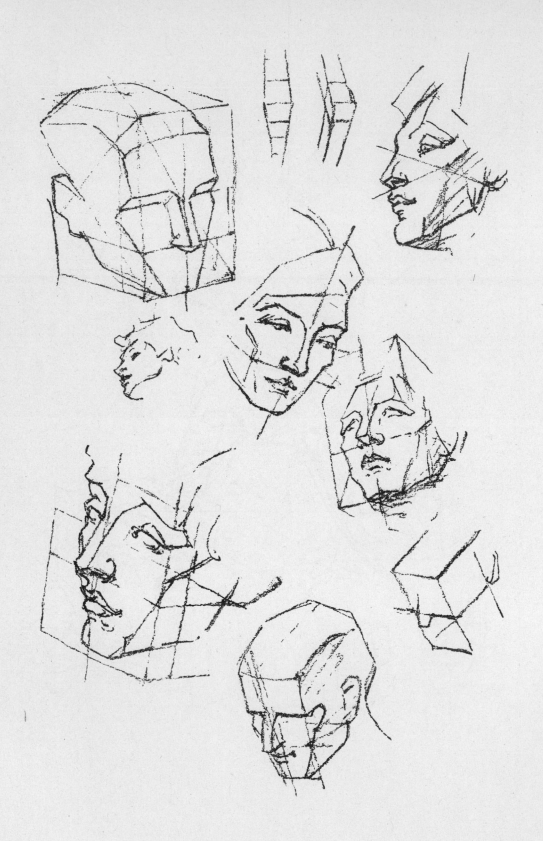

104

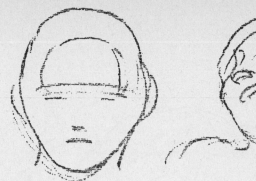
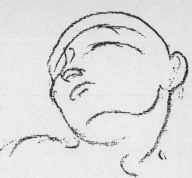

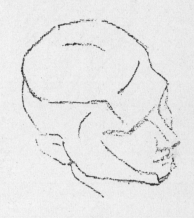

OVAL CONSTRUCTION

When heads are built on an oval, the basic idea is that the shape is rather like an egg. The main line passes through the features from top of head to chin. This is divided into three parts. The cranium and forehead of the adult occupy the top half, the lower half divided again in the middle gives the base of the nose. The mouth is placed two-thirds the distance up from chin to nose. When the head is tilted or turned, the main axis that is drawn down the face follows the oval. The divisions follow the divisions as before mentioned.

In the oval construction the eye and ear are taken as the medium line. Above this line is the top of the head, while below is the face.

A line drawn at a right angle to the line already drawn, gives another median or facial line. On this the features are marked off to give their relative positions. The carriage of the head rests upon its placing or poise upon the neck. When the head tips or leans forward, back or toward the sides, the head and neck must be in relation one to the other both in movement and rhythm.

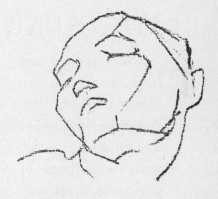

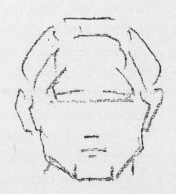

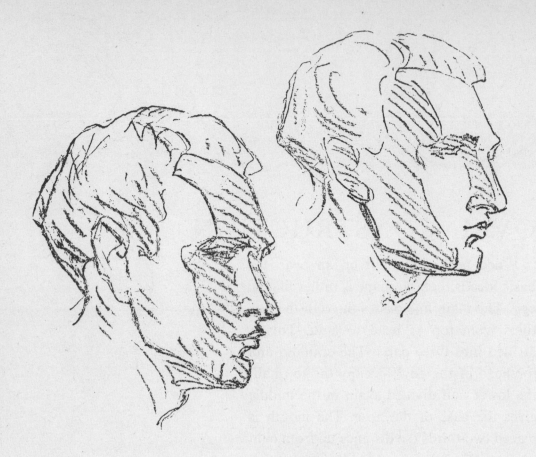

THE HEAD IN LIGHT AND SHADE

There is light and shade on any object on which light falls. There are light, shade, and cast shadows. The light blends into half light which again blends into a halftone, which again blends into a shadow. A cast shadow is the shadow of some object falling on some other object or form and bears a resemblance to the object from which it is cast.

In the parlance of Art the variations of light and shade are in a sense numbered, catalogued and called values. Light, halftone and shade, making three values, are said to be all that one can keep track of. The grading, passing, and mingling of these, through or into one another, gives the suggestion of other values, but they become more subtle and less definable.

There are many methods, mannerisms and approaches to handling light and shade. One is that form is built by light and shade, that the outline does not exist; the edges of the object are given prominence by light and shade. Another approach is that an outline drawing is solidified by light and shade, that the outline itself should suggest depth, volume and bulk with only enough shade to give it solidity.

Values are comparative and depend upon their surroundings.

106

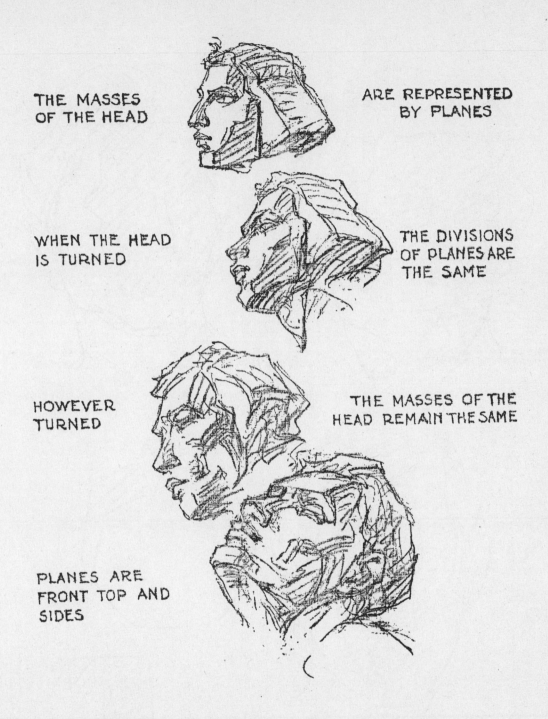

THE MASSES
OF THE HEAD

ARE REPRESENTED
BY PLANES

WHEN THE HEAD
IS TURNED

THE DIVISIONS
OF PLANES ARE
THE SAME

HOWEVER
TURNED

THE MASSES OF THE
HEAD REMAIN THE SAME

PLANES ARE
FRONT TOP AND
SIDES

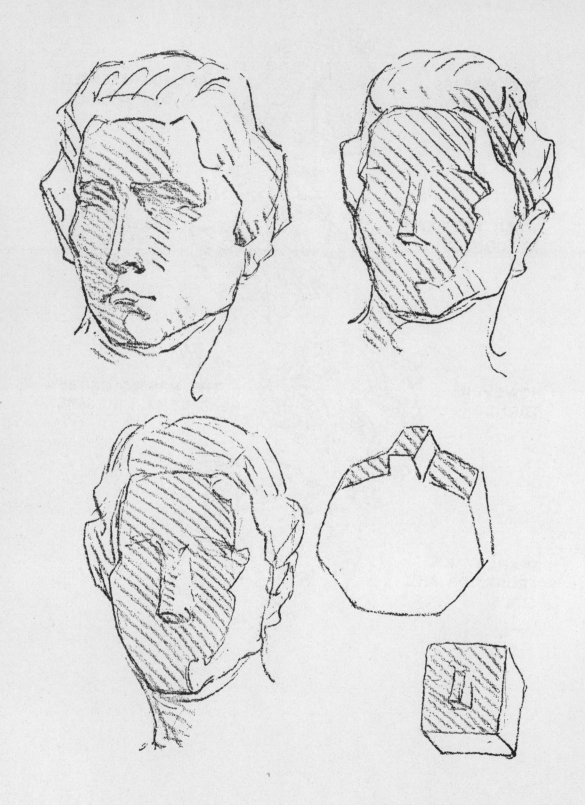

108

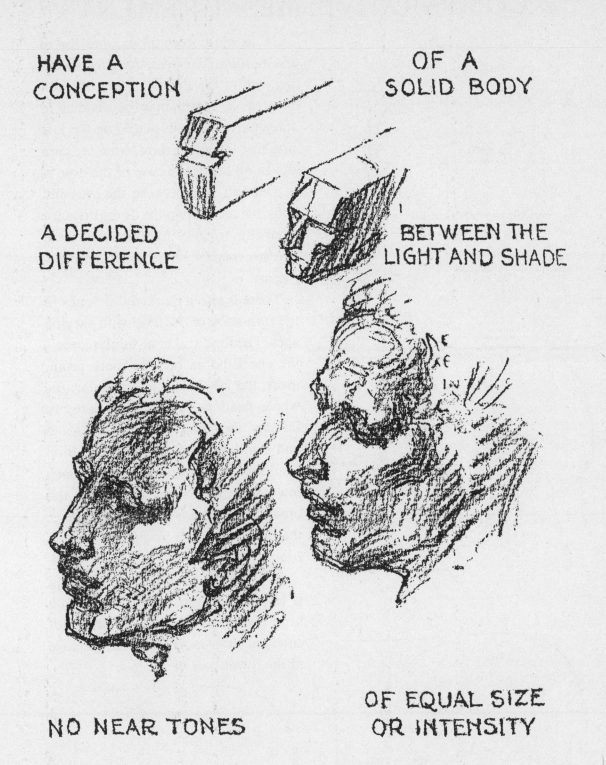

HAVE A
CONCEPTION

OF A
SOLID BODY

A DECIDED
DIFFERENCE

BETWEEN THE
LIGHT AND SHADE

NO NEAR TONES

OF EQUAL SIZE
OR INTENSITY

COMPARATIVE MEASUREMENTS

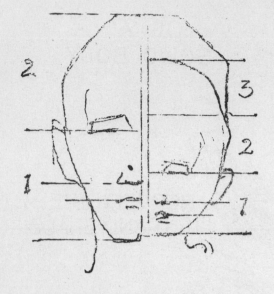

In an adult, from the extreme top to the bottom, the eyes, roughly speaking, are in the middle. The head and face of an infant may be divided in three parts, the eyes placed on the line marking the upper third, from the chin up. In all heads the base of the nose is placed half way between the eyes and chin; the mouth two-thirds the distance from chin to nose. Ages between these two necessarily range somewhere between.

There is also a marked difference in the formation of the head with varying ages. The forehead of an adult recedes, the cheek bones become more prominent, the jaw bone more angular, the whole head in fact more square. In infancy the head is more elongated and somewhat oval in form. The forehead is full, it recedes down and back toward the brows; the jaw bones and other bones of the face are diminutive; the neck is small compared to the head.

In youth the face is lengthened and is less round than in the infant. The head above the brows however, is not enlarged in proportion to the increase of the lower part of the face.

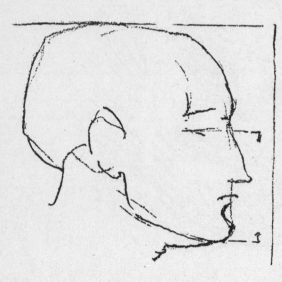

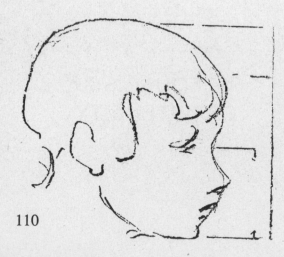

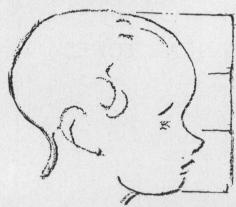

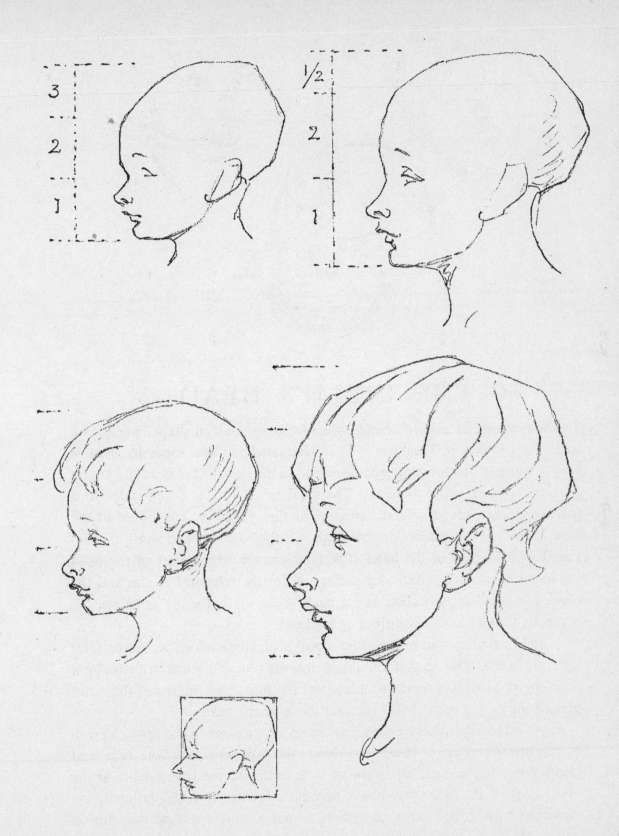

THE CHILD'S HEAD

The cranium of a child's head differs from an adult in shape, solely as a means of protection. The head is of an elongated and oval form, its greatest length being in the direction from forehead to the back of the head; its widest portion lies just above the ears. The forehead is full, and protrudes to a marked degree, receding and flattening at the eyebrows. The bones of the face, as well as the jaw bones, are small. The neck is thin and short as compared with the size of the head. The lumps at the widest part of the head are lower than in the adult as a protection for the temporal region and the ears. The peculiar projection at the back (occiput) is for the same reason, protection, and so is the protruding forehead.

A child's skull is thin and elastic; it will bear blows which would be fatal later on in life. The narrow shoulders and the almost useless arms make a necessity of a bulging forehead to protect the face from the front; the other prominent bulges protect the sides and back of the head.

From infancy to adolescence great changes take place in the upper as well as the lower portion of the face. Above, the face lengthens; the nose and cheek bones become more prominent. The teeth add width and depth at the lower part of the face. Jaw bones become more angular and pointed, the masseter muscles are more in evidence, and a squareness of the chin is noticeable.

112

MUSCLES OF THE FACE

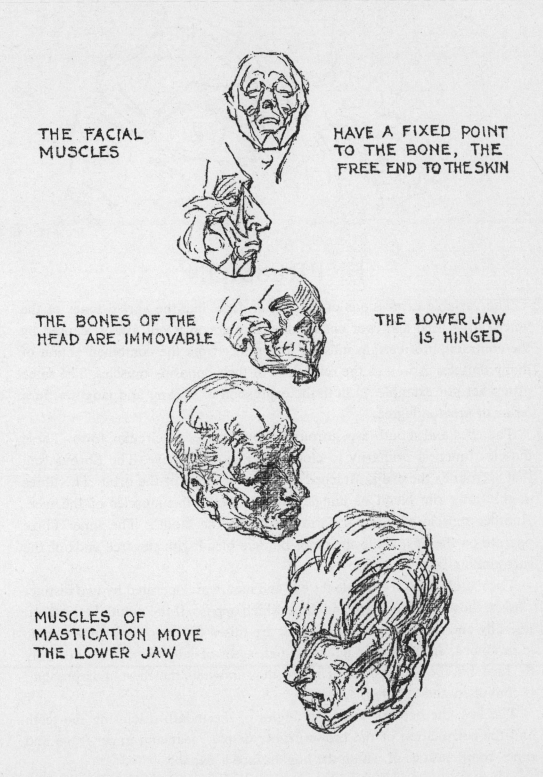

THE FACIAL
MUSCLES

HAVE A FIXED POINT
TO THE BONE, THE
FREE END TO THE SKIN

THE BONES OF THE
HEAD ARE IMMOVABLE

THE LOWER JAW
IS HINGED

MUSCLES OF
MASTICATION MOVE
THE LOWER JAW

EXPRESSION

The variable expressions of the human face, like the varied tones of the voice, are sensed and ever changeable. Expression is not always caused by the contraction of certain muscles, but rather from the combined action of many muscles as well as the relaxation of their opposing muscles. The same group act, for example, in both the expression of smiling and laughter, in a lesser or greater degree.

The eyes and mouth are surrounded by muscles of circular form. These muscles function primarily to close either mouth or eye. The fibrous ring that surrounds the eye is attached to the inner angle of the orbit. The fibres of the outer rim blend or mingle with the bordering muscles of the face. Another muscle of circular form surrounds the mouth. The inner fibres operate on the lips, while the outer borders blend with the free ends of the surrounding facial muscles.

The muscles which encircle the eye and mouth are operated by two distinct classes, those which control and those which oppose. If the mouth is stretched laterally and the muscles of the cheek are raised to the lower eyelid a smile is produced. By muscular action, a paroxysm of laughter affects not only the face, but the body as well. The breath is drawn in, the chest, a diaphragm, is convulsed and agitated.

The lips, the depression of the angles of the mouth disclosing the teeth and the corrugation of the brows denote despair, fear and anger, rage and other combinations of which the human face is capable.

114

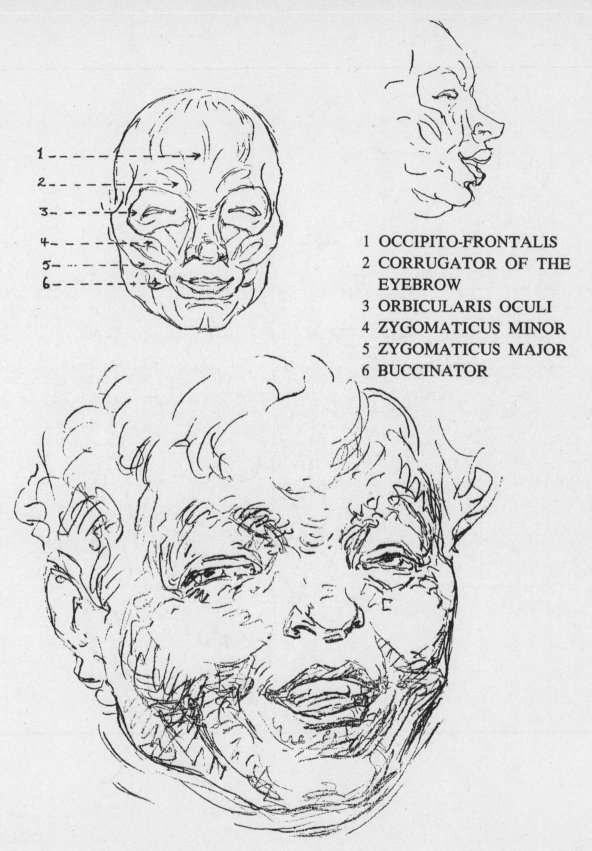

1 OCCIPITO-FRONTALIS
2 CORRUGATOR OF THE
 EYEBROW
3 ORBICULARIS OCULI
4 ZYGOMATICUS MINOR
5 ZYGOMATICUS MAJOR
6 BUCCINATOR

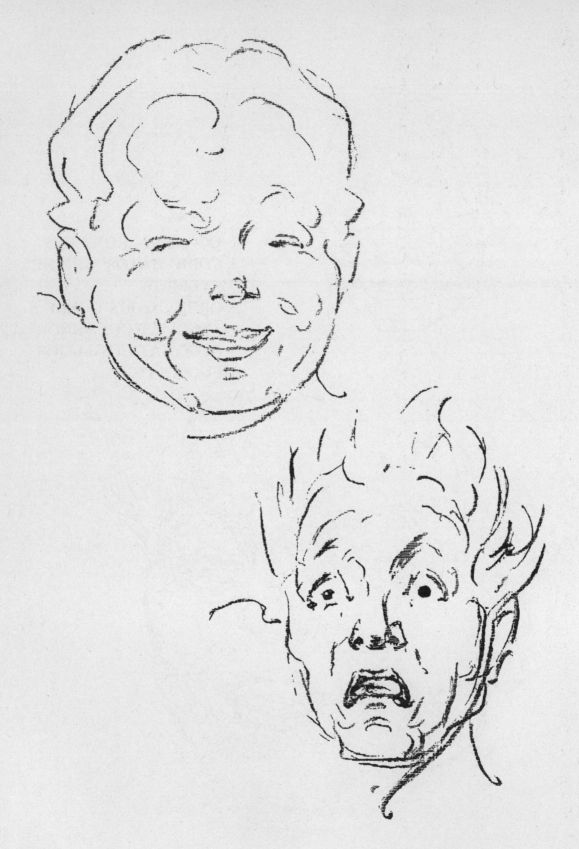

116

Features

THE CHIN

Below the cleft of the chin, the chin itself protrudes. Its breadth at the base is marked by two lines which, prolonged, would meet at the septum of the nose, making a triangle that wedges upward into the base of the lower lip. It is bordered on each side by two planes which reach to the angle of the jaw.

Variations in chins present the following comparisons: high or low; pointed or ball; flat, furrowed or dimpled; elongated, double, etc.

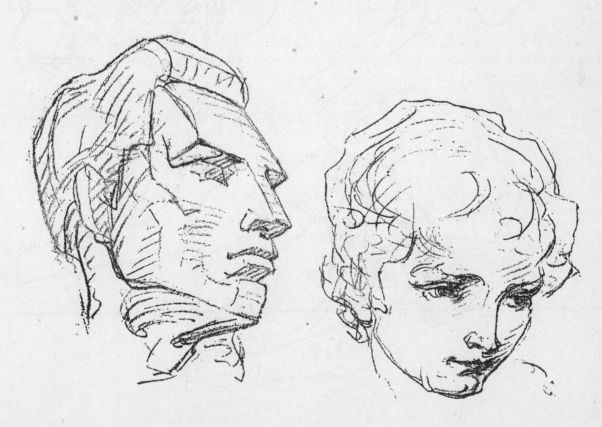

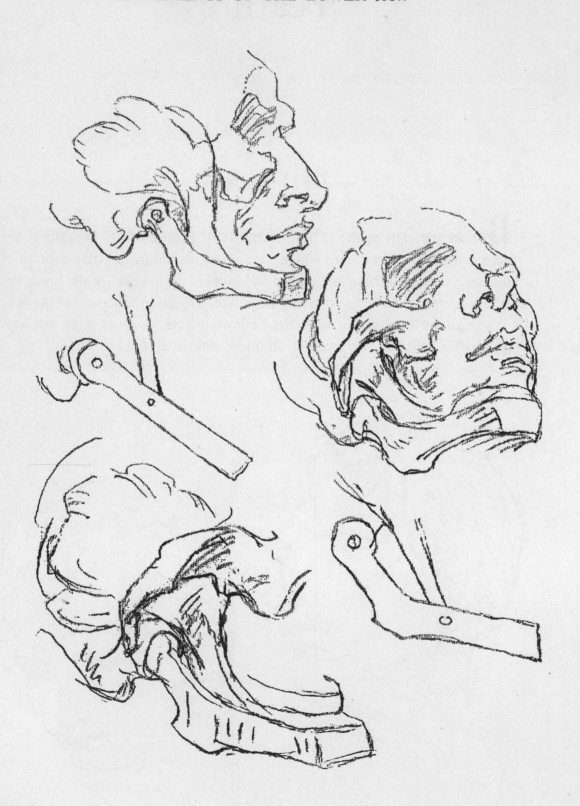

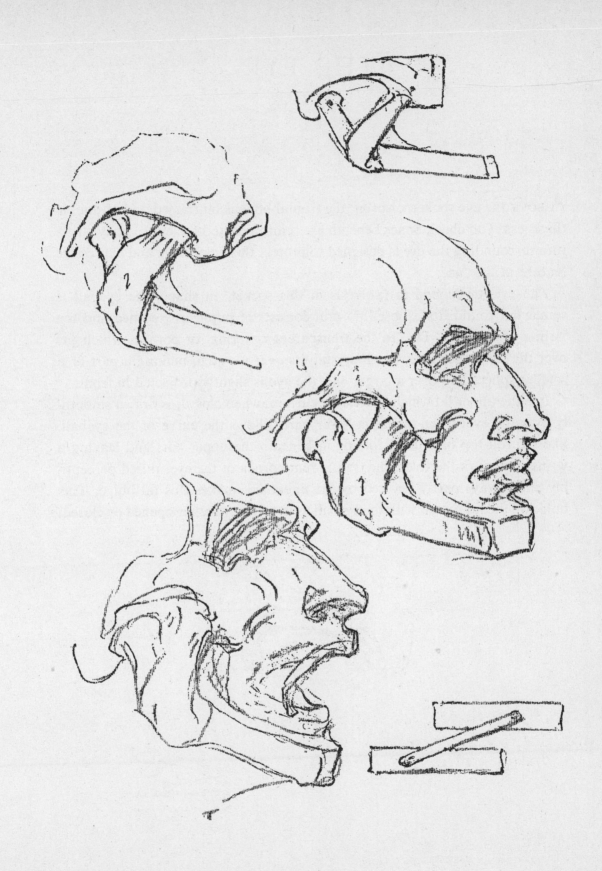

THE EYE

Above the eye socket, or orbit, the frontal bone is buttressed and of double thickness. The cheek bones beneath are reinforced and the entire bony structure surrounding the eye is designed to protect this vulnerable and expressive feature of the face.

The eye, cushioned in fat, rests in this socket. In shape, the eyeball is somewhat round. Its exposed portion consists of pupil, iris, cornea and the "white of the eye." Due to the transparent covering, or cornea, which fits over the iris, much as a watch crystal fits over a watch, making a part of a smaller sphere laid over a larger one, the eye is slightly projected in front.

It is the upper lid which moves. Its curtain, when closed, is drawn smoothly over the eye; when open, its lower part follows the curve of the eyeball, like the roll top of a desk, folding in beneath the upper part and leaving a wrinkle to mark the fold. The transparent cornea of the eye, raised perceptibly and always partly covered by the upper lid, makes this lid bulge. This bulge on the lid travels with the eyeball as it moves, whether opened or closed.

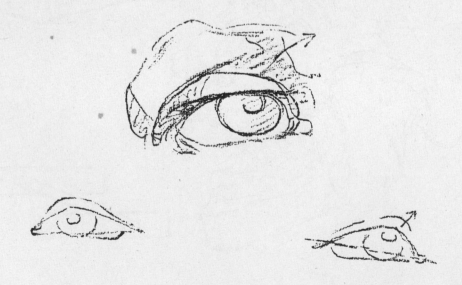

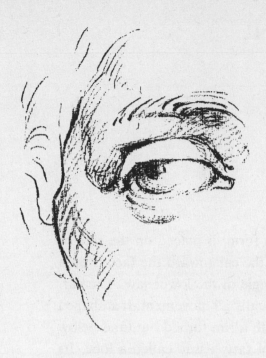

The lower lid is quite stable. It may be wrinkled and slightly lifted inward, bulging below the inner end of the lid. The lashes which fringe the upper and lower lids from their outer margin, shade the eye and serve as delicate feelers to protect it, the upper lid instinctively closing when they are touched.

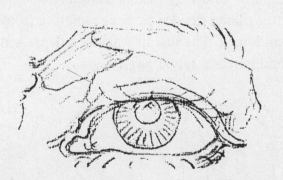

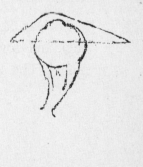

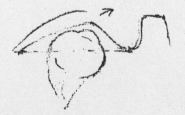

THE EAR

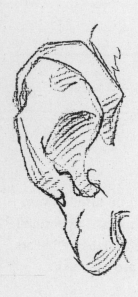

THE ear, irregular in form, is placed on the side of the head. The line of the ear toward the face is on a line with the upper angle of the lower jaw. The ear, in man, has lost practically all movement. It is shaped like half of a bowl with a rim turned out, and below is appended a piece of fatty tissue called a lobe. Its muscles which in primitive times, no doubt, could move it to catch faint sounds, now serve only to draw it into wrinkles, which, though varying widely, have certain definite forms. There is an outer rim often bearing the remains of a tip, an inner elevation in front of which is the hollow of the ear with the canal's opening protected in front by a flap and behind and below by smaller flaps.

The ear has three planes divided by lines radiating from the canal, up and back and down and back. The first line marks a depressed angle between its planes. The second marks a raised angle.

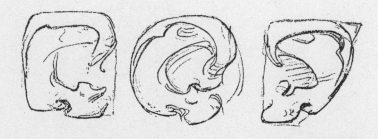

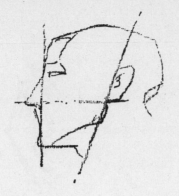

1
2
4
3

CARTILAGES OF THE EAR
1 Helix
2 Anti-helix
2 Tragus
4 Anti-tragus

PLANES OF
THE EAR

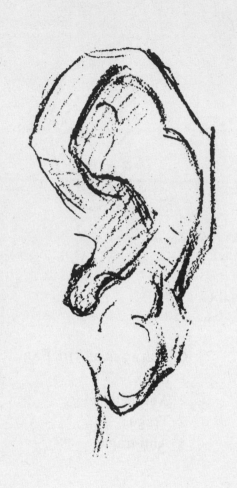

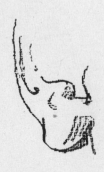

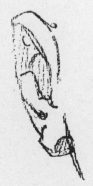

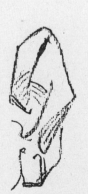

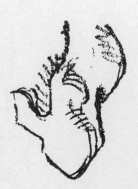

THE NOSE

THE nose is in the center of the front plane of the face. Its shape is wedge-like, its root in the forehead and its base at the center of the upper lip. As it descends from the forehead it becomes larger in width and bulk, and at its base it is held up in the middle and braced from the sides by cartilages.

The bony part of the nose descends only half way from its root and is composed of two nasal bones. The lower part is composed of cartilages, five in all: two upper, two lower laterals and one dividing the nasal cavities.

Two wedges meet on the nose, a little above the center at a point called the bridge of the nose. The direction of one is toward the base of the forehead between the eyes; that of the other toward the end of the nose, diminishing in width as it enters the bulbous portion at the tip.

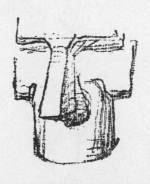

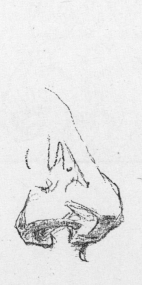

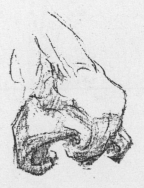

THE NOSE

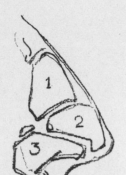

Cartilages of the Nose
1 Upper lateral
2 Lower lateral
3 Wing
4 Septum

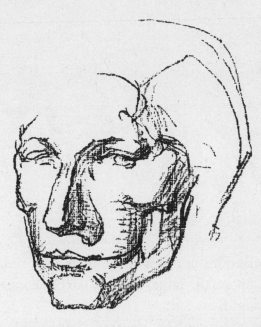

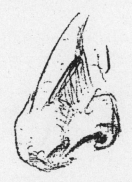

This bulb rises as two sheets of cartilage from the middle of the upper lip (septum of the nose), expands into the bulbous tip, flows over the sides, and flares out to form the alæ or wings of the nostrils.

The cartilaginous portion is quite movable. The wings are raised in laughter, dilated in heavy breathing, narrowed in distaste, and wings and tip are raised in scorn, wrinkling the skin over the nose.

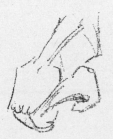

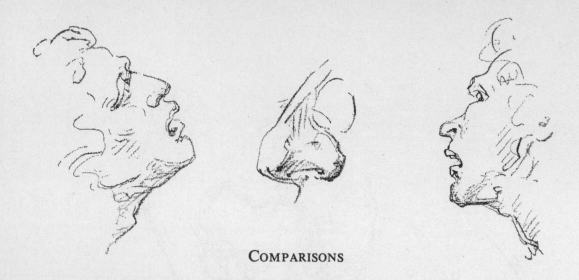

COMPARISONS

Average variations in noses divide them into classes.

They may be small, large, or very large; concave or convex; humped, Roman or straight.

At the tips they may be elevated, horizontal, or depressed; flattened, tapering or twisted.

The wings may be delicate or puffy, round or flat, triangular, square or almond-shaped.

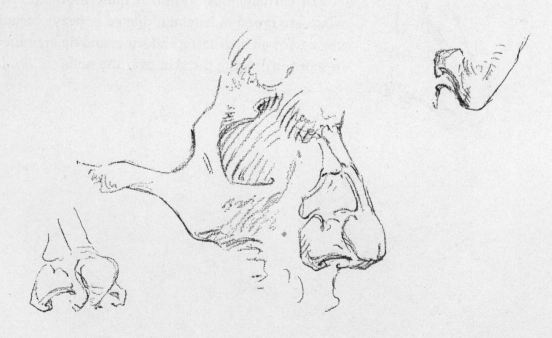

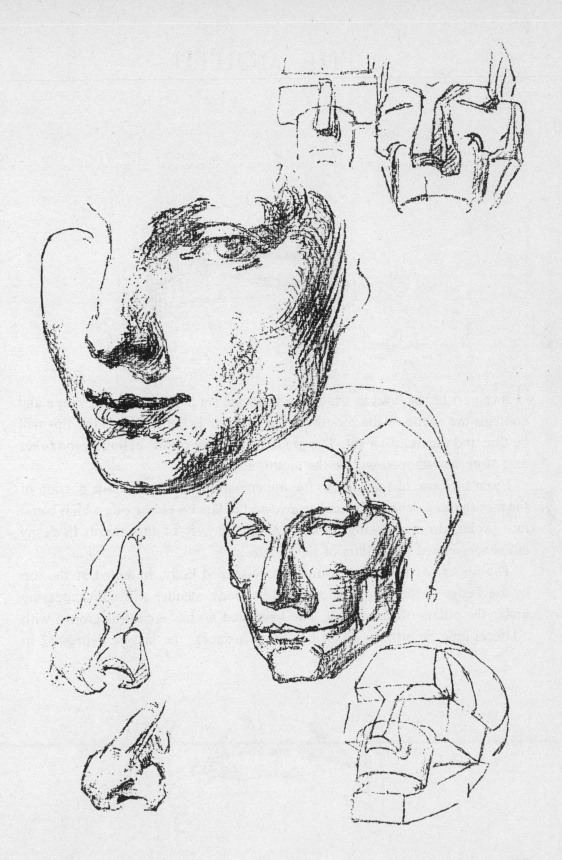

129

THE MOUTH

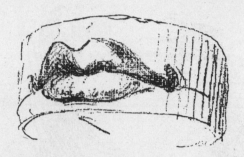

THAT part of the jaws in which the teeth are set is cylindrical in shape and controls the shape of the mouth. If the cylinder is flat in front, the lips will be thin and the mouth a slit. The greater the curve of this cylinder, the fuller and more bow-shaped will be the mouth and lips.

From the base of the nose to the upper red lip, this curtainous portion of the mouth has a central vertical groove and pillars on either side which blend into broad, drooping wings, ending at the corners of the mouth in fleshy eminences called the pillars of the mouth.

The upper red lip has a central wedge-shaped body, indented at the top by the wedge of the groove above, and two long, slender wings disappearing under the pillars of the mouth. The lower red lip has a central groove with a lateral lobe on either side. It has three surfaces: the largest depressed in

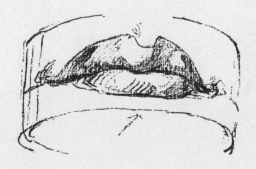

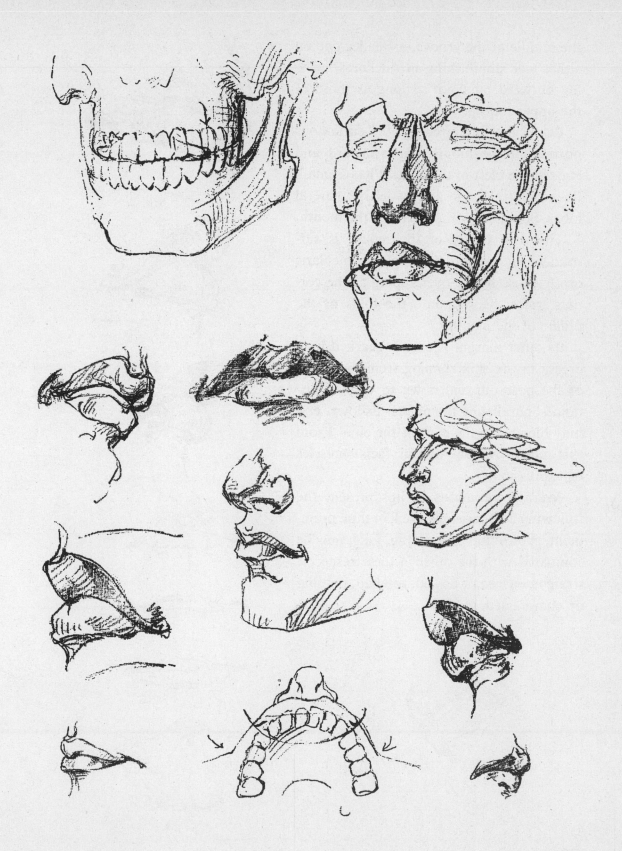

131

the middle at the groove, a smaller one on either side diminishing in thickness, curving outward, and not so long as those of the upper red lip.

Below the lower red lip, the curtainous portion of the mouth slopes inward and ends at the cleft in the chin. It has a small, linear central ridge and two large, lateral lobes, bounded by the pillars of the mouth.

The oval cavity of the mouth is surrounded by a circular muscle (orbicularis oris) whose fibres, overlapping at the corners, raise the skin into the folds or the pillars of the mouth.

Its outer margin is usually marked by a crease in the skin running from the wings of the nose out and down to varying distances, paralleling the pillars. Its lower end may blend into the cleft of the chin. From this muscle radiate various facial muscles of expression.

Average variations in lips present the following comparisons: thick or thin, prominent, protruding or receding. Each may be compared with the other in these respects: straight, curved or bowed, rosebud, pouting or compressed.

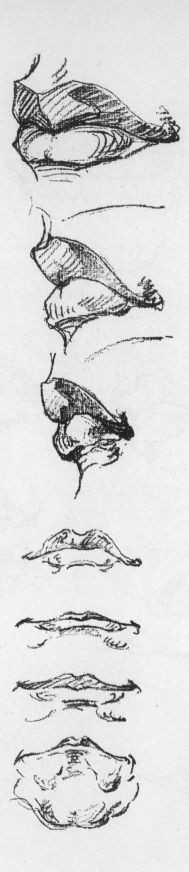

132

The Neck

THE neck is cylindrical in shape, following the curve of the spinal column; even when the head is thrown back the neck curves slightly forward.

In front, it is rooted at the chest and canopied above by the chin. In back it is somewhat flattened and the back of the head overhangs it. The neck is buttressed on each side by the shoulders. From behind each ear a muscle descends inward to the root of the neck. These muscles almost meet each other, making a point at the pit. They form, in fact, on the front plane of the neck, the sides of an inverted triangle whose base is the canopy of the chin. The two muscles referred to are called bonnet strings.

Into this triangle are set three prominent forms: a box-shaped cartilage called the larynx or voice-box; just below it a ring of cartilage called the cricoid cartilage; and beneath these a gland called the thyroid gland. In men, the voice-box or larynx is larger; in women, the thyroid gland is more prominent. The whole is known as the Adam's apple. The neck has the following action: up and down, from side to side, and rotary.

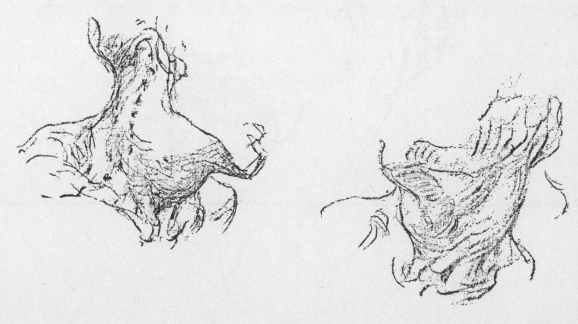

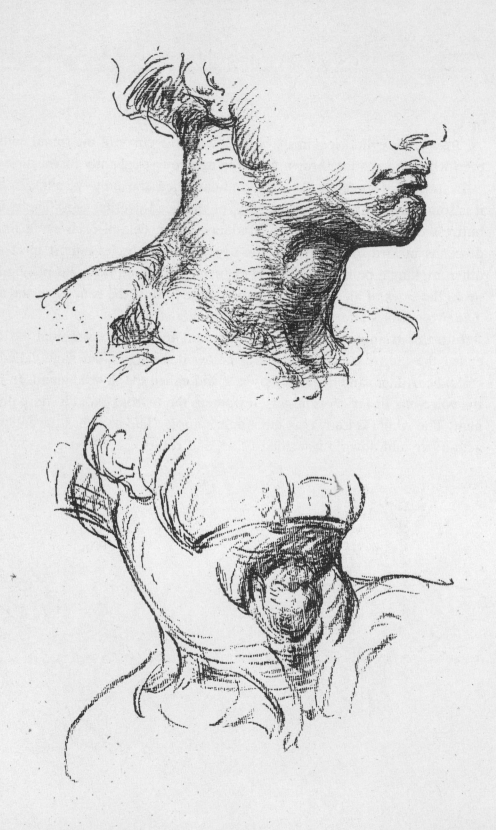

134

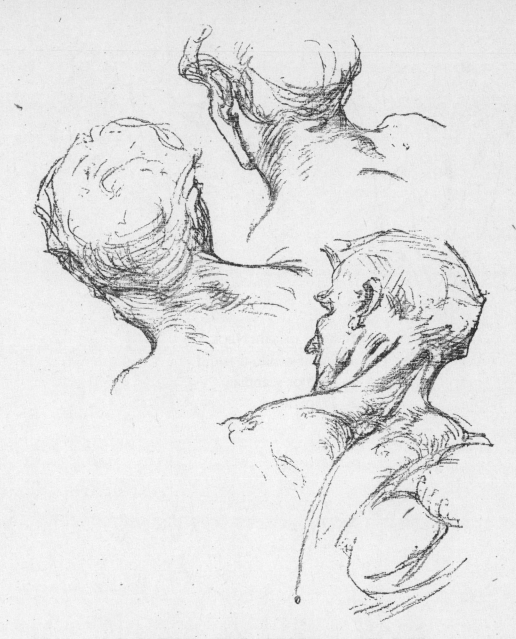

BACK OF THE NECK

From the sloping platform of the shoulders the neck rises. It is buttressed on the sides by the trapezius (table) muscle. The table shape of this muscle appears only from the back, a diamond with lower apex well down the back. Its lateral corners arise from the shoulder girdle opposite the deltoid. Rising diagonally upward it braces the back of the head.

The strength of the neck is therefore at the back, which is somewhat flat and overhung by the base of the skull.

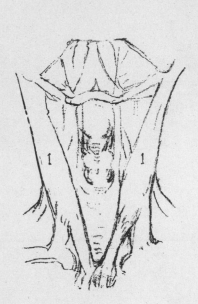

MUSCLES OF THE NECK
1 Sterno-cleido-mastoid
2 Levator scapulae
3 Trapezius

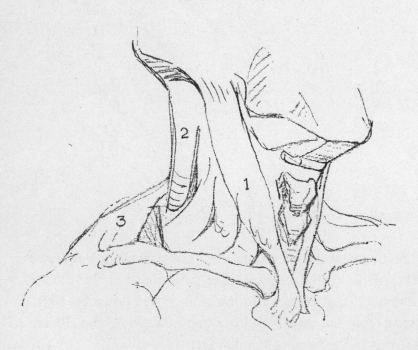

136

MUSCLES OF THE NECK

Sterno-cleido-mastoid: From top of sternum and sternal end of clavicle to mastoid process (back of ear). *Action:* Together, pull head forward; separately, rotates to opposite side, depresses head.

Levator Scapulae: From upper cervical vertebræ to upper angle of shoulder blade. *Action:* Raises angle of shoulder blade.

Trapezius: From occipital bone, nape ligament and spine as far as twelfth dorsal, to clavicle, acromion and ridge of shoulder blade. *Action:* Extends head, elevates shoulder and rotates shoulder blade.

Platysma Myoides: A sheathing from chest and shoulder to masseter and corner of mouth. *Action:* Wrinkles skin of neck, draws down corner of mouth.

Digastric (double-bellied muscle): Anterior belly, from maxilla, behind chin; posterior belly, from mastoid process; fastened by loop to hyoid bone. *Action:* Raises hyoid and tongue.

Mylo-hyoid: Forms floor of mouth and canopy of chin in front.

Stylo-hyoid: From hyoid to styloid process. *Action:* Draws back hyoid and tongue.

Sterno-hyoid: From sternum to hyoid bone. *Action:* Depresses hyoid and Adam's apple.

Omo-hyoid: From hyoid bone to shoulder, upper border of scapula. *Action:* Draws hyoid down and to one side.

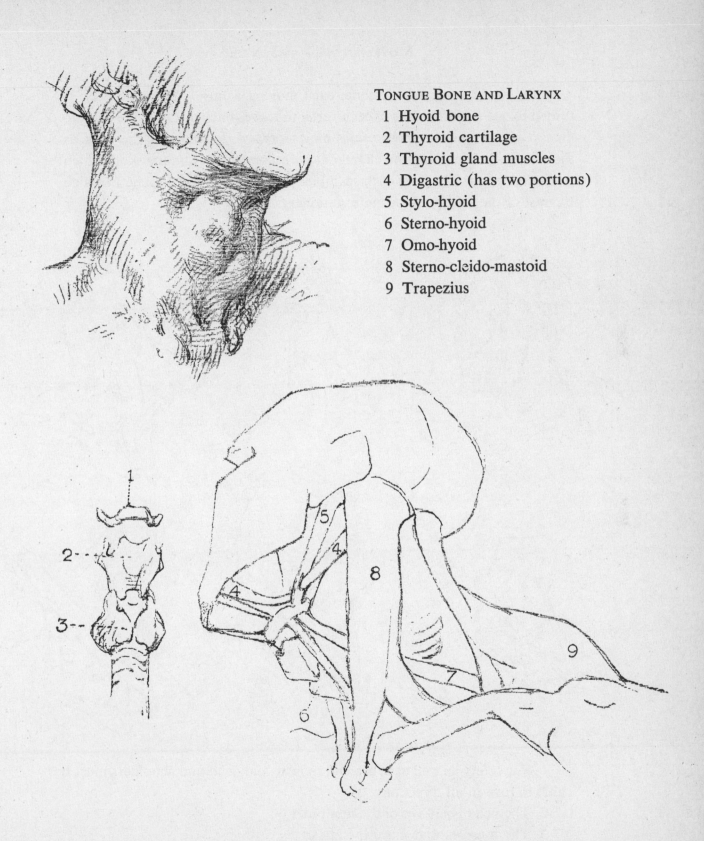

TONGUE BONE AND LARYNX
1 Hyoid bone
2 Thyroid cartilage
3 Thyroid gland muscles
4 Digastric (has two portions)
5 Stylo-hyoid
6 Sterno-hyoid
7 Omo-hyoid
8 Sterno-cleido-mastoid
9 Trapezius

In the neck are seven vertebræ, each moving a little. When the neck is turned to one side, that side of each vertebra moves back as far as the perpendicular and then the opposite sides move forward, lengthening the neck as they do so. This motion is much freer at the second joint from the skull, which turns on a pivot. The joint of the skull itself moves only in nodding, in which the rest of the neck may be quite stationary.

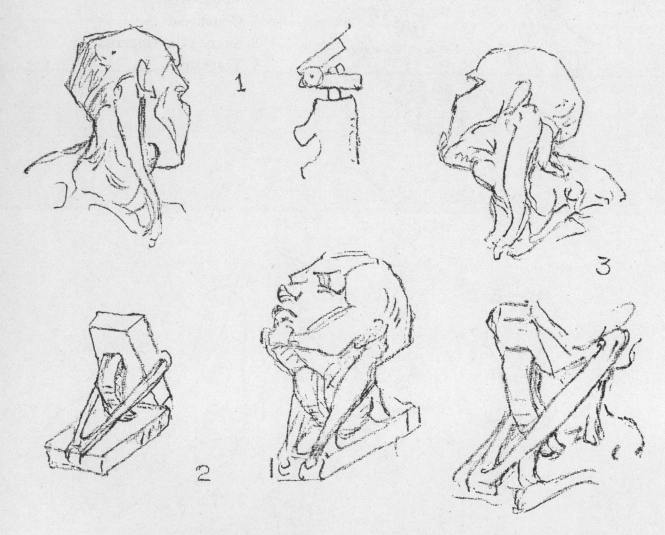

1 For safety as well as to see and to hear, the head and shoulders must be able to turn in all directions.

2 The head is a lever of the first order.

3 The muscles that move the atlas.

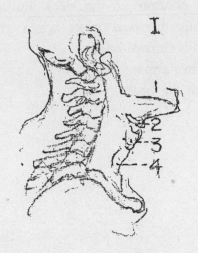

I

1 The inferior maxillary or lower jaw bone
2 The hyoid or tongue bone
3 The thyroid cartilage or Adam's apple
4 Trachea or wind pipe

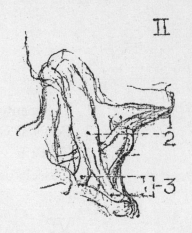

II

1 The canopy under the chin
2 The sterno-cleido-mastoid
3 Attachment to clavicle and the attachment to the sternum of the sterno-cleido-mastoid muscle, the attachment of this muscle above is directly back of the ear

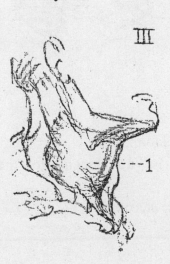

III

1 The neck in shape is a rounded cylinder that follows the direction of the spine

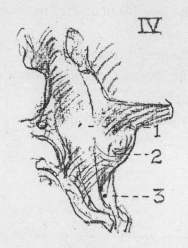

IV

1 The column of the neck curves slightly forward even when the head is thrown back
2 Adam's apple
3 Pit of the neck

V

1 The mentum or chin
2 Cervical vertebrae
3 First rib
4 Clavicle or collarbone

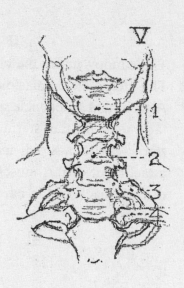

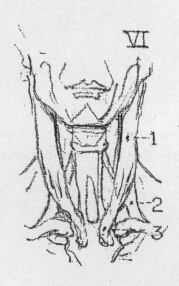

VI

1 Sterno-cleido-mastoid
2 Showing its attachment to the clavicle
3 And to the sternum

142

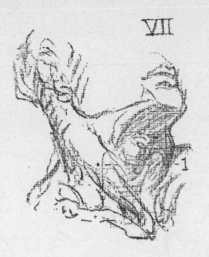

VII

1 The sterno-cleido-mastoid turns the head from side to side towards the shoulder when both muscles act together; they depress the face downward.

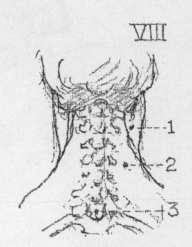

VIII

1 Sterno-cleido-mastoid muscle
2 The trapezius; to the skull at the curved line of the occipital bone; its fibres are carried obliquely downward and outward
3 The seventh cervical vertebra, a prominent projection at the back of the neck

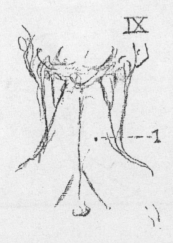

IX

1 The region at the back of the neck is somewhat flattened and much shorter than in front. The head represents the weight to be moved; the muscles, the power to make the movement of the head upon the neck possible.

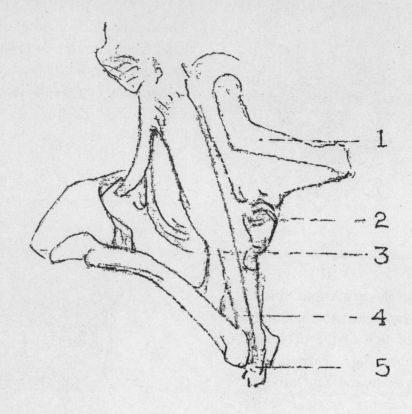

SIDE VIEW OF THE NECK

1 The lower jaw
2 The larynx or Adam's apple
3 The sterno-cleido-mastoid (sternum,
 the breastbone)
4 The clavicle, collarbone
5 The sternum, breastbone

144

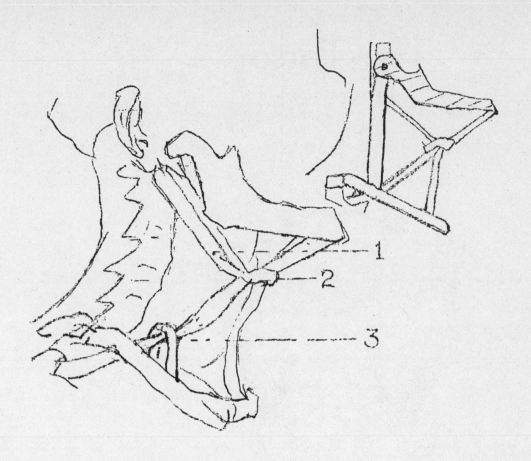

THROAT MUSCLES

1 Digastric
2 Hyoid bone
3 Omo-hyoid, passes through pulley

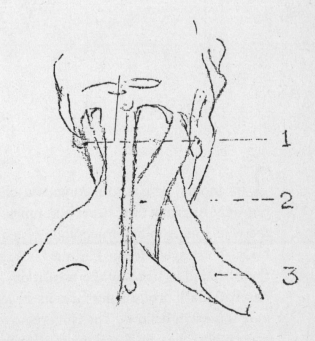

NECK FROM THE BACK

1 The sterno-cleido-mastoid
2 The splenius capitis
3 The levator scapulae (shoulder blade)

The Torso

FRONT VIEW

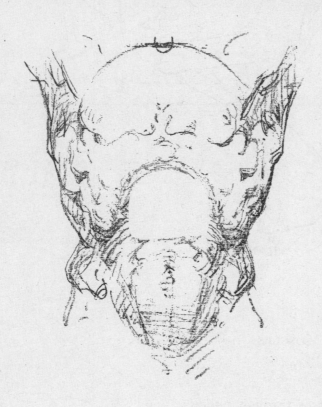

Tʜᴇ thorax, or chest, is composed of bones and cartilages. It is designed not only to protect the heart and lungs, which it contains, but also to allow the whole mass to be turned and twisted with the different movements of the body. This cage is formed, at the back, by the spinal column, on the sides by the ribs, and in front by the breastbone. It protects the heart and lungs as a baseball mask protects the face; its structure is yielding and elastic, so that it may serve as a bellows. The ribs are not complete circles, nor do they parallel each other; they incline downward from the spine and bend at an angle at

146

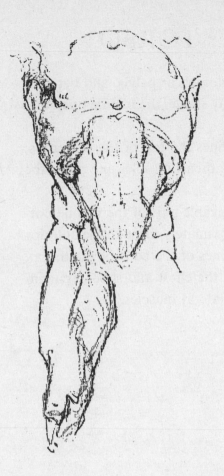

the sides, to take a forward thrust toward the breastbone. The breastbone is called the sternum.

If each rib were rigid and circular, the chest would be immovable and no chest expansion could take place. According to Keill, the breastbone, with an easy inspiration, is thrust out one-tenth of an inch, allowing forty-two cubic inches of air to enter the lungs; and this may be increased, with effort, to seventy or even one hundred cubic inches.

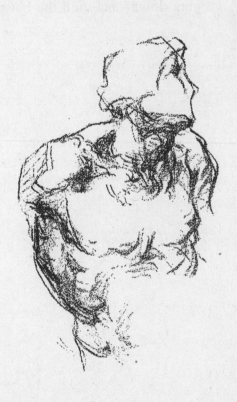

The pelvis is the mechanical axis of the body. It is the fulcrum for trunk and legs, and is large in proportion. Its mass inclines a little forward and as compared with the trunk above is somewhat square. The ridge at the sides is called the iliac crest and this is the fulcrum for the lateral muscles; it flares out widely for this purpose, rather more widely in front than behind.

MASSES OF THE TORSO

THE masses of the torso are the chest, the abdomen or pelvis, and between them the epigastrium; the first two comparatively stable, the middle one quite movable.

A straight line marking the collar bones defines the top of the first mass; and paralleling it, a line through the base of the breast muscles and pit of the epigastrium forms its base.

Below this arch is the abdomen, the most movable part of the mobile portion. It is bounded below by a line passing approximately through the anterior points of the iliac crests. Its profile shows the lines of the cone of the thorax diverging downward, the lines of the wedge of the chest and shoulders converging downward, and the buttressing of the lateral muscles.

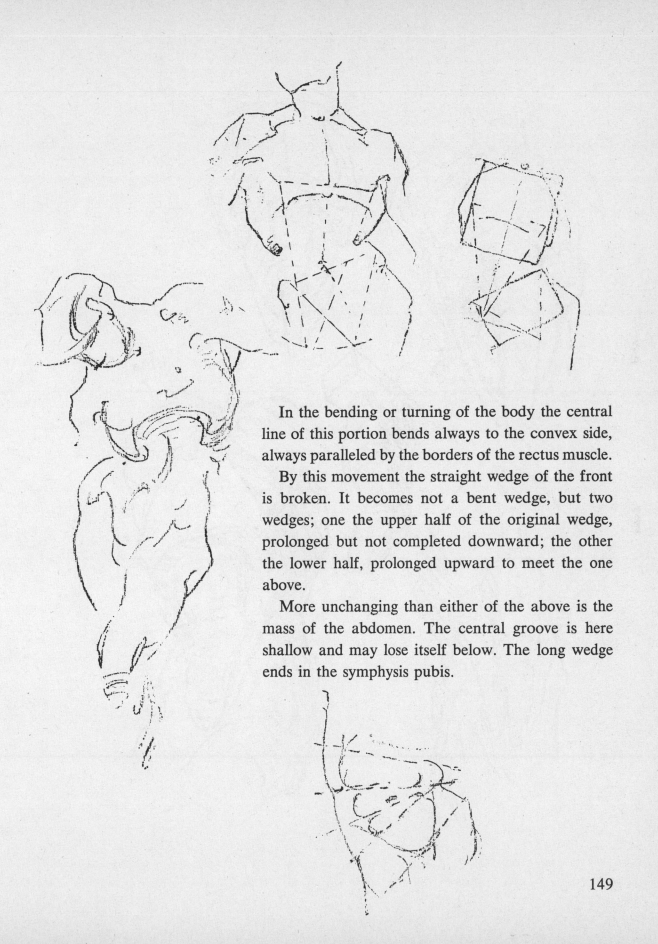

In the bending or turning of the body the central line of this portion bends always to the convex side, always paralleled by the borders of the rectus muscle.

By this movement the straight wedge of the front is broken. It becomes not a bent wedge, but two wedges; one the upper half of the original wedge, prolonged but not completed downward; the other the lower half, prolonged upward to meet the one above.

More unchanging than either of the above is the mass of the abdomen. The central groove is here shallow and may lose itself below. The long wedge ends in the symphysis pubis.

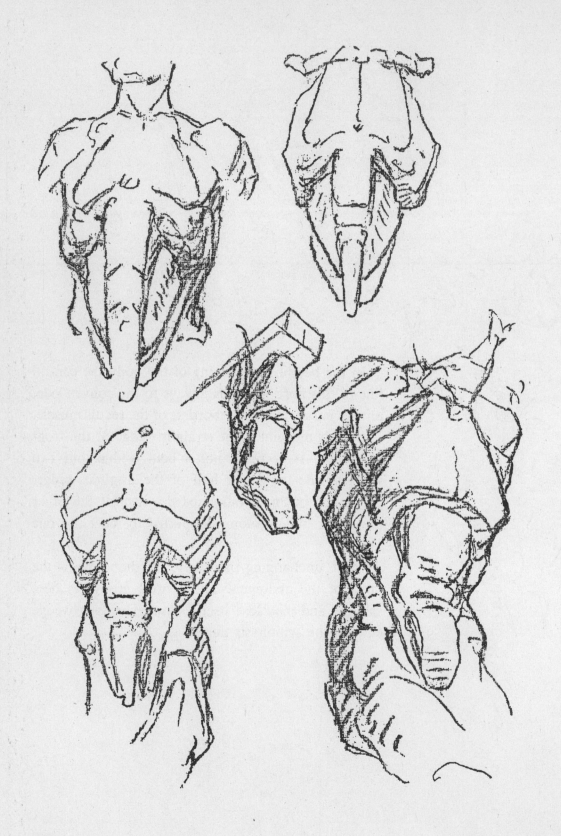

PLANES OF THE TORSO

FRONT VIEW

Fʀᴏᴍ the front, the masses of the trunk may be divided into three distinct planes.

The first may be outlined by drawing lines from the inner third of each collar bone to the base of the breast muscles (the point where they take an upward direction to their insertion on the upper arm) and then joining them with a base line across the sixth ribs.

The second is the epigastrium which forms the upper part of the abdominal region. For our purpose, it is a flattened plane bordering the breast muscles above and the stomach below.

The third plane is more rounded and is bounded at the sides by the lower ribs and pelvic bones. It is placed in the lower cavity of the trunk —the abdomen.

151

MUSCLES OF THE TORSO

1 Pectoralis: pertaining to the breast
2 The serrati: the deep muscles of the spine
3 Muscles that pull the arm down; pectoralis; latissimus dorsi
4 Abductors: draw the thigh toward the medium line
5 Tendons that pass through a loop or slit: omo-hyoid; digastric
6 Pulley: knee-cap, tendon and ligament
7 Rectus, upright: abdominis and femoris
8 Rhomboideus: rhomb-shaped, not right-angled; from the shoulder blade to the spine
9 Deltoid: delta-shaped, triangular, equilateral of the shoulder
10 Trapezius: table-shaped
11 Oblique, slanting

152

TORSO STRUCTURE

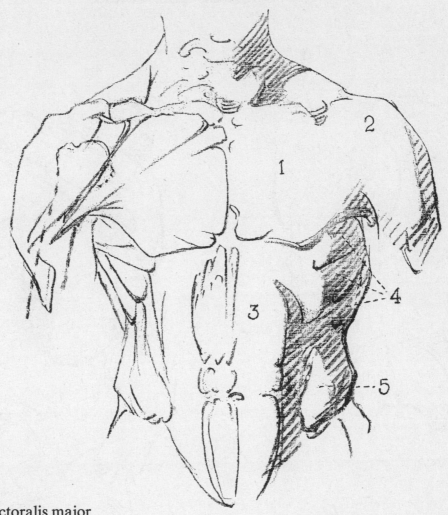

1 Pectoralis major
2 Deltoid
3 Rectus abdominis
4 Serratus magnus
5 External oblique

Rectus Abdominis: From symphysis pubis to cartilages of ribs, from fifth to seventh. *Action:* Flexes thorax.

Serratus Magnus: From eight upper ribs to scapula—spinal edge, under surface. *Action:* Draws shoulder blade forward, raises ribs.

External Oblique: From eight lower ribs to iliac crest and ligament to pubis. *Action:* Flexes thorax.

153

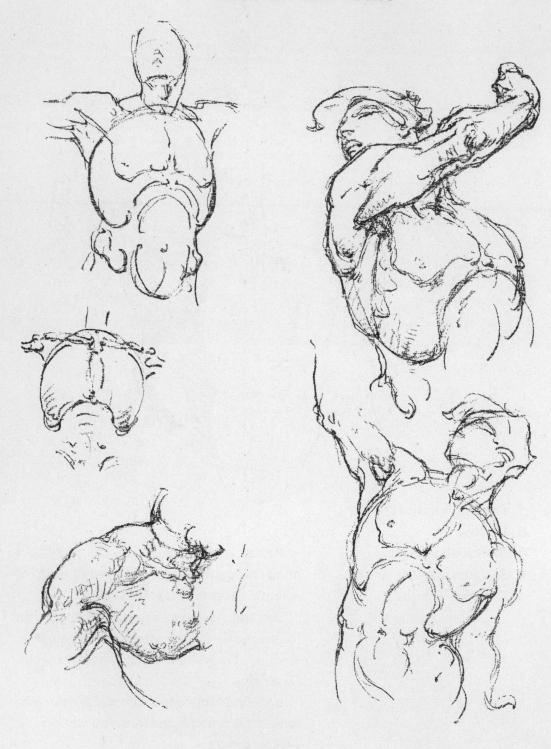

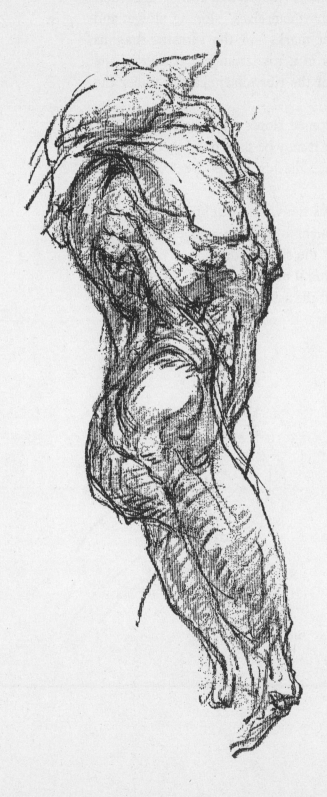

The erect torso presents in profile the long curve of the front, broken by depressions at the border of the breast muscle and at the umbilicus or navel into three lesser curves, almost equal in length. The back presents the sharp anterior curve of the waist, opposite the umbilicus, bending into the long posterior curve of the chest, and the shorter curve of the buttocks. The curve of the chest is broken by the almost vertical shoulder blade and the slight bulge of the latissimus below it.

In profile the torso presents three masses: that of the chest, that of the waist, and that of the pelvis and abdomen. The first and last are comparatively unchanging.

Above, the mass of the chest is bounded by the line of the collar bones; below, by a line following the cartilages of the ribs, being perpendicular to the long diameter of the chest.

This mass is widened by the expansion of the chest in breathing, and the shoulder moves freely over it, carrying the shoulder blade, collarbone, and muscles.

The chest is marked by the ridge of costal cartilages that forms its border, sloping up and forward, and by the ribs themselves, sloping down and forward, and by the "digitations" (finger marks) of the serratus magnus (big saw-toothed) muscle, little triangles in a row from the corner of the breast muscle, paralleling the cartilages of the ribs, disappearing under the latissimus.

Below, the mass of the pelvis and abdomen slopes up and forward. It is marked by the iliac crest and hip. In front it may be flattened by contraction of the abdominal muscles. Over its surface the hip moves freely, changing the tilt of the pelvis.

Between these the central mass contains the waist vertebrae, and is very changeable. Practically all of the movement of flexion and extension for the whole spine occurs here, and much of the side-bending.

This mass is marked by a buttress of lateral muscles, slightly overhanging the pelvic brim and bearing inward against the side above. It changes greatly in different positions of the trunk.

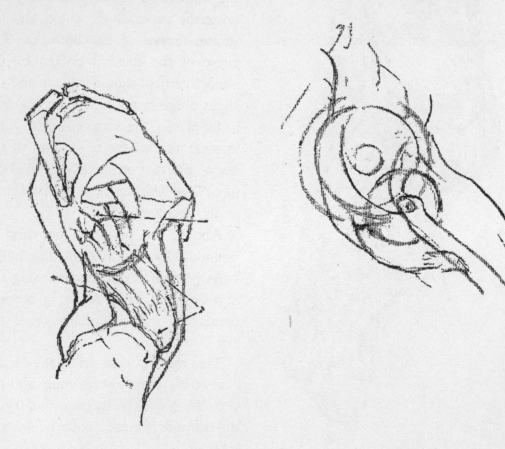

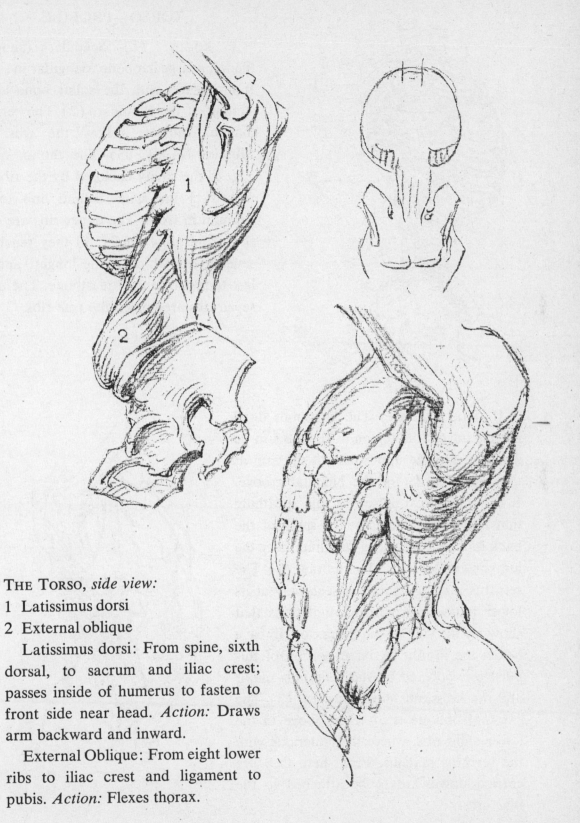

The Torso, *side view:*

1 Latissimus dorsi

2 External oblique

Latissimus dorsi: From spine, sixth dorsal, to sacrum and iliac crest; passes inside of humerus to fasten to front side near head. *Action:* Draws arm backward and inward.

External Oblique: From eight lower ribs to iliac crest and ligament to pubis. *Action:* Flexes thorax.

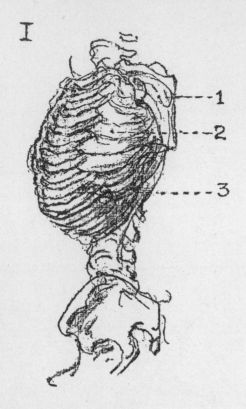

I

I. BONES: (1) Scapula, (shoulder blade), a large flat bone triangular in shape. It articulates with the collar bone at the summit of the shoulder. (2) The serratus magnus muscles follow the ribs. See Muscles No. II. (3) The thorax or rib cage is the cavity enclosed by the ribs, attached to the spine behind and to the sternum in front. The upper ribs are quite short and grow longer till they reach the seventh rib, which is the longest and the last to fasten to the breastbone. The upper seven ribs are named the true ribs.

II. MUSCLES: (1) The latissimus dorsi muscle covers the region of the loins to be inserted into the upper part of the arm at the lower border of the bicipital groove. It is a superficial muscle, a thin sheathing that finds attachments at the small of the back and at the crest of the ilium near the lumbar and last dorsal vertebrae. (2) The serratus magnus muscle is seen only at its lower parts as prominent digitations that show on the side of the thorax or rib cage below the armpit. A large portion of this muscle is covered by the pectoralis major and the latissimus dorsi muscles. (3) The external oblique is attached above to the lower eight ribs, where they interlock with the serratus magnus. From here they are carried downward to be attached to the iliac crest.

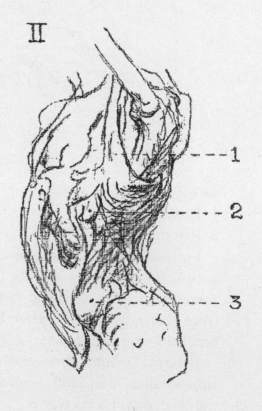

II

III. The serratus magnus draws the shoulder blade forward and raises the ribs. The latissimus dorsi draws the arm backward and inward. Its upper border curves backward at the level with the sixth or seventh dorsal vertebrae, as it passes over the lower angle of the shoulder blade.

The serratus magnus muscle forms the inner wall of the armpit. Its insertion to the ribs above are not seen, while those below, three or four in number are plainly visible in the region between the great pectoral and the latissimus dorsi.

IV. In profile, the torso in front is marked by the ridge of the costal cartilage that forms its border. Sloping up and forward (with the ribs themselves sloping down and forward) the digitations of the serratus magnus meet the external oblique.

In its attachment to the crest of the ilium, the external oblique forms a thick oblique roll, its base marking the iliac furrow. When one side of this muscle contracts, it gives the trunk a movement of rotation to the right or left side. When both sides pull, the oblique muscles draw the ribs downward, thus bending the body forward.

RIB CAGE

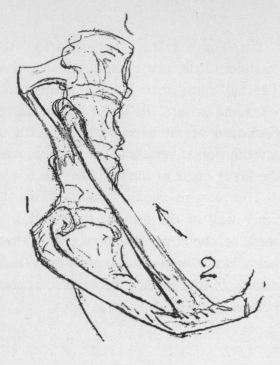

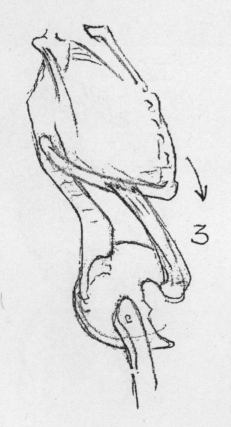

1 The fulcrum or hinge on which the lever works

2 The ribs have to be lifted by muscular force

3 The front end of the rib is lowered and raised by muscular force. Whether ascending or descending, the muscles hold or balance the axis on which the ribs turn. They are worked by two muscular engines, one that raises and expands the chest and the one that pulls the cage down. These opposing muscles are known as elevators and depressors.

The enlargement and contraction of the chest depends on the mechanical contrivance of the bones which enclose it. The ribs articulate to the sides of the backbone from where they project obliquely downward. When they are pulled upward, they are at the same time being pulled outward, which brings them more to a right angle to the spine, causing the sternum or breastbone to which they are attached at the front, to be thrust forward. The muscular bands that enlarge and contract the chest pass upward obliquely from pelvis to the front and sides of the rib cage.

160

The Torso

BACK VIEW

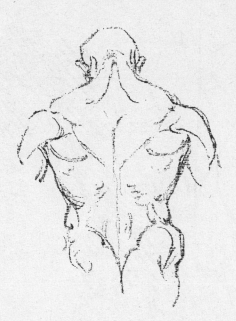

THE trapezius is a diamond-shaped muscle, with upper apex at the base of the skull, lower apex well below the shoulder blades, and corners at the shoulder girdle opposite the deltoid, as though it were a continuation of that muscle.

From the sacrum the muscles diverge upward, while the lower ribs and lower corner of the shoulder blade diverge downward, making lesser diamonds of various definiteness of outline.

The ridge of the shoulder blade is always conspicuous, pointing diagonally toward the corner of the shoulder. It sets at a fixed angle with the spinal edge (more than a right angle) and at a right angle with the lower turned-out corner.

In relaxation, both ridge and blade are ridges under the skin, and are converted into grooves by the muscles bulging in contraction.

Of these muscles, those on either side of the ridge are easily recognizable—the deltoid, below and outside, and trapezius, above and inside, but the trapezius also spreads from the inner end of the ridge to well down the spine. Under this, helping to form the bulge, are the rhomboidei, extending from the blade diagonally upward to the spine, and the levator anguli scapulae, from its upper corner almost vertically to the top of the neck.

TORSO—BACK VIEW

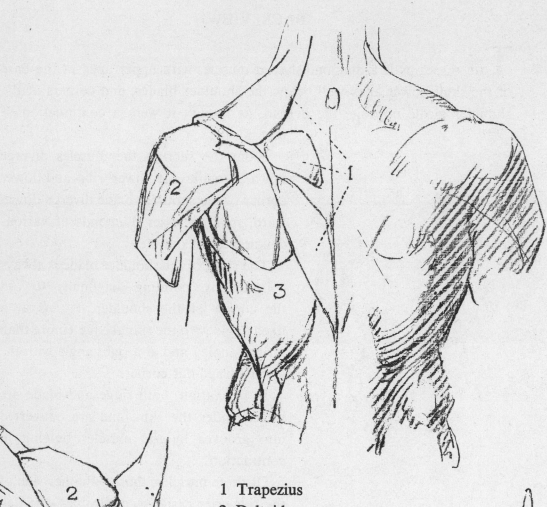

1 Trapezius
2 Deltoid
3 Latissimus dorsi
 Trapezius: From occipital
bone, nape ligament and
spine as far as twelfth dorsal,
to clavicle, acromion and
ridge of shoulder blade.
Action: Extends head, ele-
vates shoulder and rotates
shoulder blade.

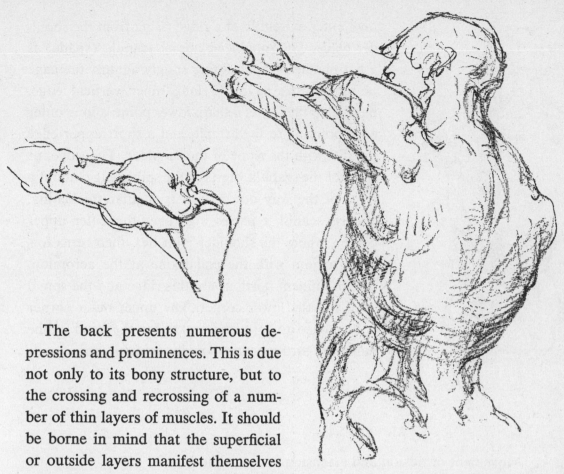

The back presents numerous depressions and prominences. This is due not only to its bony structure, but to the crossing and recrossing of a number of thin layers of muscles. It should be borne in mind that the superficial or outside layers manifest themselves only when in action. For this reason, under all changes of position, the spine, the shoulder blade with its acromion process, and the crest of the ilium, must be regarded as the landmarks of this region.

The spine is composed of twenty-four vertebræ. It extends the full length of the back, and its course is marked by a furrow. The vertebræ are known as the cervical, dorsal and lumbar. The cervical vertebræ are seven in number, and the seventh is the most prominent in the whole of the spine. It is known as vertebra prominens. In the dorsal region the furrow is not so deep as below. Here there are twelve vertebræ. When the body is bent forward, the processes of the vertebræ in this section are plainly indicated.

The spinal furrow becomes deeper as it reaches the lumbar vertebræ, where it is marked by dimples and depressions. It widens out, too, in this part of the body, and as it passes over the surface of the sacrum to the coccyx it becomes flattened. The average length of the spine is about two feet three inches.

The outer corner of the shoulder girdle is the acromion process, which is the

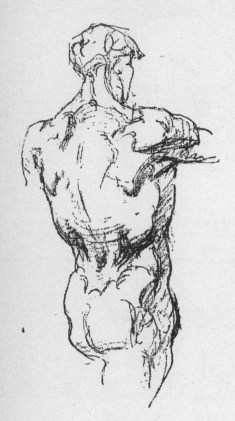

high outer extremity of a ridge rising from the shoulder blade. The shoulder blade or scapula (spade) is a flat plaque of bone fitting snugly against the cage of the thorax, having a long inner vertical edge, parallel to the spine; a sharp lower point; a long outer edge pointing to the armpit; and a short upper edge parallel with the slope of the shoulder. The ridge, or spine of the scapula, starts at the spinal edge, about a third of the way down, in a triangular thickening, and rises until it passes high over the outer upper corner, where the shoulder joint ties, then turns forward to join with the collarbone at the acromion. The prominent portions are this ridge and the spinal edge and the lower corner. The upper outer corner is thickened to form the socket for the head of the humerus, forming the shoulder joint proper.

MOVEMENTS

Movement of flexion and extension occurs almost entirely in the waist or lumbar vertebræ. Movement of side-bending occurs throughout the whole length. Movement of rotation occurs in the lumbar vertebræ when the spine is erect, in the middle vertebræ when it is half flexed, in the upper vertebræ when the spine is fully bent. In the lumbar vertebræ, the axis of this rotation is *behind* the spine; in the middle vertebræ it is neutral; in the upper dorsals it is in front of the spine.

Each vertebra moves a little, and the whole movement is the aggregate of the many little movements.

The shoulder blade slides against the surface of the cage of the thorax, in any direction, and may be lifted from it so that its point or its spinal edge becomes prominent under the skin. It produces easily fifty per cent of the whole movement of the shoulder.

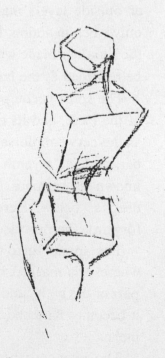

164

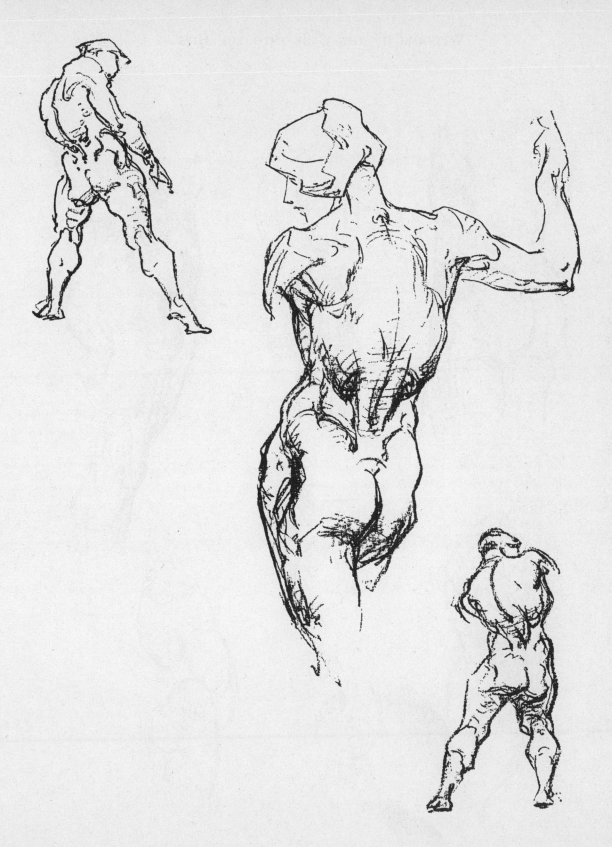

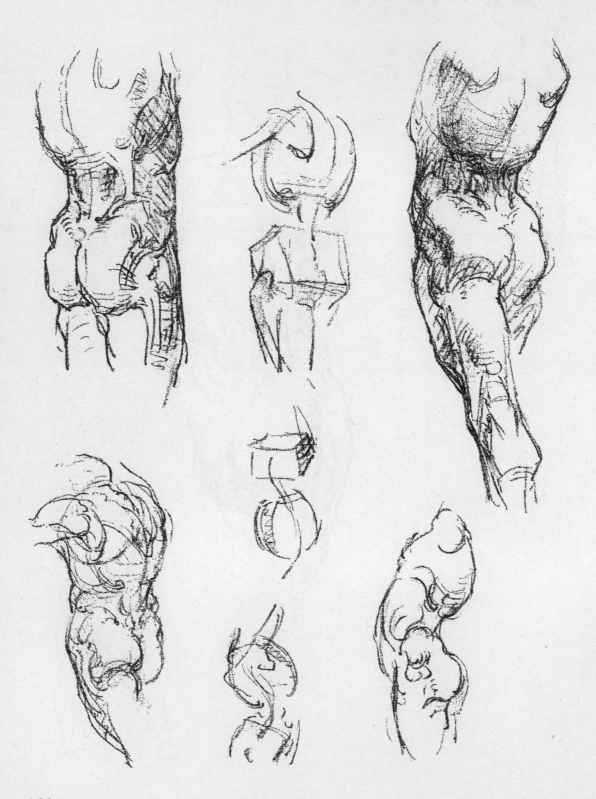

166

MECHANISM OF THE TORSO
AND HIPS

THE cage and the pelvic bones are connected by a portion of the spine called the lumbar region. Muscular power acts on these masses as levers and allows the body to move forwards and backwards or turn. The pelvis can be compared to a wheel with only two spokes; the hub is the hip joint and the spokes are the legs which swing back and forth as in walking or running. When force is applied to the long end of a lever, the power is increased. When speed is desired, the lever is shortened.

The muscular power of the human body can only pull upon and bend the levers at the joints, when the masses of the back and pelvis are bent backward or forward, or to the side. The movement of the back is limited to the extent that the bony structure of the spine allows. Each segment of the spine is a lever, upon which the masses of the rib cage and the pelvis bend or turn. From the rear, the torso presents a great wedge with its apex directed downward. The base of the wedge is at the shoulders. This wedge is driven in between the two buttresses of the hips. In movement these two masses turn or bend.

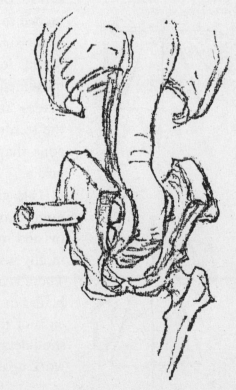

SHOULDER GIRDLE

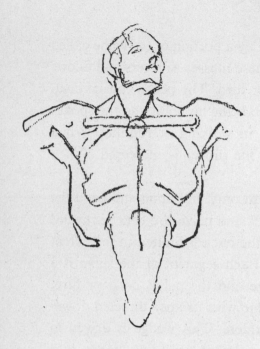

SHOULDER blades are embedded rather than attached to the back. They move from their attachment at the summit of the blade to the collarbone and are raised, lowered, or twisted by muscular force. The movements of the collar bones and the shoulder blades are free except where the collarbone joins the sternum in front. These bones curve around the cone shaped thorax, and are known as the thoracic girdle.

This girdle, except at its attachment at the sternum, may be raised or lowered; thrown forward or twisted round the static rib cage without interfering in any way with the act of expiration or inspiration. There is a space between the borders of the shoulder blades at the back and in front and between the two ends of the collar bones. The muscles that raise the shoulders away from the rib cage, when set in motion, work against each other with perfect balance.

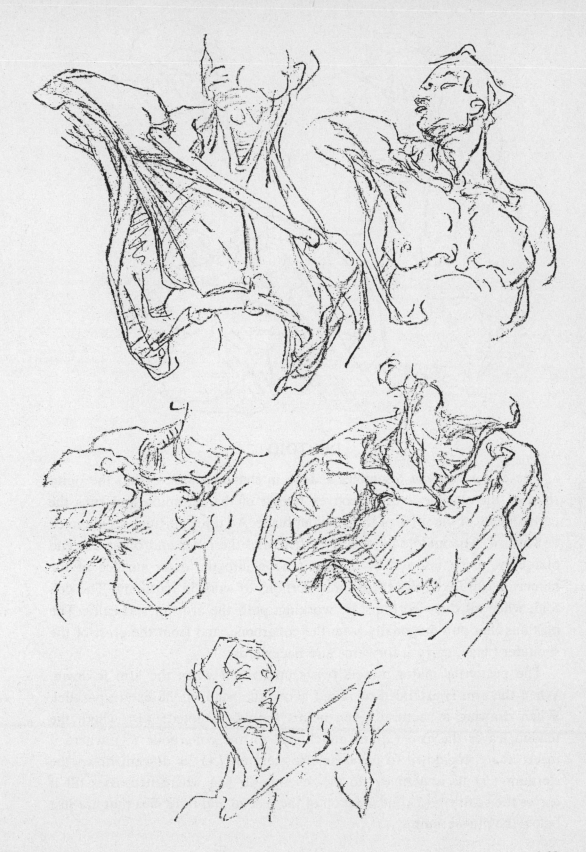

169

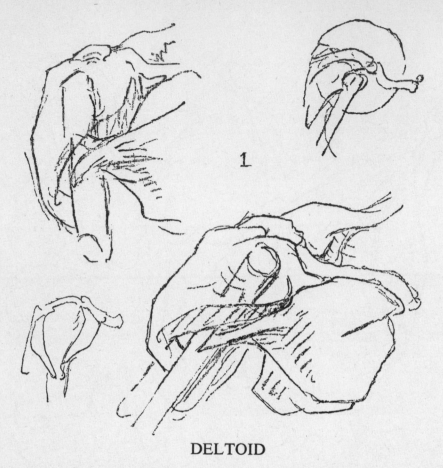

1

DELTOID

The deltoid muscle resembles a delta in shape. It arises from the outer third of the clavicle and the convex border of the acromion and runs the entire length of the spine of the shoulder blade. All three portions are directed downward. The middle portion is vertical and the inner and outer descend obliquely, to be inserted by a short tendon into the outer surface of the humerus. Nature allows these three portions to work in harmony. The deltoid, when all three portions are working, pulls the arm up vertically. The portions that pull diagonally from the collarbone, and from the crest of the shoulder blade, carry it forwards and backwards.

The pectoralis major muscle twists upon itself when the arm is down. When the arm is extended or raised above the head, its fibres are parallel. When drawing a pectoral seven points should be noted: (1) where the tendon leaves the arm (2) its attachment on the collarbone (3) where it meets at its step-down from clavicle to sternum (4) its descent down the sternum (5) its attachment to the seventh rib (6) where it crosses till it leaves the sixth rib (7) the location of the second and third ribs that are just below the pre-sternum.

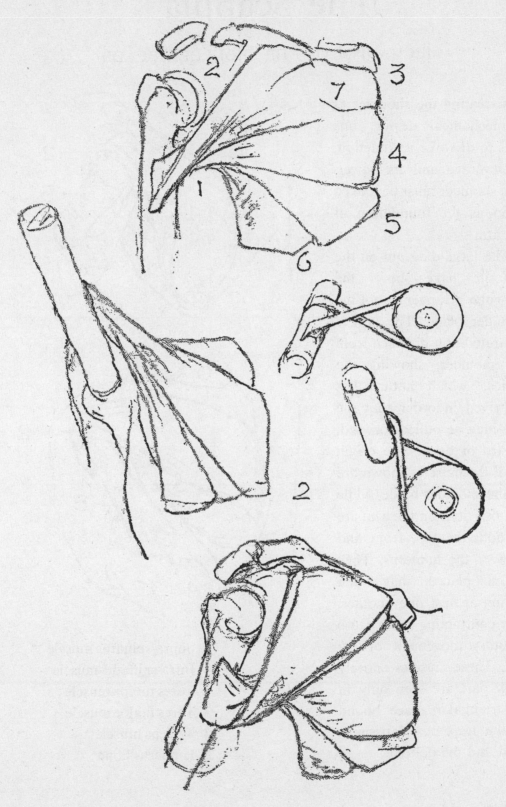

The Scapula

MECHANISM OF THE SHOULDER BLADE

IN treating the shoulder as a mechanical device, one tries to discover its function, its leverage and its power. The shoulder must be looked upon as the foundation of the arm.

The large diagram on the opposite page shows the muscular arrangement of the shoulder blade. The arm is separated at a distance from the shoulder, showing the devices which nature has contrived in order that the arm may be pulled forward, inward or back. The origin of all the muscles shown are on the shoulder blade, while the insertions on the arm are on both the top, front and back of the humerus. They are so placed, that when pulling against one another, their contracting fibres cause a rotary movement of the arm. These muscles entirely or in part are seen only in the triangular space bound by the trapezius, latissimus dorsi and the deltoid.

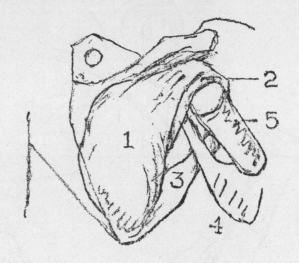

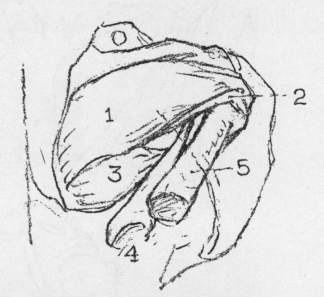

0 Supra-spinatus muscle
1 Infra-spinatus muscle
2 Teres minor muscle
3 Teres major muscle
4 Triceps muscle
5 Humerus bone

172

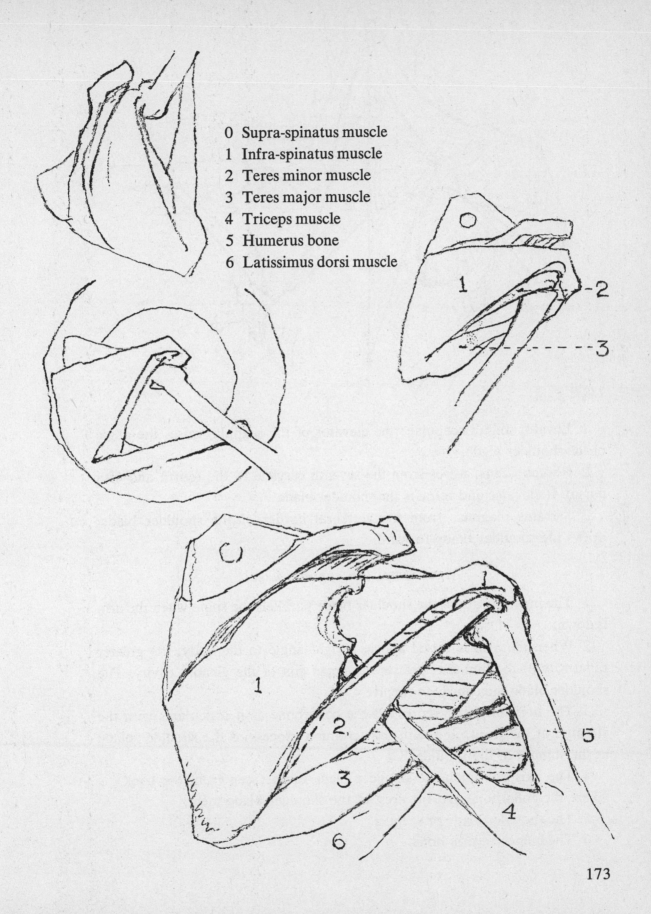

0 Supra-spinatus muscle
1 Infra-spinatus muscle
2 Teres minor muscle
3 Teres major muscle
4 Triceps muscle
5 Humerus bone
6 Latissimus dorsi muscle

173

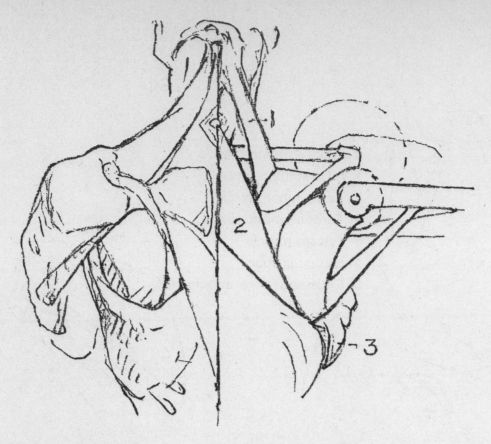

1 Levator anguli scapulae: the elevator of the scapula, raises the angle of the shoulder blade.

2 Rhomboideus: arises from the seventh cervicle to the fourth and fifth dorsal. It elevates and retracts the shoulder blade.

3 Serratus magnus: from the vertebral border of the shoulder blade; draws the shoulder blade forward.

MECHANISM (*on opposite page*)

1 The inner border of the shoulder blade parallels the spine when the arm is down.

2 When the arm is raised above, a right angle to the body, the greater tuberosity of the humerus presses the upper rim of the glenoid cavity. The shoulder blade then starts to revolve.

3 The horizontal bar represents the collarbone as it articulates with the sternum at the front, and with the acromion process of the shoulder blade at the summit of the shoulder.

4 The axis on which the shoulder blade turns (seen from the back) is where the collarbone and the crest of the shoulder blade meet.

5 The shoulder blade or scapula.

6 The humerus: arm bone.

174

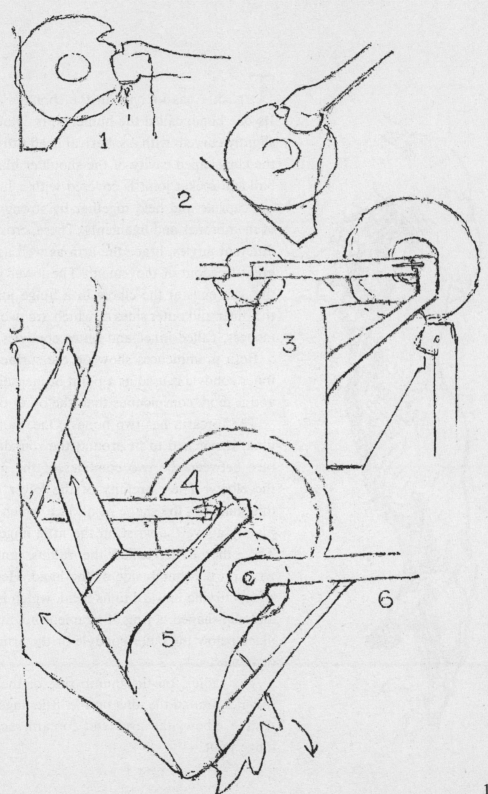

The Arm

THE ARM has its base in the shoulder girdle. Its one bone, called the humerus, is cylindrical, slightly curved, with a spherical head fitting into the cup-shaped cavity of the shoulder blade. Its ball-and-socket joint is covered with a lubricating capsule and held together by strong braces of membranes and ligaments. These, crossing at different angles, brace the arm as well as allow great freedom of movement. The lower part of the arm ends at the elbow in a hinge joint, on the inner and outer sides of which are two prominences, called inner and outer condyles.

Both prominences show on the surface. The inner condyle is used as a point of measurement and is more conspicuous than the outer one.

The forearm has two bones. One, called the ulna, is notched to fit around the rounded surface between the two condyles of the arm, at the elbow. The extremity of the lower end of this shaft has the shape of a knob which shows plainly above the wrist on the little finger side. The other bone, called the radius, joins the wrist on the thumb side of the hand. Here it is wide, curving upward to its head, which is small and cup-shaped, a ring of ligament holding it in place below the outer condyle of the arm bone, or humerus.

The radius, on the thumb side of the wrist, radiates around the ulna on the little finger side. At the elbow, the arm and forearm act as a hinge joint.

176

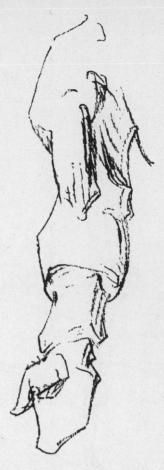

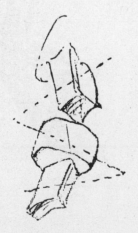

The mass of the shoulder descends as a wedge, sinking into the flattened outer arm half way down.

At this point, from the front, the arm wedges downward to enter the forearm below the elbow. When the thumb is turned away from the body, the mass of the forearm is oval, becoming round when the bones of the forearm cross.

The mass corresponding to the wrist is twice as wide as it is thick and enters the forearm half way up, as a flattened wedge.

From the back, the shoulder enters the arm on the side. Beneath it there is a truncated wedge from the center of which, in a line from elbow to shoulder, is the plane of the tendon of the elbow. The forearm is rounded or oval, depending upon whether or not the bones of the forearm are crossed. The wrist is twice as wide as it is thick.

177

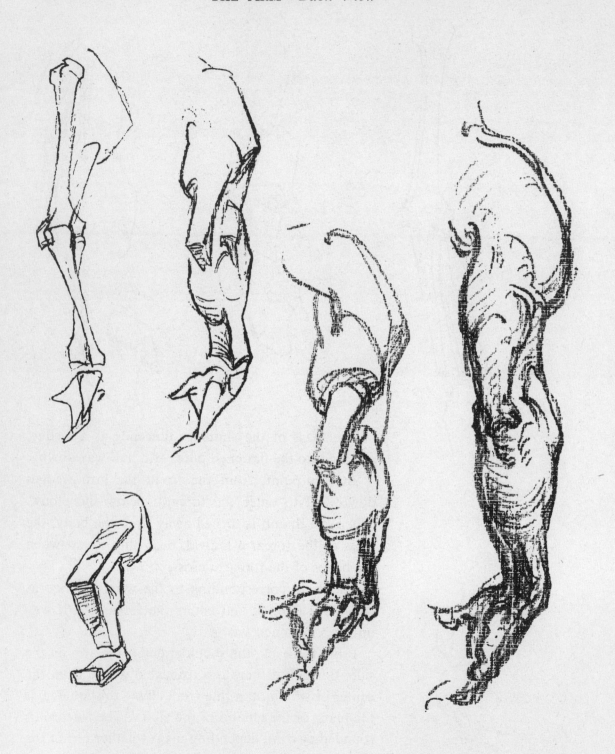

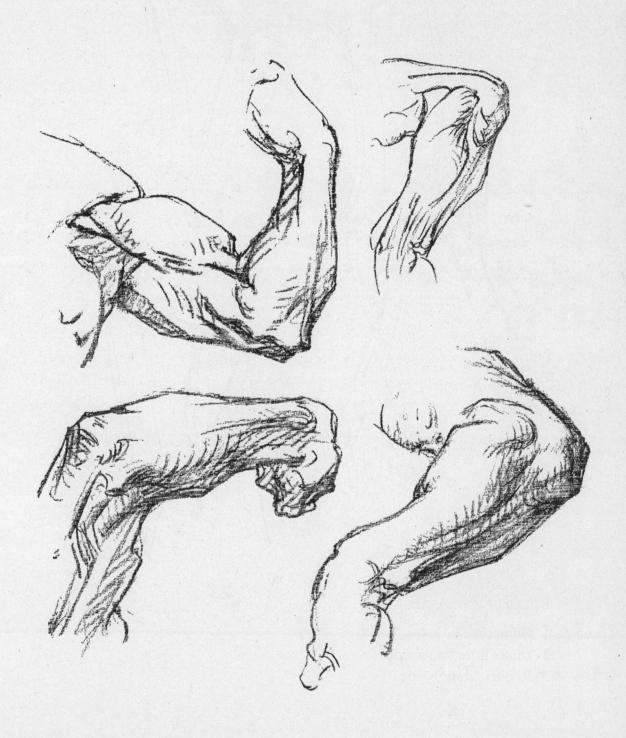

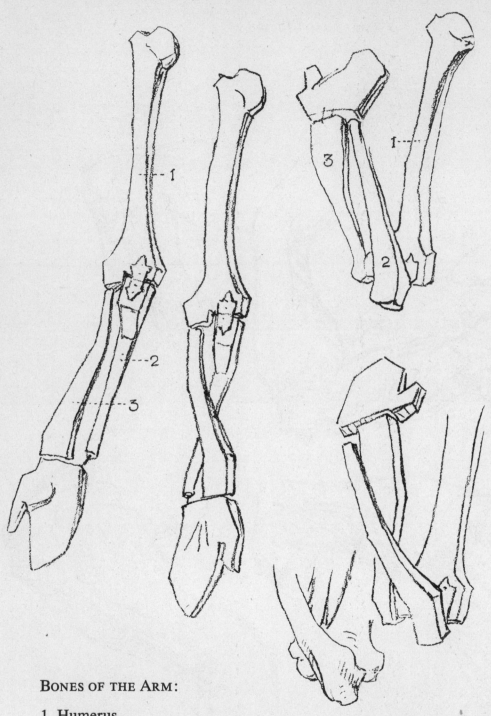

BONES OF THE ARM:

1 Humerus
2 Ulna (little finger side)
3 Radius (thumb side)

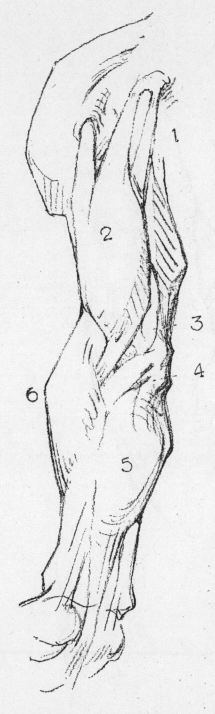

MUSCLES OF THE UPPER ARM, *front view:*

1 Coraco-brachialis
2 Biceps
3 Brachialis anticus
4 Pronator radii teres
5 Flexors, grouped
6 Supinator longus

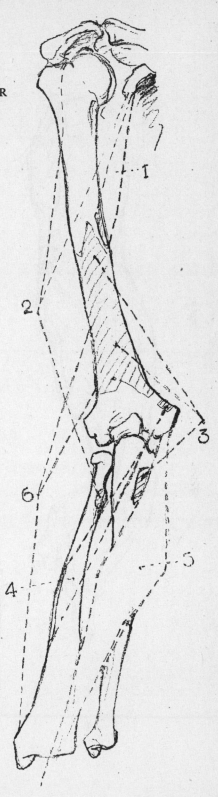

Coraco-brachialis: From coracoid process, to humerus, inner side, half way down. *Action:* Draws humerus forward, rotates humerus outward.

Biceps: Long head from glenoid cavity (under acromion) through groove in head of humerus; short head from coracoid process; to radius. *Action:* Depresses shoulder blade; flexes forearm; rotates radius outward.

181

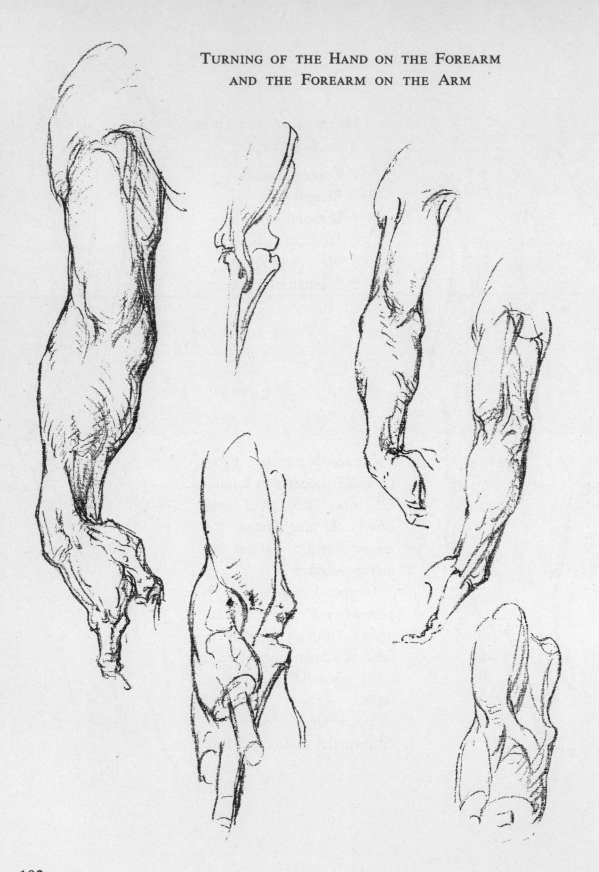

182

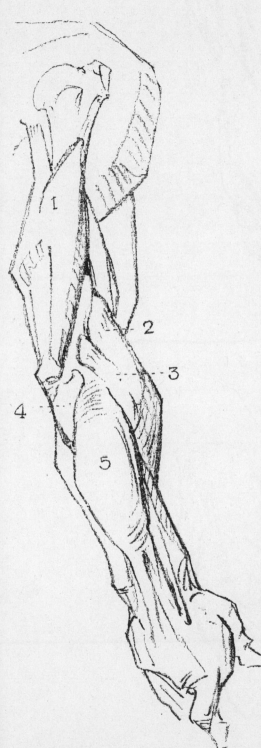

MUSCLES OF THE UPPER ARM, *outer view:*
1 Triceps
2 Supinator longus
3 Extensor carpi radialis longus
4 Anconeus
5 Extensors, grouped

EXTENSOR GROUP

Extensor Digitorum Communis: From external condyle to second and third phalanges of all fingers. *Action:* Extends fingers.

Extensor Minimi Digiti: From external condyle to second and third phalanges of little finger. *Action:* Extends little finger.

Extensor Carpi Ulnaris: From external condyle and back of ulna to base of little finger. *Action:* Extends wrist and bends down.

Anconeus: From back of external condyle to olecranon process and shaft of ulna. *Action:* Extends forearm.

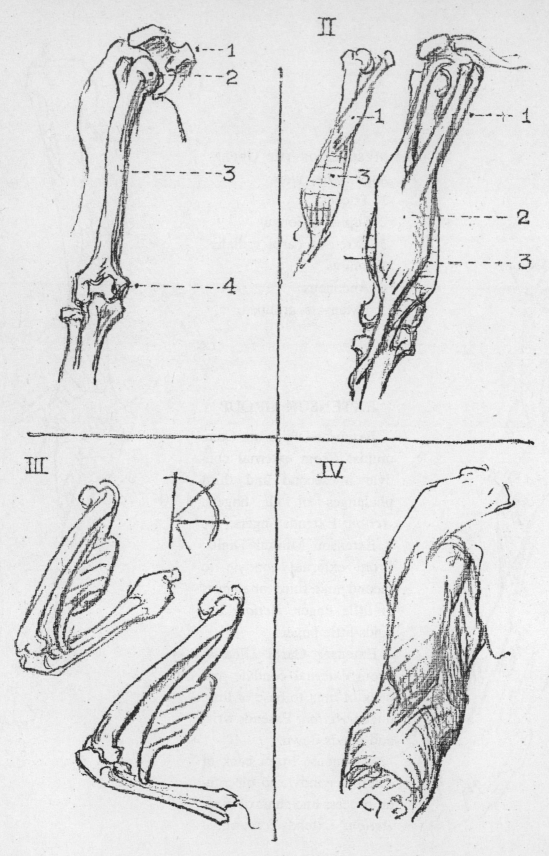

THE ARM

Front View

I. BONES: (1) The coracoid process is a part of the shoulder blade that extends beyond and above the rim of the cup that holds the head of the humerus. (2) The head of the humerus is rounded and covered with cartilage. It contacts with the glenoid cavity of the shoulder blade. (3) The humerus is one of the long bones of the body. It is composed of a shaft and two large extremities; the upper articulates at the shoulder and the lower at the elbow. (4) The shaft of the humerus at the elbow is flattened from front to back ending in two projections: one on the inner, the other on the outer side, called the inner and outer condyles. The inner side is the more prominent.

II. MUSCLES: (1) The coraco-brachialis is a small round muscle placed on the inner surface of the arm lying next to the short head of the biceps. (2) The biceps is so called because it is divided into two parts: the long and the short. The long head ascends in the bicipital groove of the humerus to be inserted just above the upper margin of the glenoid cavity of the shoulder blade. The short head has its attachment to the coracoid process. The biceps descends as a tendon to the radius below the elbow. (3) The brachialis anticus muscle lies beneath the biceps. It stretches across the lower half of the humerus to the ulna.

III. Both the biceps and brachialis muscles are placed in front of the arm. When they contract they bend the elbow. Every muscle is provided with an adversary; as an example: the finger is not bent or straightened without the contraction of two muscles taking place. The biceps and brachialis anticus are the direct antagonists of the triceps. The brachialis anticus muscle covers the lower half of the humerus in front and is inserted into the ulna just below the elbow. Its attachment to the ulna is so short that it is at a great disadvantage as to power, but what is lost in strength is gained in speed by its short leverage.

IV. The mass of the shoulder descends as a wedge on the outer surface of the arm half way down. The biceps is seen as a flattened mass when not in contraction as it wedges downward to enter the forearm below the elbow. There are great changes in the form of the arm above the elbow as a mass; the biceps is lengthened in repose, but becomes short and globular during contraction.

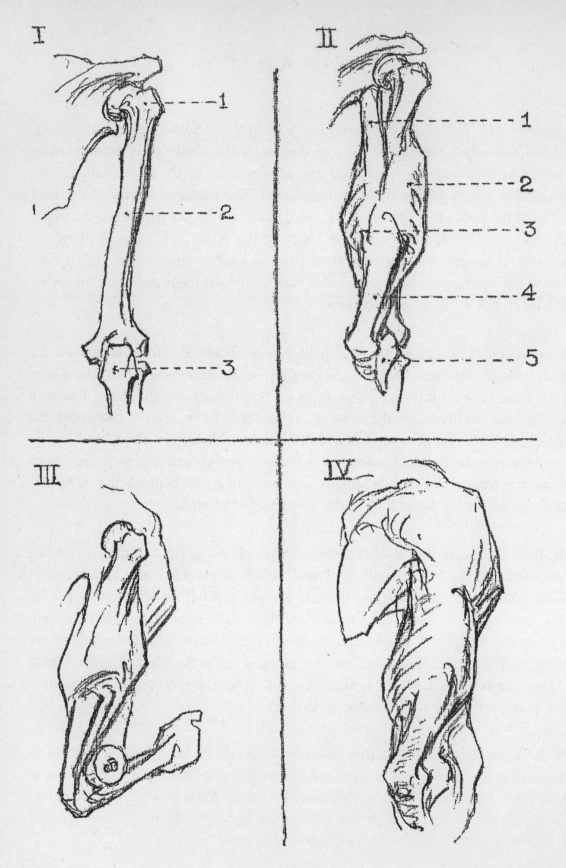

I

1

2

3

II

1

2

3

4

5

III

IV

186

THE ARM

Back View

I. BONES: (1) The great tuberosity of the humerus is situated on the outer side of the bicipital groove. At its upper extremity it is a prominent bony point of the shoulder. Though covered by the deltoid, it materially influences the surface form. (2) The shaft of the humerus is cylindrical. (3) The olecranon of the ulna forms the point of the elbow.

II. MUSCLES: (1) Long head. (2) External portion. (3) Internal portion of the triceps. (4) Common tendon of the triceps. The triceps muscle has been so named because it is composed of three portions or heads, one of which is central and two lateral. The long head arises from the border of the shoulder blade immediately below the glenoid cavity and terminates in a broad flat tendon, which is also the termination of the internal and external portions. The external head arises from the upper and outer part of the humerus. The inner head is also on the humerus, but on the inner side. Both muscles are attached to the common tendon, which is inserted into the olecranon process of the ulna. (5) The anconeus muscle, small and triangular in shape, is attached in the external condyle of the humerus above, and below to the ulna, a continuation of the triceps.

III. Muscles act only by contraction. When exertion ceases they relax. The muscles that are placed on the front part of the arm, by their contraction bend the elbow; and extend and straighten the limb. The triceps (the opposing muscle) is brought into play with no less than that which bent it. The elbow joint that these muscles move is a hinge joint that moves in one plane only either forward or backward.

IV. The back of the arm is covered by the large muscular form of the triceps, which extends the entire length of the humerus. This muscle is narrow above, widening below to the furrow of the outer head of the triceps. From here the common tendon of the triceps follows the humerus as a flattened plane to the olecranon process of the ulna. The common tendon of the triceps receives the muscular fibres from all three heads of the triceps. The direction of this broad flat tendon is in line with the humerus.

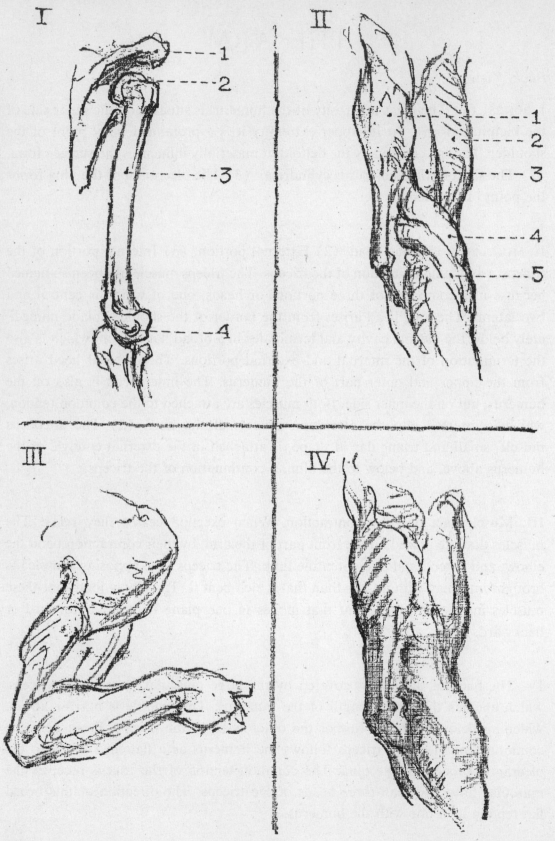

I

1
2

3

4

II

1
2
3

4

5

III

IV

THE ARM

I. BONES: (1) Acromion process of the shoulder blade. (2) Head of the humerus. (3) Shaft of the humerus. (4) The external condyle.

II. MUSCLES: (1) The triceps is a three-headed muscle. By contraction, it extends the forearm. (2) The biceps is a two-headed muscle. By contraction, it depresses the shoulder blade, flexes the forearm and rotates the radius outward. (3) Brachialis anticus (*brachialis,* pertaining to arm; *anticus,* in front): By contraction, it flexes the forearm. (4) Supinator longus. (5) Extensor carpi radialis longus; extensor (extender); carpi (*carpus,* the wrist); radialis (radiates); longus, (long) is responsible for the action that extends the wrist.

III. Muscles with their tendons are the instruments of motion as much as the wires and strings that give the movements to a puppet. In the upper arm, the wires that raise or lower the forearm are placed in directions which parallel the bones. All the muscles of the body are in opposing pairs. When a muscle pulls, the opposing one yields with just sufficient resistance to balance the one that is pulling. The forearm is the lever on which both the biceps and the triceps flex and straighten out the arm at the elbow. The muscles just mentioned parallel the arm to swing the forearm backward and forward. Another contrivance is needed to give rotary motion to the thumb side of the hand. In order to do this, the power is attached to the lower third of the humerus above the outer condyle and extends to near the end of the radius at the wrist. It is this muscle that aids in turning the doorknob and the screwdriver.

IV. In looking at the arm from the outer side it is seen that the deltoid descends as a wedge sinking into an outer groove of the arm. The masses of the biceps and triceps lie on either side. There is as well an outer wedge, the supinator longus. These different forms denote entirely different functions. Mechanism has always in view one of two purposes; either to move a great weight slowly, or a lighter weight with speed. The wedge at the shoulder creates power; lower down on the arm, speed. This mechanism allows the wrist and hand to move up and down as well as circularly, with a certain firmness and flexibility compared to the comparatively slow motion with which the arm can be raised.

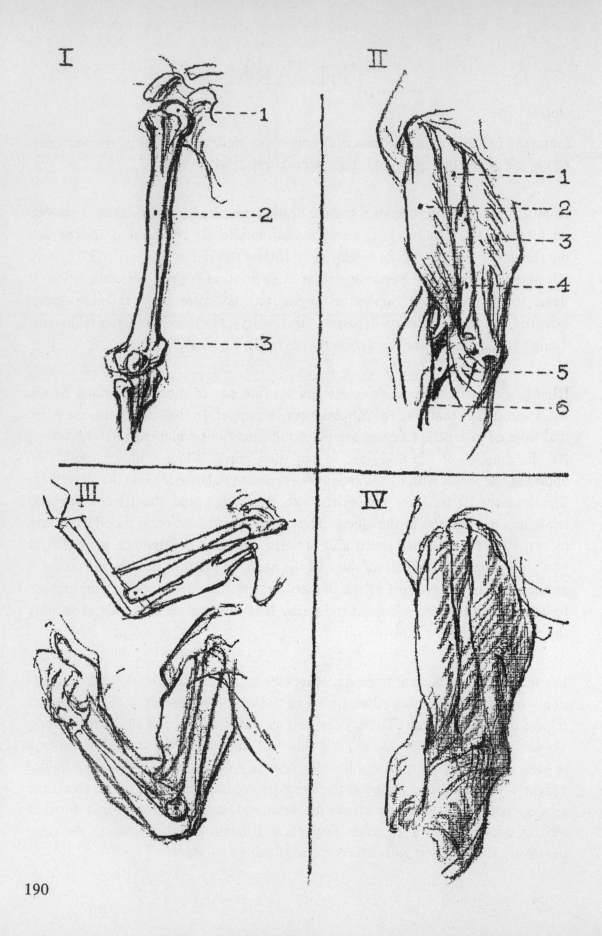

I

1
2
3

II

1
2
3
4
5
6

III

IV

190

THE ARM

I. BONES: (1) The bone of the upper arm, the humerus, consists of a long strong cylinder. As it is not flexible, it can turn only on joints, one at the shoulder to raise the arm and one at the elbow to bend it. The upper extremity seen from the inner side consists of a round smooth ball that is covered over by a layer of cartilage and is known as the head of the humerus. It glides in the cup-shaped cavity of the shoulder blade, the glenoid cavity. (2) The cylindrical shaft of the humerus. (3) The inner condyle of the humerus is larger and more prominent than the outer one. It is the origin of the flexors of the forearm as well as a muscle that pulls the thumb side of the forearm toward the body, the pronator teres.

II. MUSCLES: (1) Coraco-brachialis: from coracoid process to humerus, inner side half way down. It draws forward and rotates the humerus outward. (2) Biceps: the long head from upper margin of the glenoid cavity, the short head from coracoid process to radius. It flexes the forearm and rotates the radius outward. (3) Triceps: the middle or long head; the external head; the internal or short head. It extends the forearm. (4) Brachialis anticus: from front of the humerus and the lower half to the ulna. It flexes the forearm. (5) Pronator radii teres: extends from the internal condyle to the radius on the outer side and half way down. It pronates the hand and flexes the forearm. (6) Supinator longus: the external condyloid ridge of the humerus to the end of the radius. It supinates the forearm.

III. The arm and forearm are pivoted or jointed at the elbow. The elbow is the fulcrum. The power that moves the lever is a muscular engine. When the forearm is raised the power is exerted by the biceps and brachialis anticus. When this action takes place, the triceps are inert.

IV. The arm, seen from the inner side, presents the greatest width at the fleshy region of the deltoid, two-thirds of the way above the elbow, then diminishes as a hollow groove, bordered by its common tendon. The inner view of the arm, the side that lies next the body, has a number of muscles that point this way and that way, as well as up and down, to pull and draw the joint in the direction to which it is attached. The crossing at different angles braces the arm as well as allowing great freedom of movement.

TRICEPS AND BICEPS

1 The triceps straightens out the flexed arm.

2 The biceps bends the elbow and flexes the forearm on the arm.

A finger is not bent or straightened without the contraction of two muscles taking place. A muscle acts only by contraction. In the same way a finger is bent, the forearm is bent. The muscles on the front part of the arm by their contraction, bend the elbow; those on the back extend and straighten the arm. The lever of the forearm is pivoted or jointed at the elbow which acts as its fulcrum. To straighten the arm, the heavy three-headed triceps plays against its antagonist, the two-headed biceps. When the exertion of either of these two muscles ceases, they relax to their former state.

The arm consists of a strong cylinder of bone which turns on the joint at the shoulder to raise the arm, and another joint at the elbow to bend it. These joints are made to slip on one another and are pulled as they contract or relax, thus changing the surface forms while undergoing action or relaxation.

MECHANISM OF THE ARM

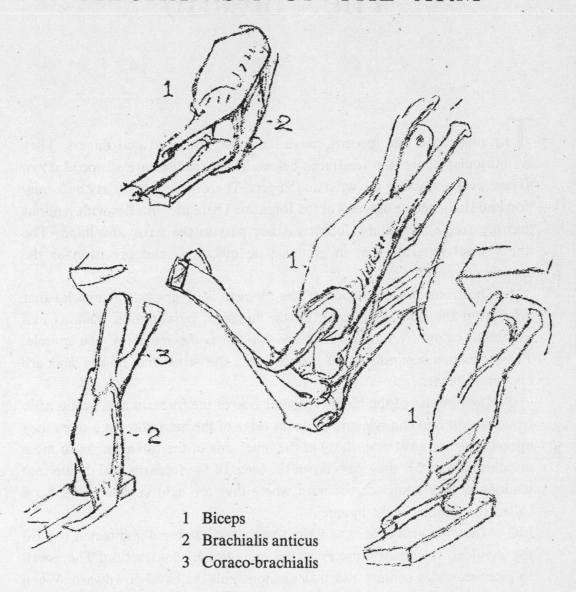

1 Biceps
2 Brachialis anticus
3 Coraco-brachialis

The muscles of the human body not only bend the body by muscular force, but also serve as brakes, slowing the reactions. For instance, the biceps and the brachialis anticus muscles are placed in the front of the upper arm and, by their contraction, they bend the elbow. If power ceased altogether, the forearm would drop down. But the opposing muscle slows the otherwise uncontrolled movement after the manner of a brake. This mechanism of slow motion pervades all the limbs and every movement of the body.

The Forearm

THE muscles of the forearm move the wrist, the hand and fingers. They are muscular above and tendinous below. These tendons are strapped down to pass over and under the wrist and fingers. There is a great variety of formation and shape to the muscles of the forearm. There are muscles with tendons that are single and again double as they pass to the wrist and hand. The muscles act separately or in groups with quickness and precision as the occasion requires.

1 The front and inner side of the forearm is composed of muscles that arise from the internal condyle of the humerus by common tendons and terminate below by tendons that are two-thirds the length of the muscle. These tendons separate to be inserted into the wrist and fingers and are known as flexors.

2 The muscles of the back and outer side of the forearm as a group arise from the external condyle and adjacent ridge of the humerus. As a mass they are on a higher level than those of the inner side of the forearm. As to these muscles in general: they pass down the back of the forearm and divide into tendons as they approach the wrist where they are held in place by a band called the annular wrist ligament.

3 When the arm is bent to a right angle and the hand is directed toward the shoulder, the flexor muscles are set in motion by contraction. They swell to their muscular centers and their tendons pull the hand downward. When the hand is bent at the wrist in the direction toward the front of the forearm, it is flexion. The reverse is called extension.

4 The extension of the hand on the forearm shows the muscles and the tendons lying on the outer side and back of the forearm. These are held in place by the annular ligament. The rounded forearm is made up of the fleshy bodies of muscle that terminate mostly in long tendons that pass to and over the wrist and hand. Some of these muscles move the hand on the forearm or the different finger joints on each other. There are also deep muscles of the forearm from which the tendons emerge though the muscles are hidden.

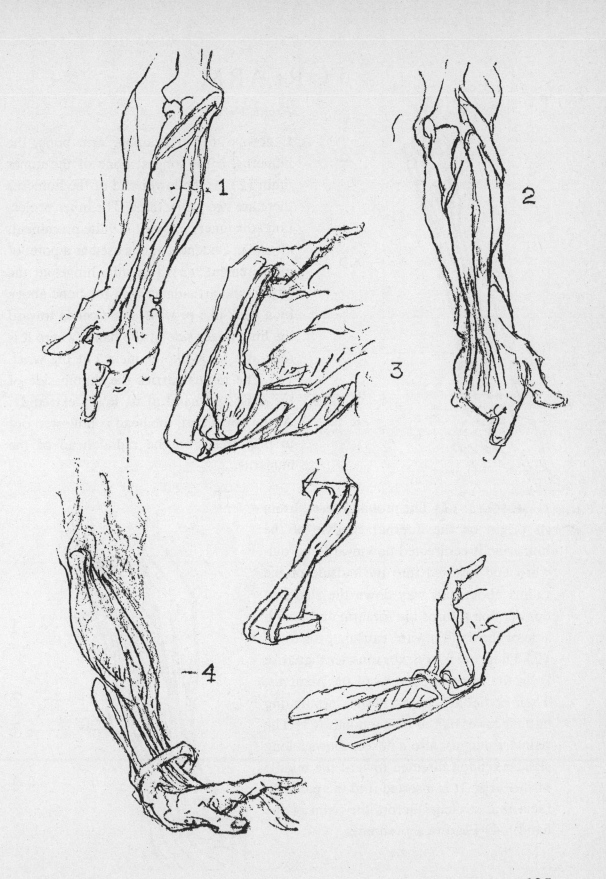

FOREARM

I

Front View

I. BONES: (1) The upper arm bone, the humerus, is the longest bone of the upper limb. (2) At the lower end of the humerus there are two projections. The inner projection (the inner condyle) is quite prominent, always in evidence, and is used as a point of measurement. (3) The ulna hinges at the elbow, and articulates with the bone above by a beak-like process. It descends toward the little finger side of the hand, where it is seen as a knob-like eminence at the wrist. (4) The radius carries the thumb side of the wrist and hand at its lower extremity. At the upper end, the head is hollowed out to play freely on the radial head of the humerus.

II. MUSCLES: (1) The pronator teres. From its origin on the internal condyle of the humerus, it is directed downward and outward and inserted into the outside of the radius about half way down the shaft. In contraction it turns the forearm and thumb side of the hand inward causing pronation. (2) There are four flexor muscles that arise from the internal condyle of the humerus. Their bodies are mostly fleshy, terminating at their lower half in long tendons. (3) The palmaris longus, also a flexor, shows a long slender tendon directed toward the middle of the wrist. It is inserted into the palmaris facia that stretches across the palm of the hand. (4) Flexor carpi ulnaris.

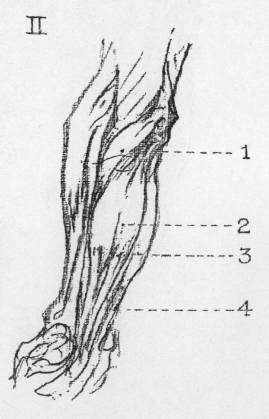

196

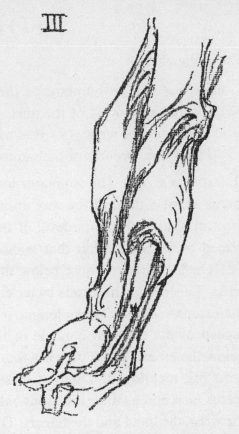

III. Muscles must lie above and below the joint they move. Muscles that bulge the forearm in front are flexors. They terminate as wires or strings that pull the wrist, hand and fingers together as they contract.

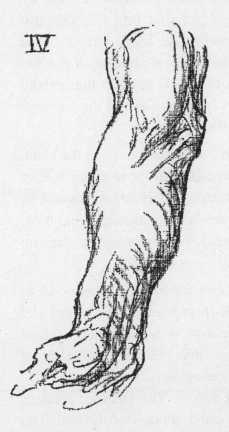

IV. The inner condyle of the humerus is a landmark when the forearm is seen from the front and the bones are parallel. In this position, the muscles and their tendons are directed downward to the wrist and hand.

The first, the pronator teres, passes obliquely to the middle of the radius. The second, the flexor carpi, radiates toward the outer side of the hand. The third, the palmaris longus, is toward the middle. The fourth, the flexor carpi ulnaris, is toward the inner border of the hand. The muscles just named are situated on the front and inner side of the forearm and all arise from the inner condyle of the humerus.

FOREARM

Back View

I. BONES: (1) The humerus of the arm presents a shaft and two extremities. (2) Olecranon process of the ulna, elbow. (3) The ulna, from the elbow to the little finger side of wrist. (4) Radius, the thumb side of the forearm at the wrist. (5) The styloid process of the radius.

II. MUSCLES: (1) The supinator longus arises from the outer border of the humerus about a third of the way up its shaft. It then enlarges as it descends to its greatest size at about the level of the external condyle. Below, its fibres are replaced by a long tendon that is inserted into the styloid process of the radius. (2) On the humerus, just below the supinator, arises the long extensor of the wrist. This muscle descends by a slender tendon to the index finger and is named the extensor carpi radialis longus. (3) Anconeus, a small triangular muscle attached to the external condyle of the humerus and inserted into the ulna just below the elbow. (4) There are four extensors including the long extensor of the wrist just mentioned. Three of these arise from the external condyle of the humerus, descend as muscles about half way down and end as tendons that extend the wrist, the hand and the fingers. The fourth arises from the shaft of the humerus just above the external condyle. (5) Extensors of the thumb.

III. The muscles of the forearm are placed just below the elbow, moving the hand, the wrist and fingers by long slim tendons that are securely strapped down as they pass under or over the wrist. It is a fixed law that a muscle contracts toward its center. Its quickness and precision of movement depends upon its length and bulk. If the muscles of the forearm had been placed lower down, the beauty of the arm would have been destroyed.

IV. The muscles that lies on the outer side and back of the forearm are known as the supinator and the extensor group. They emerge from between the biceps and the triceps at about a third of the distance up the arm as a fleshy mass. These wedge-shaped muscles are placed on a higher level than the pronator or flexor group, as they arise some distance above the outer condyle of the humerus. The extensor group take their origin from the condyle below. The extensor tendons are on the back of the arm and always point to the outer condyle of the humerus. The extensor muscles are the direct antagonists of the pronators and flexors in front. The chief action of the supinator longus is that of a flexor but acts as in supination as well.

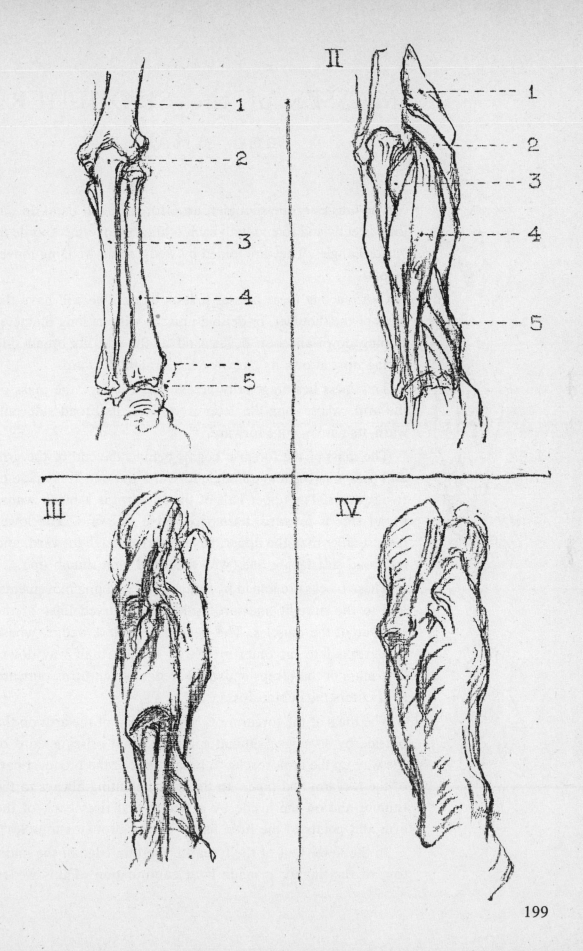

II

1

2

3

4

5

III

IV

199

MASSES of the SHOULDER and ARMS

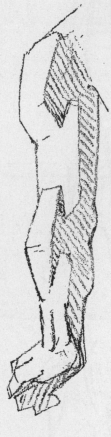

The masses of the shoulder, arm, forearm and hand do not join directly end to end with each other, but overlap and lie at various angles. They are joined by wedges and wedging movements.

Constructing these masses first as blocks, we will have the mass of the shoulder, or deltoid muscle, with its long diameter sloping down and out, beveled off at the end; its broad side facing up and out; its narrow edge straight forward.

This mass lies diagonally across and overlaps the mass of the arm, whose long diameter is vertical, its broad side outward, its narrow edge forward.

The mass of the forearm begins behind the end of the arm and passes across it at an angle forward and out. It is made of two squares. The upper half of the forearm is a block whose broad side is forward, its narrow edge sideways. The lower half, smaller than the upper, has its narrow edge forward, and its broad side facing out (with the hand held thumb up).

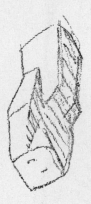

These blocks are joined by wedges and wedging movements, and to the straight lines are wedded the curved lines of the contour of the muscles. The deltoid is itself a wedge, whose apex sinks into the outer groove of the arm half way down. The mass of the biceps ends in a wedge which turns outward as it enters the cubital fossa.

The mass of the forearm overlaps the end of the arm on the outside by a wedge (supinator longus) that arises a third of the way up the arm, reaches a broad apex at the broadest part of the forearm and tapers to the wrist, pointing always to the thumb; and on the inside by a wedge that rises back of the arm and points to the little finger (flexor-pronator muscles).

In the lower half of the forearm, the thin edge of the mass, toward the thumb, is made by a continuation of this wedge

from the outside. The thin edge toward the little finger is made by the end of the wedge from the inside.

When the elbow is straight and the hand turned in, the inner line of the forearm is straight with that of the arm. When the hand is turned out, this line is set out at an angle that corresponds with the width of the wrist. The little finger side (ulna) is the hub of its movement.

The flexor tendons on the front of the forearm point always to the inner condyle; the extensor tendons on the back point always to the outer condyle.

The breadth of the hand corresponds with that of the lower mass, not joining it directly, but with a step-down toward the front.

In the back view of the arm, the mass of the shoulder sits across its top as in the front view. The back edge of this mass is seen to be a truncated wedge arising under the deltoid and focusing on the elbow. The upper end resolves itself into the three heads of the triceps; the lower or truncated end is the triceps tendon, to which is to be added the tiny wedge of the anconeus (donkey's foot) muscle bridging from outer condyle to ulna.

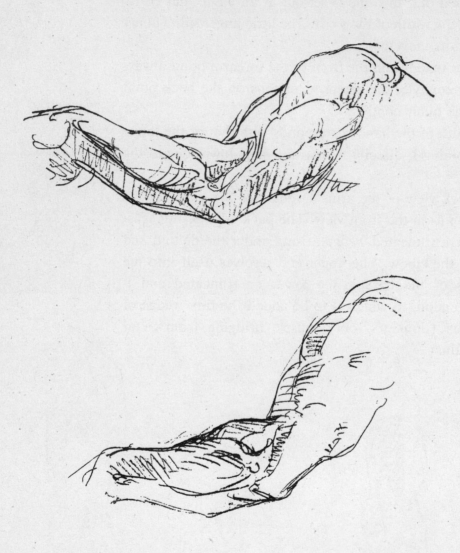

202

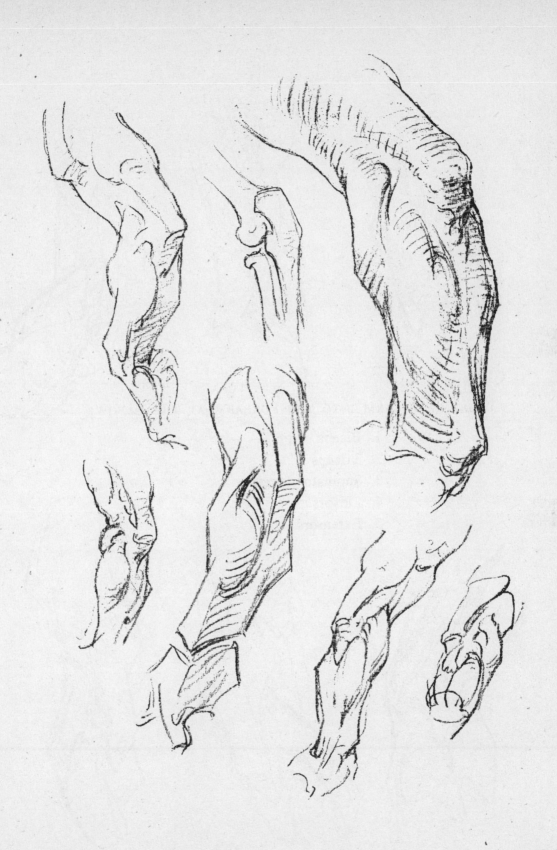

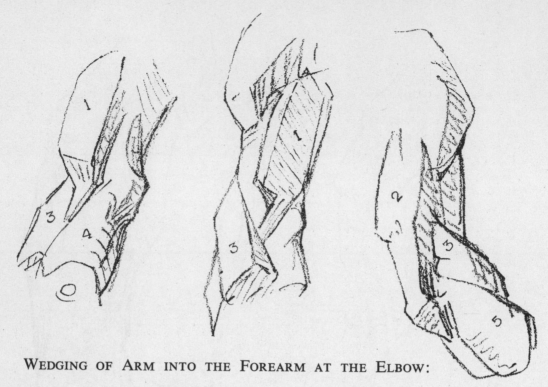

WEDGING OF ARM INTO THE FOREARM AT THE ELBOW:

1 Biceps
2 Triceps
3 Supinator longus
4 Flexors
5 Extensors

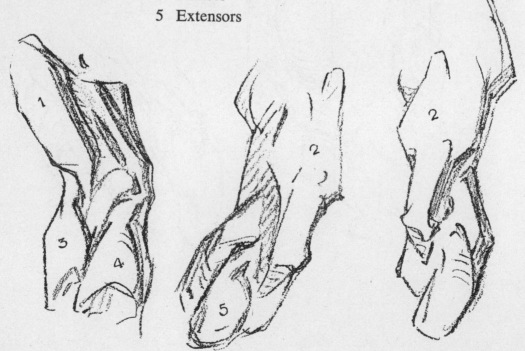

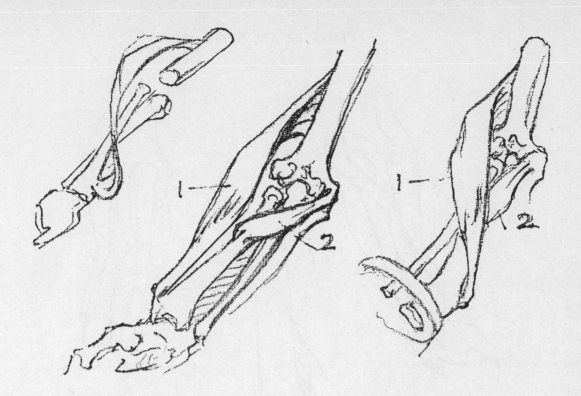

PRONATOR AND SUPINATOR

THE two muscular forces that rotate or turn the forearm, by crossing one bone over the other, are the supinator and the pronator.

1 The supinator extends from the wrist to about a third way up the bone of the upper arm. It is a long muscle. The lower third is tendinous. It rises above the outer condyle of the humerus. The upper portion is the large fleshy mass that lies on the outer and upper third of the forearm. In action it flexes as well as supinates.

2 The opposing muscle to the supinator is the short round pronator teres, which passes obliquely downward across the forearm. It arises from the inner condyle of the humerus to be inserted near the middle of the outer border of the radius.

These two muscles pull the radius with a wheel-like motion over the ulna and back again carrying the thumb side of the hand toward or away from the body. The supinator is the force that turns the doorknob and the screwdriver away from the body. It is the only flexor of the forearm that can be seen on the surface of its entire length.

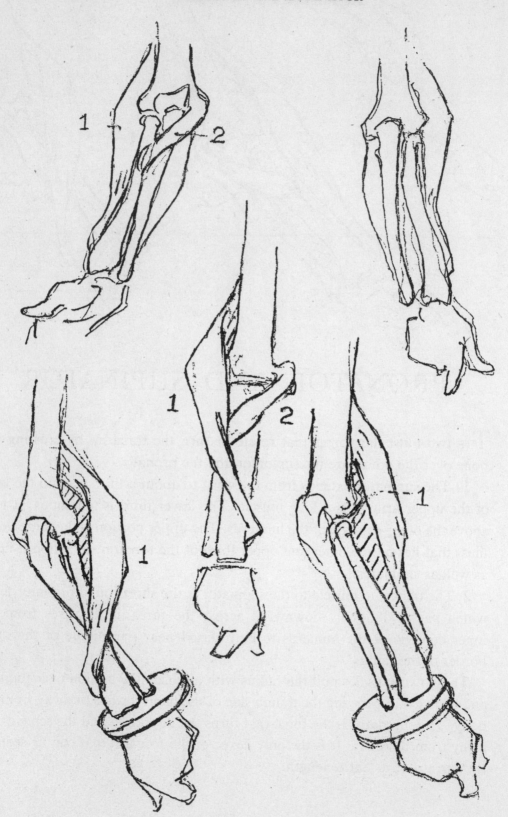

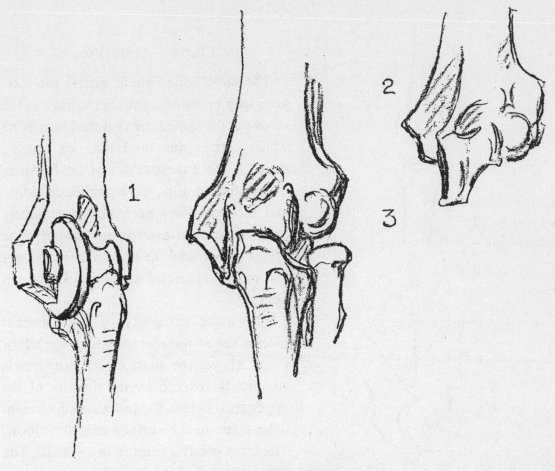

ELBOW

1 The upper extremity of the elbow as seen from the front. The inner surface of the coranoid process of the ulna is curved so as to clasp the pulley-like trochlea of the humerus.

2 The lower extremity of the humerus is somewhat flat. Projecting from each side are the internal and external condyles. Between the two is the rounded groove that receives the lip of the ulna.

3 Here the bones of the arm and forearm are connected. This is a view from the front. The humerus above shows the two condyles with a notch that receives the coranoid process of the ulna, when the arm is bent. The ulna at the elbow swings hinge-like on the bone of the upper arm. It moves backward and forward in one plane only. Just below the outer condyle of the humerus is a small and rounded bursa, called the radial head of the humerus, on the surface of which rolls the head of the radius.

207

ELBOW—*Front View*

The large bone, which carries the forearm, may be swinging upon its hinge at the elbow, at the same time that the lesser bone which carries the hand may be turning round it. Both these bones of the forearm, the radius and ulna, have prominent ridges and grooves. They are directed obliquely from above, downward and inward. The radius turns round the ulna in these grooves and on the tubercles at the heads of both bones.

The lower extremity of the humerus gives a key to the movements of the elbow joint. Above, the shaft of the humerus is completely covered by the muscles of the upper arm. Below, the inner and outer condyles come to the surface near the elbow. The inner condyle is more in evidence. The outer one is hidden by muscle, when the arm is straightened out. When the arm is bent, it becomes more prominent and easier to locate.

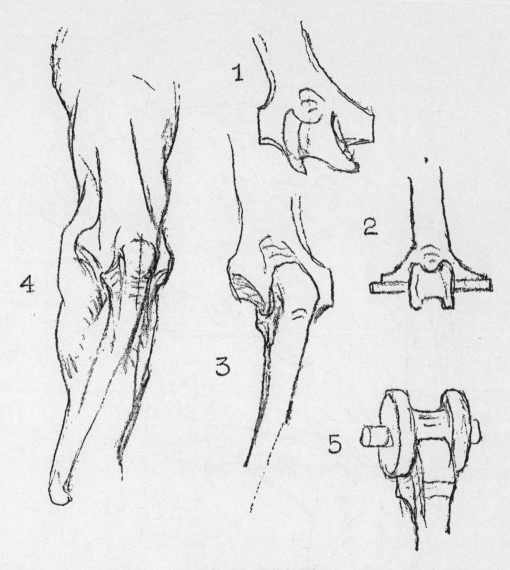

ELBOW—*Back View*

1 The humerus at the elbow is flattened in front and back, terminating in two condyles. Between these is placed the trochlea, a rounded spool-like form that is clasped by the olecranon process of the ulna.

2 This is a diagram of the spool-like form of the trochlea with the embracing condyles at the sides.

3 From the back, the olecranon process of the ulna is lodged into the hollowed-out portion of the back of the humerus, forming the elbow point.

4 This shows the bony structure of the hinge joint at the elbow.

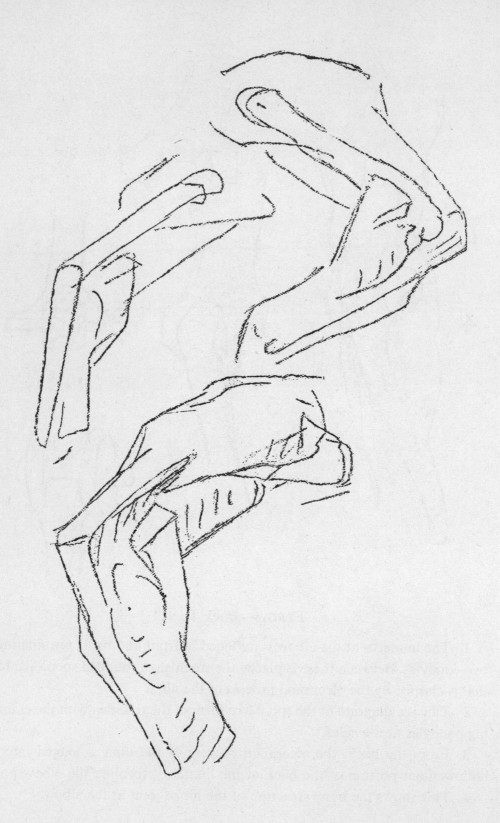

210

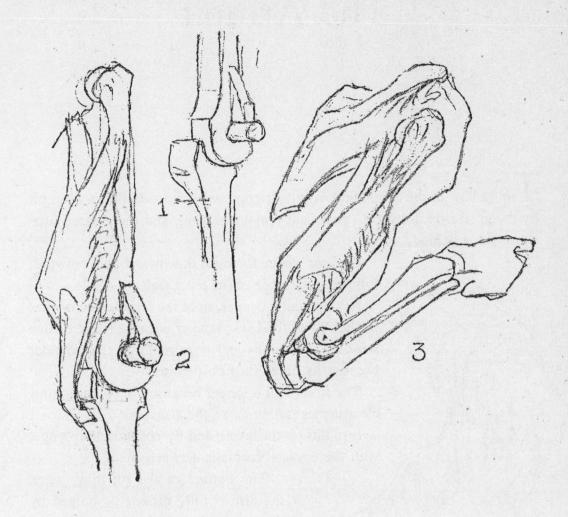

ELBOW—*Side View*

1 The ulna swings on the pulley of the humerus. The articulation is known as a hinge joint.

2 Shows the mechanical device used in straightening the forearm, on the arm, at the elbow. The common tendon of the triceps grasps the olecranon of the ulna, which in turn clasps round the spool-like trochlea of the humerus.

3 When the forearm is flexed on the arm, the ulna hooks round the pulley-like device of the humerus. The triceps in this position is opposed by the biceps and brachialis anticus in front, which becomes the power that raises the forearm upward. The triceps in reverse is inert and somewhat flattened out.

The Armpit

THE hollow of the arm, filled with its friction hairs, is made into a deep pit by the great breast muscle (pectoralis major) in front, and the greater latissimus dorsi behind.

Its floor slopes forward, downward and outward, following the slope of the chest wall.

Its rear wall is deeper, since the latissimus attaches farther down the back; thicker because made of two muscles (latissimus and teres major); and rounder because its fibres turn on themselves.

The front wall is longer because the pectoral muscle attaches farther down the arm.

Into this pit the biceps and triceps muscles plunge, with the coraco-brachialis between them.

The bottom of the pit may, when the arm is fully raised, be bulged by the head of the arm bone and the lymph glands that lie there.

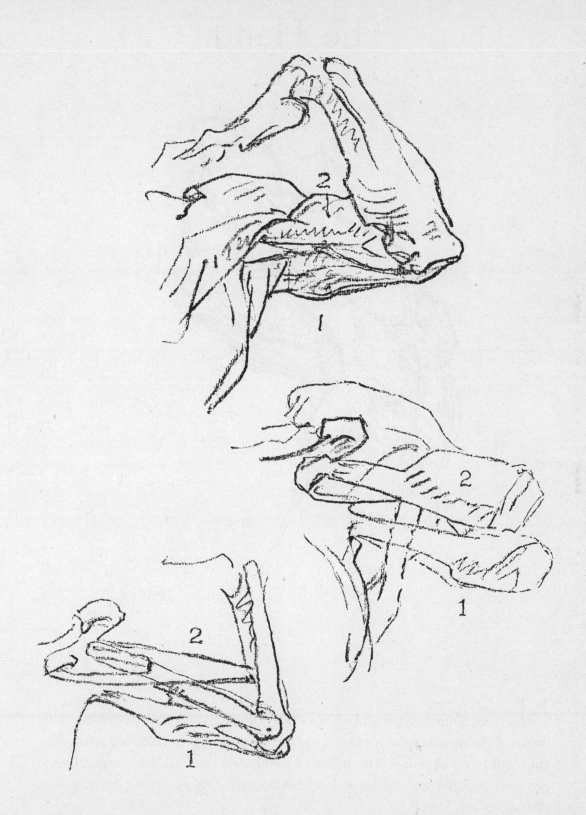

The Hand

Nature standardizes all hands to laws of mechanics and dynamics. The hands of the mummies of ancient Egypt, thousands of years old, are not different from those of today. The bones of prehistoric man are the same. Ninety per cent and more of the hand is standardized by its use to the unchanging laws of its use.

214

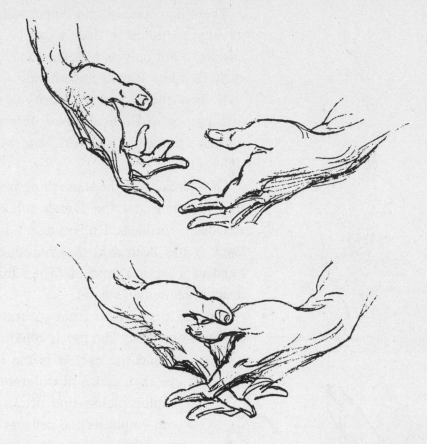

But the hand as drawn and sculptured has varied markedly in different ages. Cave dwellers marked the walls and roofs of their dwellings and their implements with signs and figures, and among them, hands. The hands they drew or carved had a general character distinctly of that age.

The Peruvian, the Aztec, the American Indians in their written sign languages, the Alaskan on his totem pole, each of these—whether the hand was carved out or cut in, drawn or painted, in red or blue, wherever a hand was shown—adhered to a certain style of hand whose character marked it as belonging to that age or that tribe or that race, and all distinctly different from other periods or races or tribes.

The Assyrians graved hands on their palace walls and carved them in stone; and they were Assyrian hands, distinguishable easily from those of any other race or age. The Egyptians told stories by means of carved and painted hands, as individual as those of any other place or time.

When we come to the ages of a more studied art, the same psychological law is in evidence. There is an early Gothic hand, distinctly different from that of any other period.

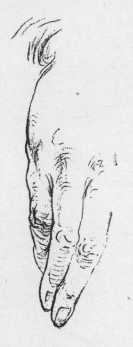

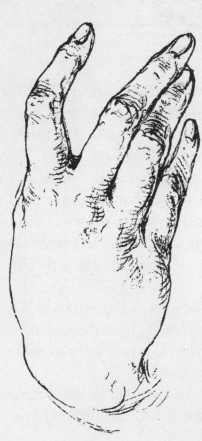

There is a Renaissance hand with a character of its own; so much so that it can be picked out and classified, not only as a Renaissance hand, but as an early or a late Renaissance hand.

No one questions the sincerity of Ghirlandajo, or of Lippi, or of Botticelli. Not only were they great masters, but close students, and yet each drew a different style of hand.

Of later schools the same thing may be said; as of the Venetian and the Dutch schools, and of the schools of Jordaens, Rubens and Van Dyck. Of Van Dyck it has been said that he could not draw the hand of a laborer, and of Millet that he could not draw a gentleman's hand.

Indeed, it is very far from accurate to say that we see with our eyes. The eye is blind but for the idea behind the eye. It is the idea behind the eye that makes it different from a photographic plate—that pricks out some parts with emphasis and censors other parts. We see with the idea, and only *through* the eye.

Michelangelo, Leonardo da Vinci and Raphael, all of the same period, all had the same style of models, and yet they produced hands of three very distinct types.

Albert Dürer, Holbein the younger, Rembrandt, all made hands that, because of their individuality, are classed as a Holbein or a Dürer or a Rembrandt hand by the art world.

Reasons for this change and flux in character and style of hands are no doubt familiar to every one. Briefly, the hand as pictured is not subject to the automatic forces that standardize the actual hand to the laws of its use. The pictured hand is standardized to no laws except those of

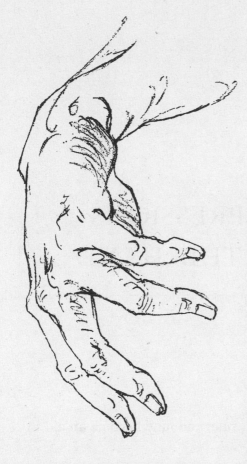

perception; which means to the current concepts and to individual taste. The business of the artist in such a connection is to standardize his concepts of the hand to those of nature—to see it as nature sees its purpose, methods and laws.

It may be reflected that the science of anatomy is a comparatively recent acquisition of the race. It is not many decades since the cutting up of the human body was forbidden by law and abhorred in religion. Even after such a study is well developed, it takes a certain time for its significance to penetrate to other domains of thought and effort, and a much longer time for it to be assimilated there.

It has taken man centuries to learn to look under the form for the mechanisms in the human body; and he is only now learning to look under the mechanisms for the reasons that underlie them. The world of art is beginning to appropriate these things to itself, and the improvement in one man's technic by this means compels others to seek improvement in the same school—the school of nature, her reasons and her purposes.

If this tendency to fluctuations, to styles and fashions is more marked in the hand than in other parts of the body, it is probably because the importance of the hand as an avenue of expression has not been understood. The hand is thought of as the slave of action. But the slave of action is the master of expression.

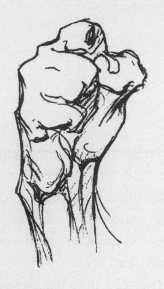

EXPRESSIONS
OF THE HAND

THE face is well schooled to self-control as a rule, and may become an aid in dissimulation of thought and feeling.

Rarely is the hand so trained; and responding unconsciously to the mental states, it may reveal what the face would conceal.

Like any other living thing, the hand is modified to its use. The total modification in any individual is less than one per cent; but in a succession of generations it may be cumulative. Also it happens that it is the more superficial and conspicuous parts that are thus modified.

On the background of the mechanics, then, which is older than the human race, we may have racial variations; then on this basis, accumulated hereditary or family modifications, and on them in turn expressions of individual history and character.

The hand of the child is almost unmodified. With its creases and dimples and its tapering fingers, it represents almost the pure symmetry that is the natural heritage of all created things.

The hand of age represents the opposite extreme, the end product, the

insanity of over-modification; furrowed, wrinkled with the scars of time, with enlarged squared joints, and shaky.

On the background then of mechanics and racial variations, we have many variations, such as those of youth or age; male or female; healthy or unsound; laboring or aristocratic; strong or weak.

Types of hands may be classified as: square, round, compact; long or short; thick or thin. The relative length of fingers varies, both among themselves and in comparison with the hand. The relative thickness of joint and shaft and finger tip varies. The thumb may be short, thick or thin, may lie close or spread far from the hand.

The hand that is inured to heavy labor shows very definite changes. It is larger and heavier. The muscles are of course developed, but these lie for the most part above the hand in the forearm. Those of the palmar (thenar) and hypothenar eminences are somewhat larger and more square. Chiefly, the joints become enlarged, square, rugged and irregular in appearance. The tendons are more in evidence. The skin is hardened, so that creases are deeper, especially the skin pads are heavier and may overhang the borders. The skin hairs may stand up like bristles. In repose it assumes a more crooked position. Clenched, with the aggressive thumb twisted around the fingers, it becomes a squared, knobbed and formidable looking weapon.

The converse of this is true in the hand not inured to labor. The muscles of the palm present a softly rounded appearance, the skin is smooth and silky, the skin pads not clearly demarked; the joints are not only not rugged, but may be unduly flexible, small and weakly angled. The bones of the hand and fingers will have less of the spring curve, that is, they will be straighter and slighter. The hand will on the whole be much more symmetrical and expressionless.

When the hand is employed in what may by contrast be called the intelligent uses, in which flexibility is necessary, it will have as a consequence greater freedom of movement, will assume much more varied positions, and will express much more readily the mental states. In proportion as this habitual exercise is free and intelligent, will the symmetries assumed be free and expressive.

Certain typical positions are due not so much to the mental states as to the mechanics of the hand. For instance, the little finger side is always more flexible than the thumb side, because it is opposite to the powerful thumb. The middle finger is always inclined to bend farther forward, or to bend forward

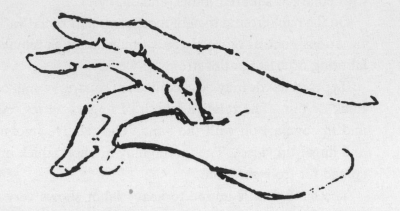

first; this on account of its relatively greater power. All fingers bend forward first at the knuckles, then at each joint in turn. The thumb is habitually carried somewhat extended, out of the way of the fingers.

Modern psychology, studying the dynamics of the nervous system, informs us in regard to many of the instinctive positions and actions of the body (including the hand) and the things expressed by them. For instance, there is a wholly involuntary opening out movement of the whole body, limbs and features, in pleasant emotions, honesty, courage, understanding, etc.; and conversely, there is a closing up, a drawing in, a turning away, in unpleasant emotions, in mental dishonesty, etc.

In states of self-consciousness, and the effort at self-control, there is a tendency to express the same by clasping one's self; as clasping the thumb with the fingers; clasping or twisting the other hand, or some part of the body.

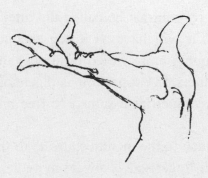

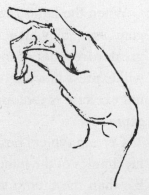

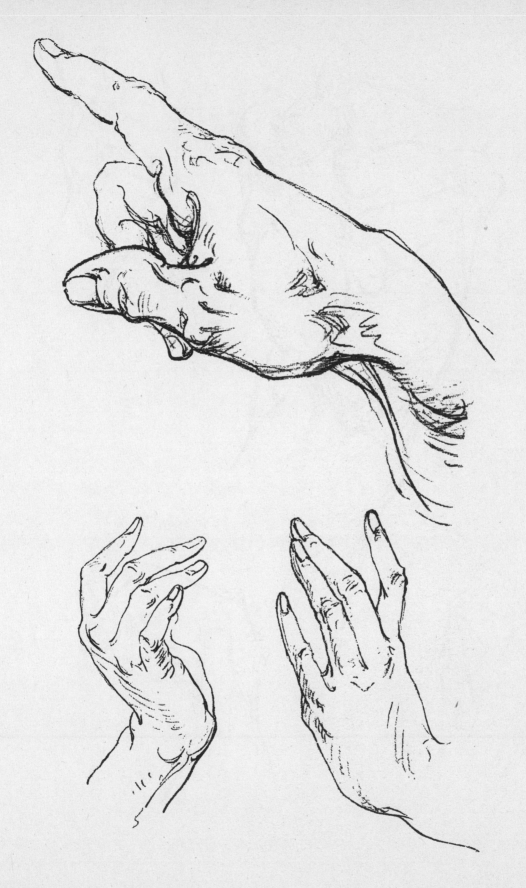

221

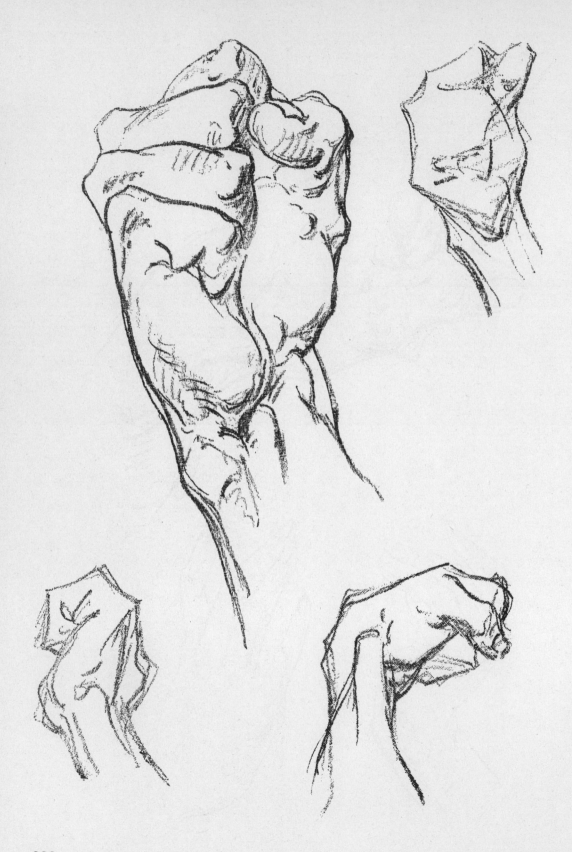

THE WRIST
AND THE HAND

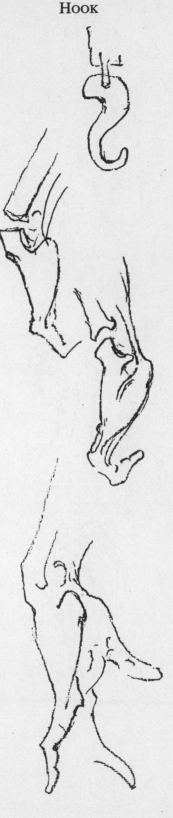

THE bones of the wrist are mortised with those of the hand, making one mass, the hand moving with the wrist. The width of the wrist is twice its thickness and where it joins the arm it diminishes in both width and thickness. There is always a step-down from the back of the arm, over the wrist, to the hand.

The wrist moves with the hand on the forearm, and in combination with these has some rotary movement, but no twisting movement. The twisting movement is accomplished by the forearm.

The hand has two masses: that of the hand proper, and that of the thumb.

The first of these masses is beveled from knuckles to wrist on the edge, from wrist to knuckles on the flat side, and from first to little finger from side to side. It is slightly arched across the back.

TONGS

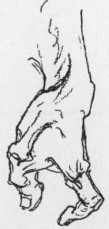

223

WEAPON

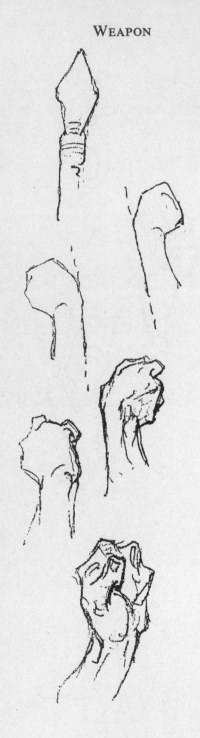

The knuckles are somewhat more arched. They are concentric around the base of the thumb, the second knuckle larger and higher than the rest, the first knuckle lower on its thumb side, where it has an overhang, as has also the knuckle of the little finger, due to their exposed positions.

On the little finger side, the form of the hand is given by the abductor muscle and the overhang of the knuckle, by which the curve of that side is carried well up to the middle of the first segment of the little finger.

On the back of the hand, nearly flat except in the clenched fist, the tendons of the long extensors are superficial, and may be raised sharply under the skin.

The hand had four primal uses: weapon, scoop, hook and tongs.

SCOOP

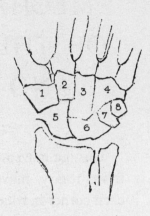

BONES OF THE WRIST,

Palm side

1 Trapezium—No two sides parallel
2 Trapezoid—Two sides parallel
3 Os magnum—Great bone
4 Unciform—Hook-like
5 Scaphoid—Boat-shaped
6 Semi-Lunar—Half-moon
7 Cuneiform—Wedge-shaped
8 Pisiform—Pea-shaped

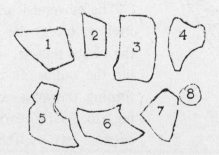

MECHANISMS
OF THE HAND
AND ARM

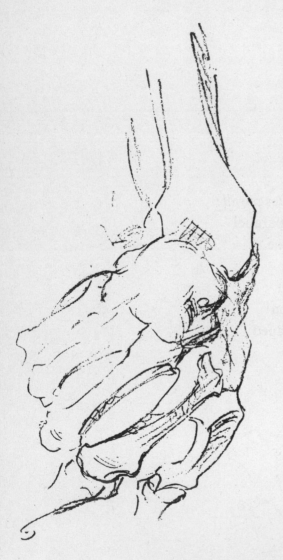

Turning movement as distinguished from rotary movement (flexion to each corner in rotation) is not present in the wrist, but is produced by the radius or turning bone of the forearm. Movement in the wrist is confined to flexion and extension (about one right angle) and side-bending (a little more than half a right angle, in the average hand); these two combined produce some rotary movement.

In movements of the wrist to extreme positions, the hand and fingers almost always participate, on account of association of tendons and muscular action; and in these positions it is practically always separation and hooking of the fingers that is produced.

The movement of the hand reflects itself as far as the shoulder, through the biceps muscle, which aids in turning the radius. In all movement but turning, the wrist can act alone. Turning, to nearly two right angles, is carried out by the radius. Further movement of any kind must be performed by elbow or shoulder.

At the elbow it is the hinge movement that is important, wherefore the large size of the ulna or hinge bone, and the small size of the radius. At the wrist it is the turning movement that is important, wherefore the radius forms two-thirds of the joint, the ulna one-third.

226

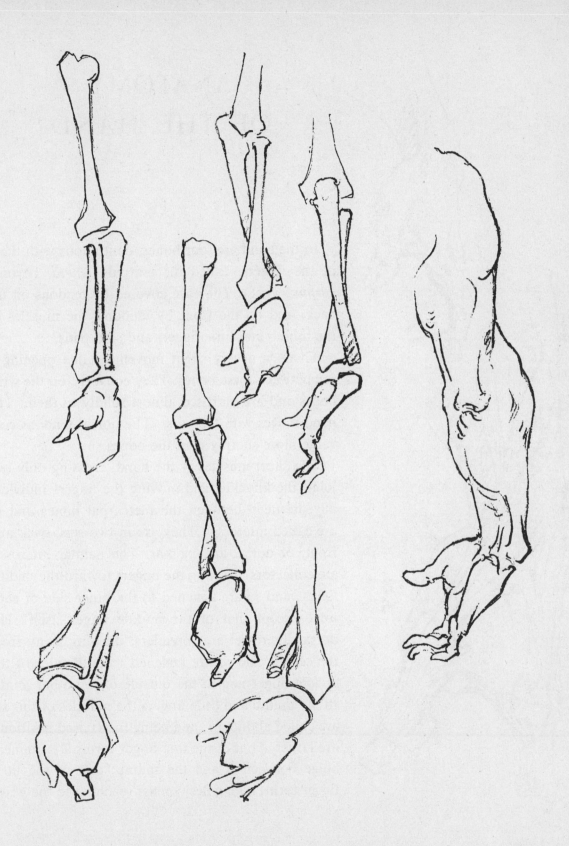

227

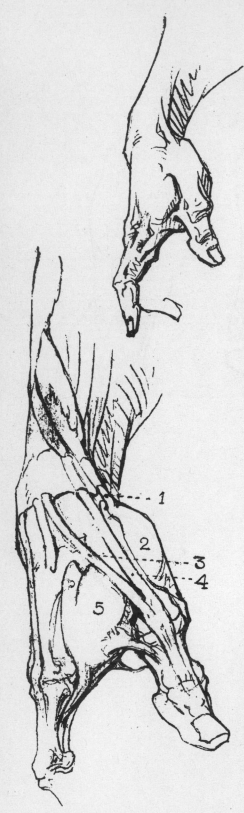

ANATOMY
OF THE HAND

In the hand are four bones, continuous with those of the fingers, called metacarpals (*meta,* beyond, *carpus,* wrist). They are covered by tendons on the back, and on the front by tendons, the muscles of the thumb and little finger, and skin pads.

There is a very slight movement like opening a fan between these bones. They converge on the wrist bones and are mortised almost solidly to them. The hand moves with the wrist. The dorsal tendons converge more sharply than the bones.

The short muscles of the hand, crossing only one joint, the knuckle, and moving the fingers individually, lie deep between the metcarpal bones and so are called interossei. They are in two sets, back and front, or dorsal and palmar. The palmar interossei are collectors, drawing the fingers toward the middle finger, and so are fastened to the inner side of each joint except that of the middle finger itself. The dorsal interossei are spreaders, drawing away from the centre, and so are fastened to both sides of the middle finger and to the outside of the other joints. In the thumb and little fingers the muscles of this set are called abductors, and being in exposed positions, are larger. That of the first finger forms a prominent bulge between it and the thumb; that of the little finger forms a long fleshy mass reaching to the wrist.

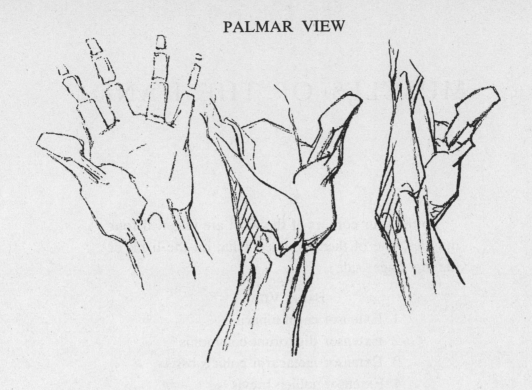

1 Dorsal interossei.

2 Palmar interossei.

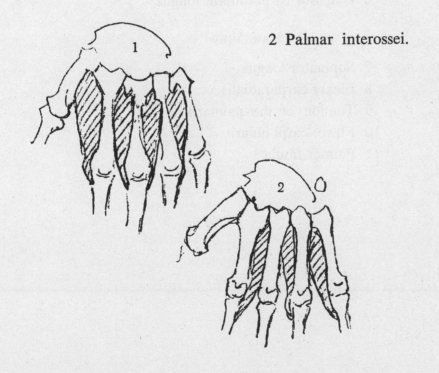

MUSCLES OF THE HAND

To the four corners of the wrist are fastened four muscles, one of them doubled (that on the back of the first finger side).

Back View

1 Extensor carpi ulnaris
2 Extensor digitorum communis
3 Extensor metacarpi pollicis ossis
4 Extensor pollicis brevis
5 Extensor carpi radialis brevis
6 Extensor carpi radialis longus

Palmar View

7 Supinator longus
8 Flexor carpi radialis
9 Tendon of the palmaris longus
10 Flexor carpi ulnaris
11 Palmar fascia

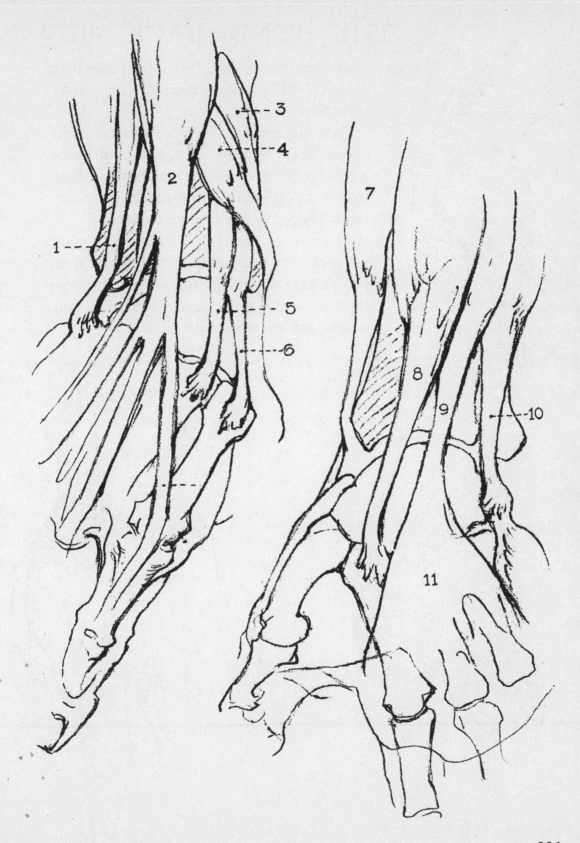

THE HAND—BACK VIEW

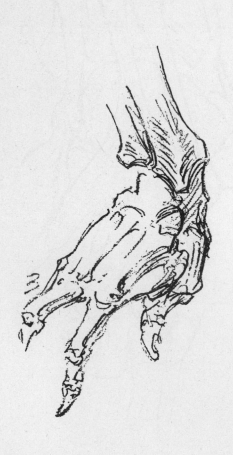

The wrist bones are collectively smaller than the end of the forearm, so there is a constriction at the sides.

The wrist bones are in two transverse layers with an angle between, forming in profile view a hook, point backward; over this is a step-down to the back of the hand. A little to the outer side, this is bridged by the extensor tendons.

The rows of wrist bones are arched toward the back. The two pillars of this arch in front far overhang the anterior line of the arm. From them arise the thenar and hypothenar eminences, and the palm of the hand.

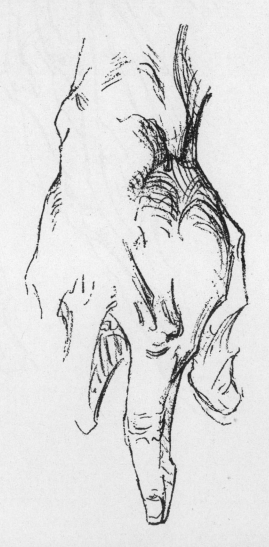

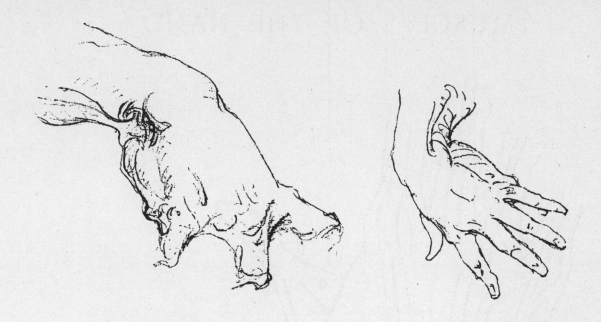

Except for the thumb and the extensor tendons, the back of the hand is smooth. It is slightly arched from side to side.

It is beveled from knuckles to wrist, and is narrower on the back than on the palmar surface. There is a slight fan-like movement among the bones of the hand.

The general mass of the back flows from the wrist toward the first and second knuckles, and is flattened and thinned toward the little finger side.

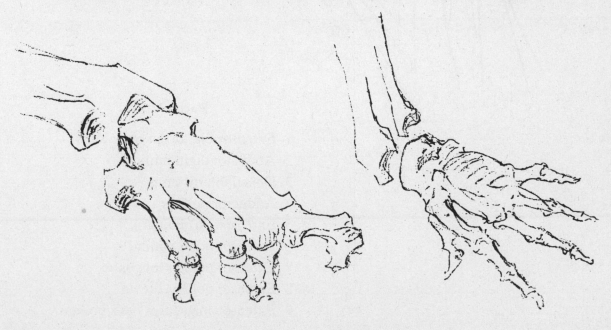

233

MUSCLES OF THE HAND

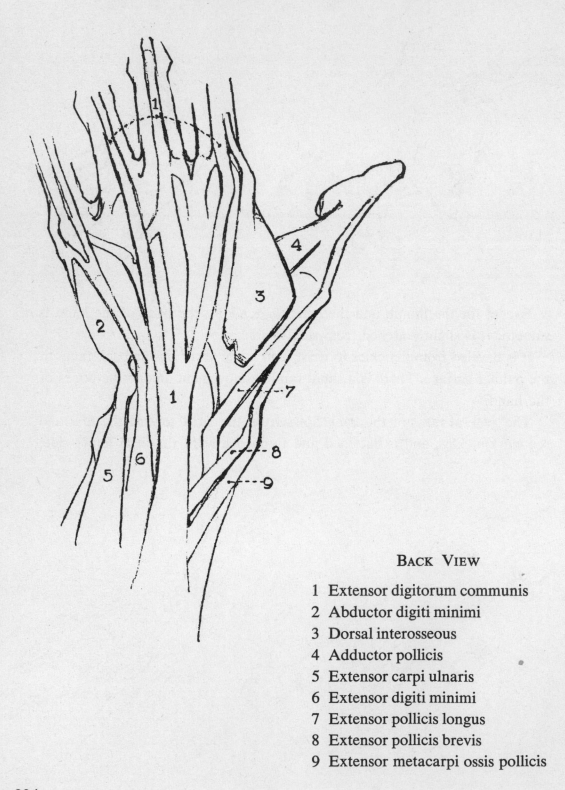

BACK VIEW

1 Extensor digitorum communis
2 Abductor digiti minimi
3 Dorsal interosseous
4 Adductor pollicis
5 Extensor carpi ulnaris
6 Extensor digiti minimi
7 Extensor pollicis longus
8 Extensor pollicis brevis
9 Extensor metacarpi ossis pollicis

234

Distributed over the back are seen the extensor tendons. These represent two sets which have become blended, so have duplications and various connecting bands. Those to the thumb and little finger remain separate.

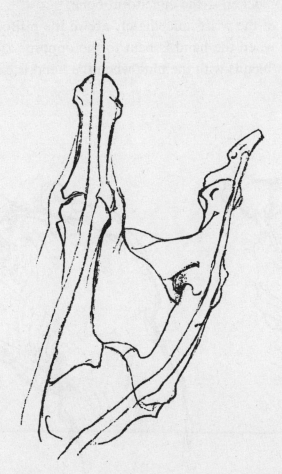

THE HAND—BACK VIEW

The tendons on the back of the hand pass quite high over the wrist. It is clearly impossible to arch the wrist both ways; and flexion being so much more important a function, the extensor tendons are forced far from the centre of movement backward and outward. They converge on the low outer part of the wrist arch. Thus placed they are taut in extreme flexion, so that the fingers cannot be tightly closed.

The thumb side of the wrist arch is larger, higher and projects farther forward, carrying the thumb; it has a deeper inset at the wrist and is square compared with the heel inside, which ends in a ball—the pisiform bone.

On the little finger side of the wrist, between the end of the ulna and the pisiform bone, may be seen a "rocker"—the cuneiform bone.

This is the part of the arch of the wrist immediately above the pisiform—its outer end. It is prominent when the hand is bent to the opposite side or in the act of pulling. It almost blends with the ulna when the hand is carried to that side.

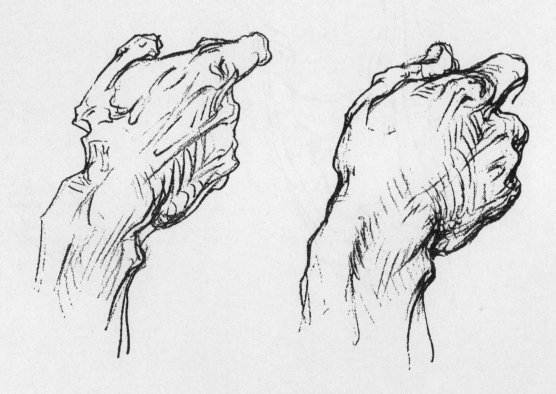

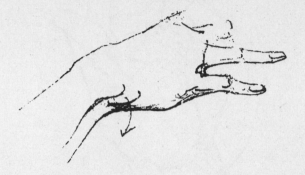

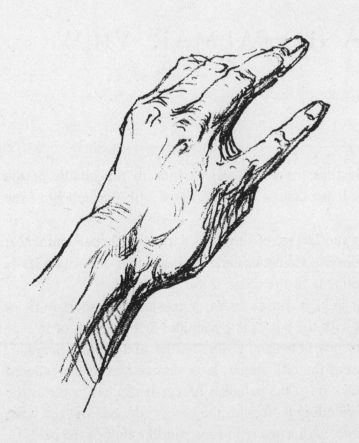

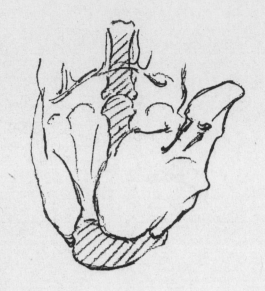

THE HAND—PALMAR VIEW

The palm slightly overlies the wrist, and extends to the middle of the first joint of the fingers. It is made of three portions, with the hollow of the palm between them.

On the thumb side is the largest of these portions, the thenar eminence; opposite it is the hypothenar eminence, and across under the knuckles is the third portion, the mounds of the palm.

The thenar eminence is high, fat and soft; it contains the short muscles of the thumb and forms with the bone the pyramidal first segment of it.

The hypothenar eminence is longer, lower, harder and more triangular. It contains some muscles of the little finger, large on account of the exposed position of that digit, and part of the palmaris brevis. It reaches as far as the base of the little finger, blending there with the row of mounds. At the wrist it covers the pisiform bone, with a heavy fibrous pad like that of the heel.

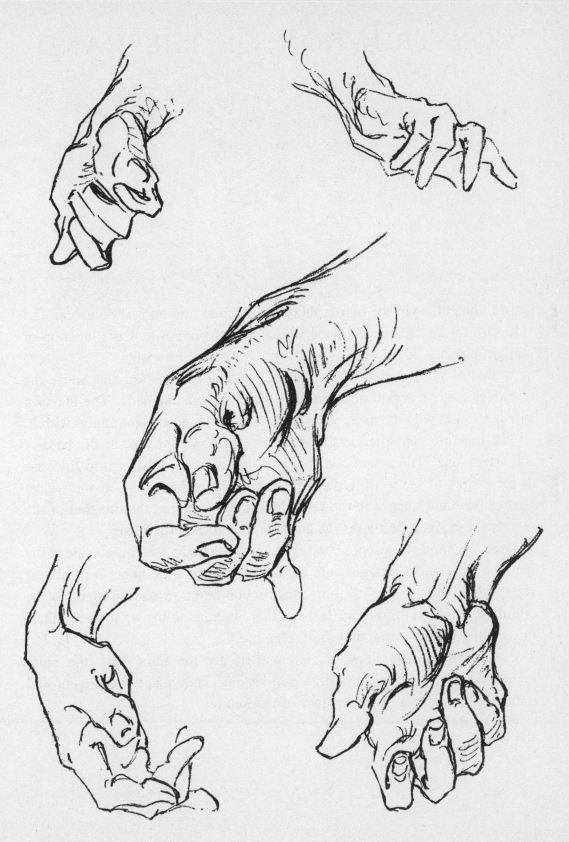

CONSTRUCTION OF THE HAND

PALMAR VIEW

In the hand, as in the figure, there is an action and an inaction side. The side with the greatest angle is the action side, the opposite is the inaction or straight side.

With the hand turned down (prone) and drawn toward the body, the thumb side is the action side, the little finger the inaction side. The inaction side is straight with the arm, while the thumb is almost at right angles with it.

The inaction construction line runs straight down the arm to the base of the little finger. The action construction line runs down the arm to the base of the thumb at the wrist, from there out to the middle joint, at the widest part of the hand; thence to the knuckle of the first finger, then to that of the second finger, and then joins the inaction line at the little finger.

With the hand still prone, but drawn *from* the body, the thumb side is the inaction side, and is straight with the arm, while the little finger is at almost right angles with it. The inaction construction line now runs straight to the middle joint of the thumb, while the action line runs to the wrist on the little finger side, thence to the first joint, etc., etc.

These construction lines, six in number, are the same with the palm turned up, according as it is drawn in or out. They place the fingers and indicate the action and proportions of the hand.

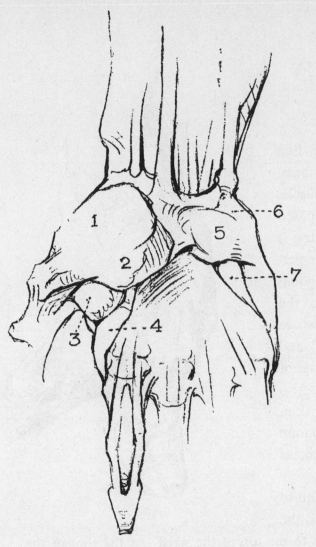

1 Abductor pollicis
2 Flexor pollicis brevis
3 Adductor pollicis trans-
versus
4 Lumbricales
5 Annular ligament
6 Abductor digiti minimi
7 Flexor digiti minimi

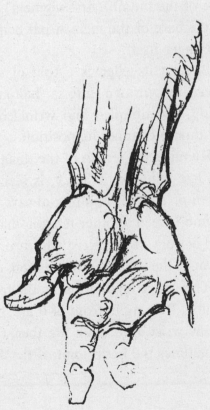

THUMB SIDE
OF THE HAND

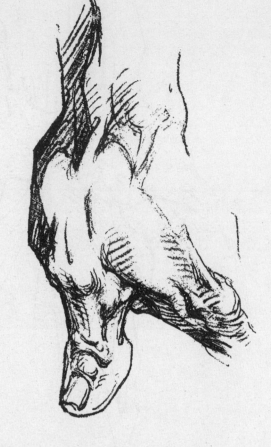

Between the knuckle of the first finger and the thumb is a bulging mass. This is the first interosseous muscle, large here on account of the exposed position of the finger, also because it aids the thumb. In clasping, it is perpendicular to the thumb and diagonal to the knuckle. It attaches to the phalanx at the knuckle, to the whole side of the thumb (first segment) and to the base of the metacarpal bone of the finger itself.

Beyond its edge is a fold of skin, alternately drawn into a half-moon blade, and dimpled and wrinkled, as the thumb changes its position.

Running the length of the thumb to the last joint, on its back, is seen the extensor tendon, pointing always to the top of the wrist. At the root of the thumb is seen another tendon, that of the short extensor, pointing always to the bottom of the wrist; the two converging on the second joint. Between them at the wrist is a depression, quite deep when the thumb is extended.

This latter tendon marks the front border of the metacarpal bone of the thumb. Bulging in front of it are, first, the trapezium, marking the radial end of the wrist arch, then the thenar eminence, to the big joint of the thumb. Sometimes the basal joint of the thumb still farther bulges this eminence.

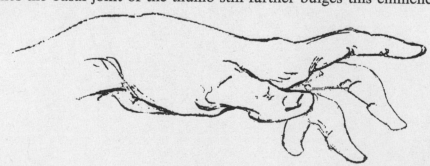

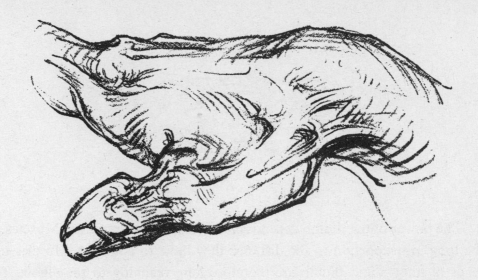

The mass of the hand sets an an angle across the end of the forearm; the mass of the thumb sets at an angle across the base of the hand.

THE MUSCLES OF THE THUMB
1 Long extensor of the thumb
2 Short extensor of the thumb
3 Long abductor of the thumb

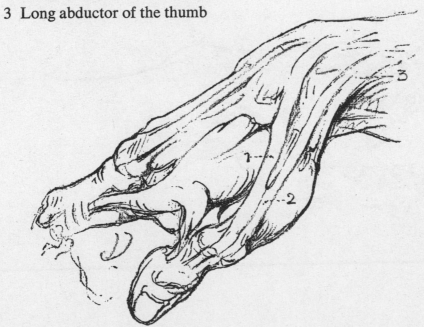

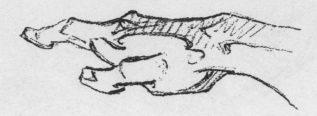

The power of the thumb depends chiefly on its short muscles. Muscles must be long in proportion to the distance they have to contract. Muscles to the ends of fingers and thumb are therefore long reaching to the elbow. Those of the first and middle segments of the thumb (the latter with very little movement) are short and are developed about the segment and across the palm, where they act in direct line with the movement of the bone. The power produced by muscular action depends on the leverage and the angle at which it is applied. The long muscles act at an acute angle, with rapid movement but little power.

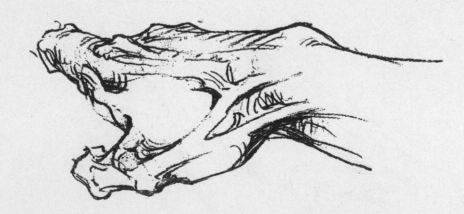

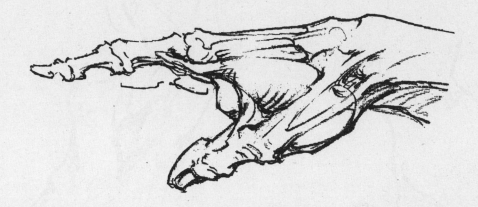

These short muscles being in direct line produce great power but are relatively slow. The fastest movement of the thumb is therefore slow compared to that of the fingers; its power is proportionately greater.

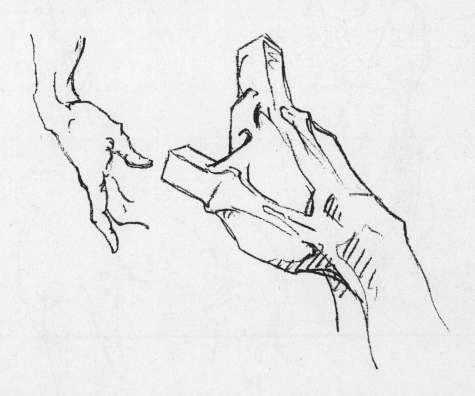

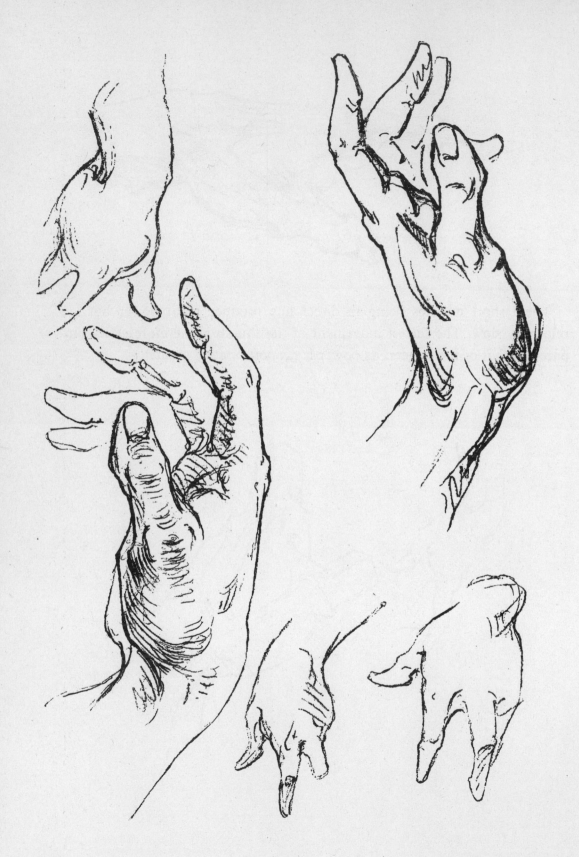

THUMB SIDE OF THE HAND

Distinguishable under the skin of the thumb (palmar side) are three muscles, sometimes a fourth. These, from the back forward, are the fat opponens, hugging the bone; the broad abductor, forming the bulk of the mass; and the thin flexor brevis, inside. Deeper and reaching transversely across the hand is the adductor muscle, which throws the skin of the palm into a bulging wrinkle when the thumb is flattened back.

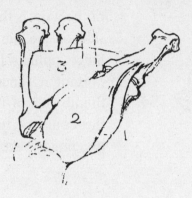

1 Opponens pollicis
2 Abductor pollicis
3 Adductor transversus

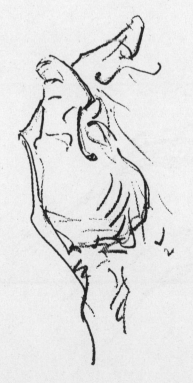

LITTLE FINGER SIDE
OF THE HAND

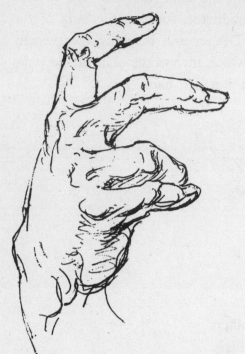

The little finger side of the hand is the pushing side; the little finger side of the wrist is the heel side. The thumb side of the hand is the pulling side. Since pulling is so much more important a function of the hand, the thumb side of hand and wrist and all the bones of that side, with the first two fingers, are larger.

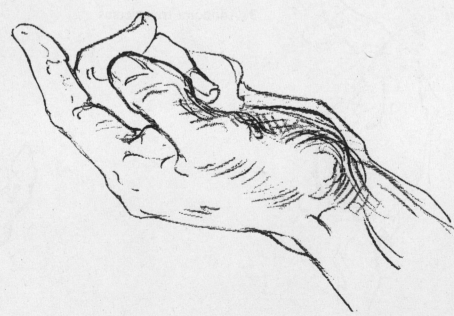

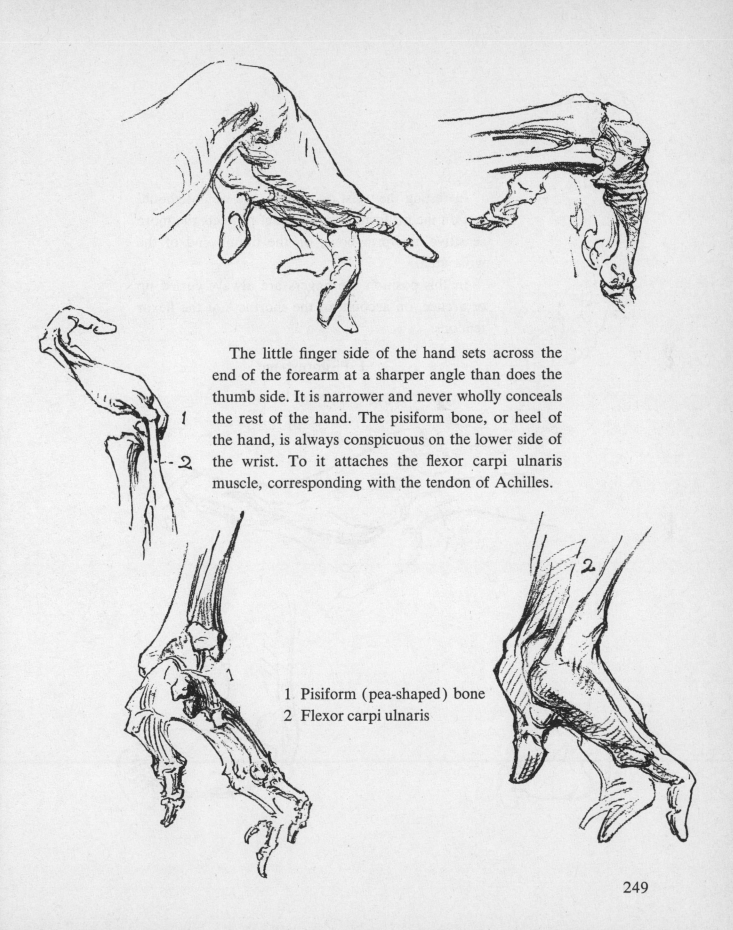

The little finger side of the hand sets across the end of the forearm at a sharper angle than does the thumb side. It is narrower and never wholly conceals the rest of the hand. The pisiform bone, or heel of the hand, is always conspicuous on the lower side of the wrist. To it attaches the flexor carpi ulnaris muscle, corresponding with the tendon of Achilles.

1 Pisiform (pea-shaped) bone
2 Flexor carpi ulnaris

249

In resting the wrist on a table, the weight should rest on the pisiform bone. Instinct protects the more sensitive unciform bone, on the thumb end of the wrist arch.

In this position the fingers are always curled up or arched, on account of the shortness of the flexor tendons.

1 Pisiform bone

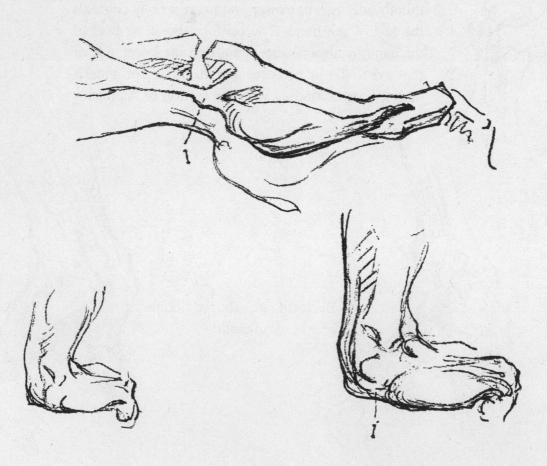

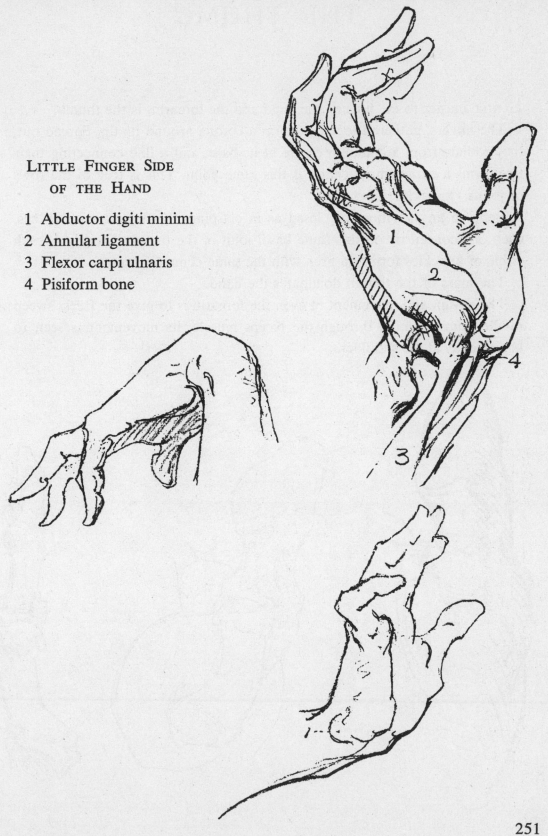

LITTLE FINGER SIDE
OF THE HAND

1 Abductor digiti minimi
2 Annular ligament
3 Flexor carpi ulnaris
4 Pisiform bone

251

THE THUMB

DRILL master to the fingers, the hand and the forearm, is the thumb.

The fingers, gathered together, form a corona around its tip. Spread out, they radiate from a common centre at its base; and a line connecting their tips forms a curve whose centre is this same point. This is true of the rows of joints (knuckles) also.

Bent, in any position, or closed as in clasping, the fingers form arches, each one concentric on this same basal joint of the thumb. Clenched, each circle of knuckles forms an arch with the same common centre.

The mass of the thumb dominates the hand.

The design and movement of even the forearm is to give the freest sweep to the thumb; while, through the biceps muscle, its movement is seen to begin really at the shoulder.

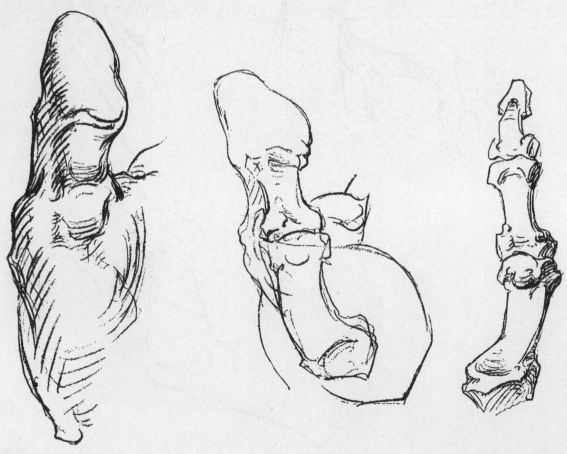

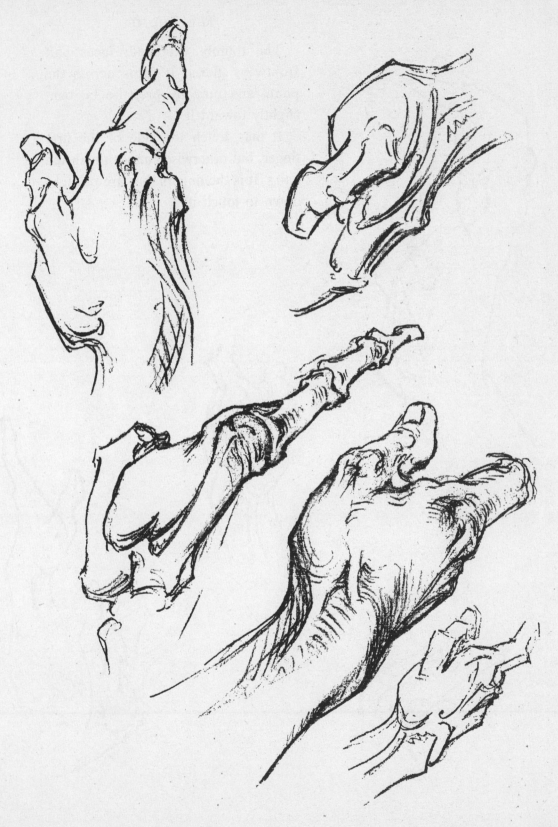

THE THUMB

The thumb, extended, faces half frontways; flexed it faces across the palm, and may by pressure be bent slightly toward it.

It may touch the side of the first finger, but otherwise cannot touch the palm. It is the fingers that are brought down to touch it.

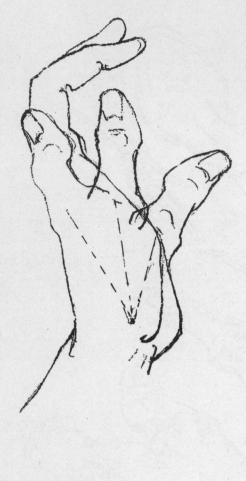

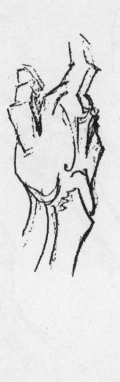

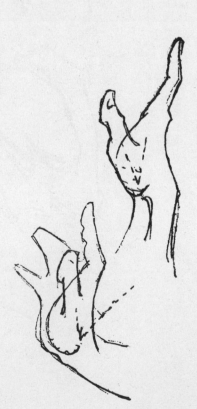

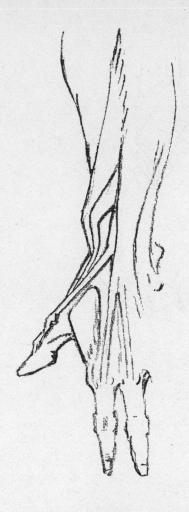

Anatomy
of the Thumb

The thumb has three segments and as many joints. Its bones are heavier than those of the fingers, its joints more rugged.

Its last segment has a nail and a heavy skin pad. The middle segment has only tendons. The basal segment is a pyramidal mass of muscle reaching to the wrist, the "line of life" of the palm, and the base of the first finger.

The superficial muscles of this mass are a fat one, a broad one, and a thin one. The fat muscle hugs the bone (opponens), the broad one forms the bulk of the pyramid (abductor) and the thin one lies inside, toward the index finger (flexor brevis).

Between the thumb and first finger the skin is raised into a web, which is bulged, especially when the thumb is flattened, by the abductor pollicis muscle.

255

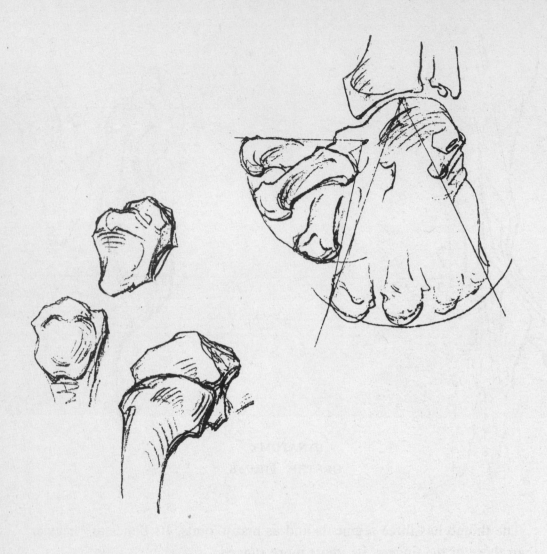

Saddle Joint of the Thumb

The range of movement of the thumb is slight—half a right angle at the base, much less at the middle joint, a right angle at the last joint.

The basal joint is a saddle joint permitting half a right angle of movement sideways, and very much less fore and aft. The middle joint is extra large in proportion to others on account of its exposed position, permitting slight flexion and very slight torsion. It is built for strength rather than movement. The last joint with its long muscle reaching to the elbow has a right angle of movement (this long muscle must take up the slack of the other joints, including the wrist, also).

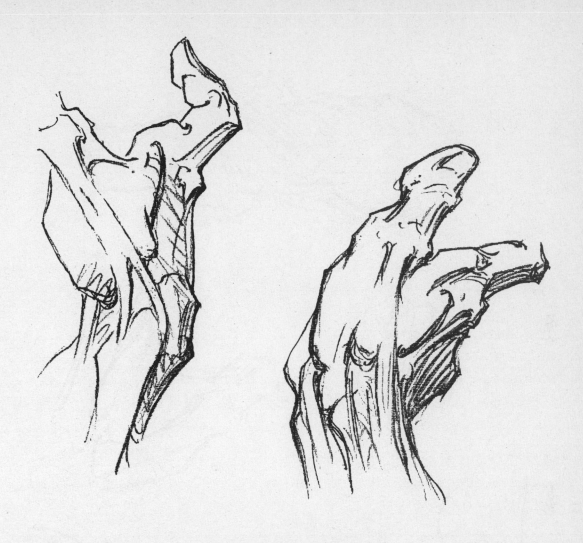

MASSES OF THE THUMB

The thumb is pyramidal at the base, narrow in the middle, pear-shaped at the end. The ball faces to the front more than sideways. It reaches to the middle joint of the first finger.

The last segment bends sharply back, carrying the nail. Its skin pad, broad at the base, gives it an appearance not unlike a foot, expressing its pressure-bearing function.

The middle segment is square with rounded edges, smaller than the other two, with a small pad.

The basal segment is rounded and bulged on all sides except where the one is superficial at the back.

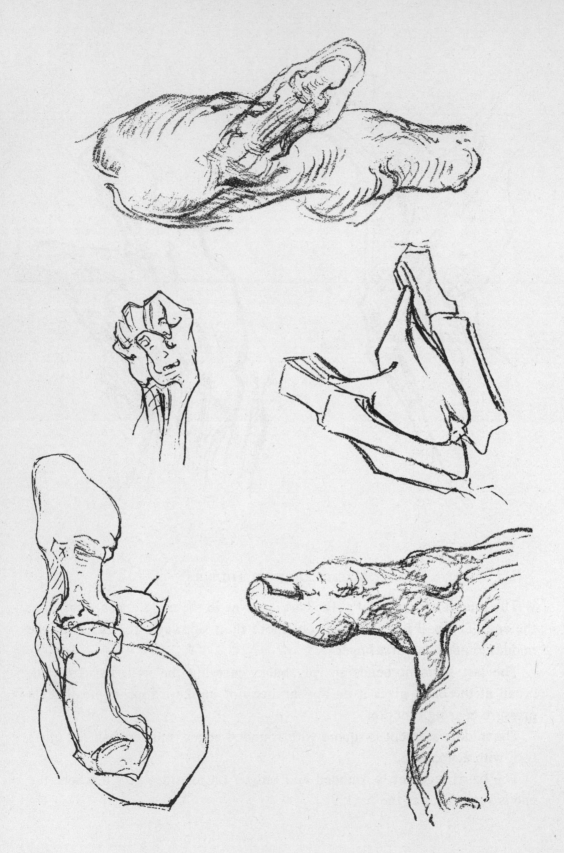

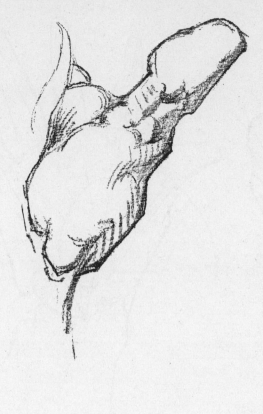

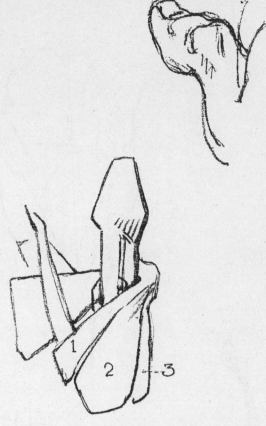

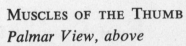

MUSCLES OF THE THUMB
Palmar View, above

1 Flexor pollicis brevis
2 Abductor pollicis
3 Opponens pollicis

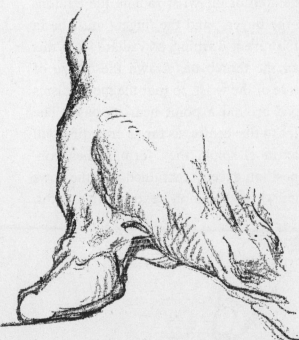

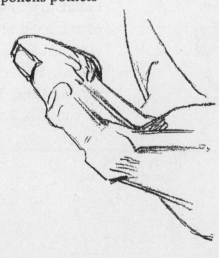

THE FINGERS

From the centre of the arch of the wrist radiate the tendons of the long muscles to the fingers; and the fingers must be in line with their power, to prevent warping, so radiate from this point. But the power of the thumb has drawn the centre of radiation a trifle to its side of the wrist, so that the mechanisms of the hand are grouped around a point near its base. The clenched fingers all point to this centre, as far as crowding will permit. Half closed, as in clasping, they form arches converging there. In any position except a strained one the rows of knuckles form arches whose common centre is this point.

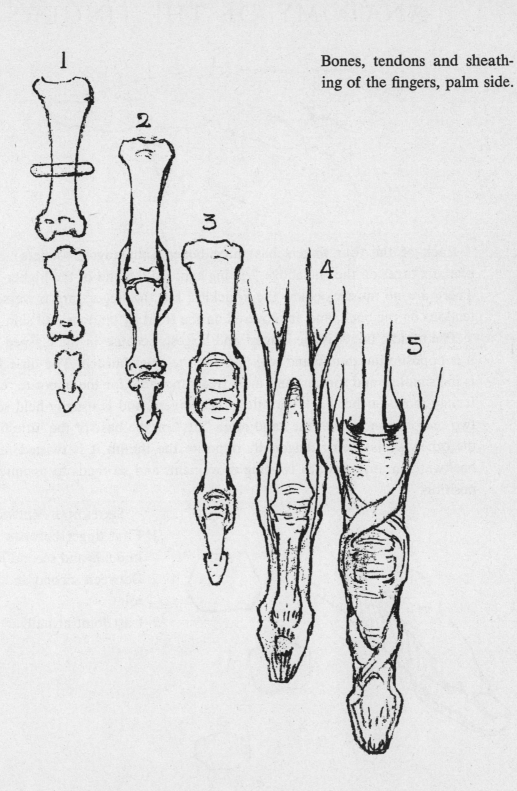

Bones, tendons and sheathing of the fingers, palm side.

261

ANATOMY OF THE FINGERS

Each of the four fingers has three bones (phalanges, soldiers). Each phalanx turns on the one above, leaving exposed the end of the higher bone. There are no muscles below the knuckles; but the fingers are traversed by tendons on the back, and are covered on the front by tendons and skin pads.

The middle finger is the longest and largest, because in the clasped hand it is opposite the thumb and with it bears the chief burden. The little finger is the smallest and shortest and most freely movable for the opposite reason. It may move farther back than the other fingers, and is usually held so, for two reasons; one is that the hand often "sits" on the base of the little finger; the other is that being diagonally opposite the thumb it is twisted farther backward in any outward twisting movement, and so tends to assume that position.

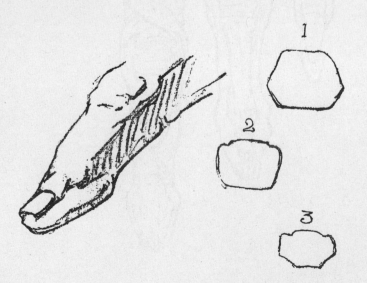

SECTIONAL VIEWS

1 First finger between knuckle and second joint
2 Between second and third joint
3 Last joint at nail

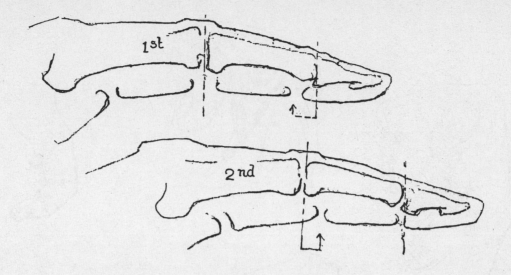

The skin pads are of approximately the same length, as necessary when the finger is tightly closed, but the segments are of different lengths; so the creases are not opposite the joints.

In the first finger the creases are beyond the knuckle, opposite the middle joint, and short of the last; in the second finger they are beyond the knuckle, beyond the second joint, about opposite the last; in the third finger they are beyond the knuckle, beyond the second. The other positions vary in different individuals.

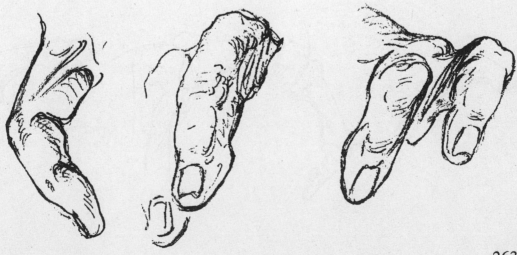

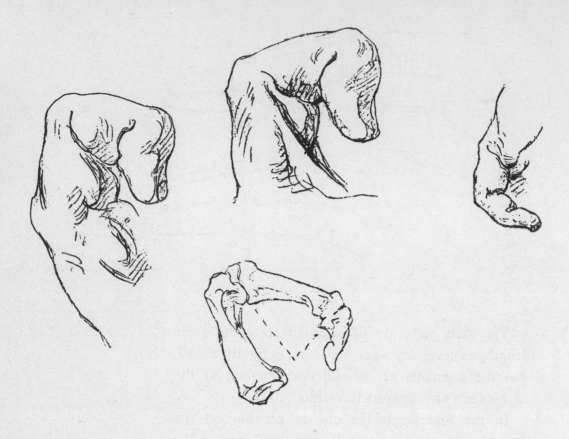

FINGERS

The joints of the fingers are built like shallow saddle joints; that is, one reaches up on the sides, the other reaches down on the front and back.

In every case it is the more distant bone that turns on the convex end of the nearer bone, leaving the end of the latter exposed in flexion.

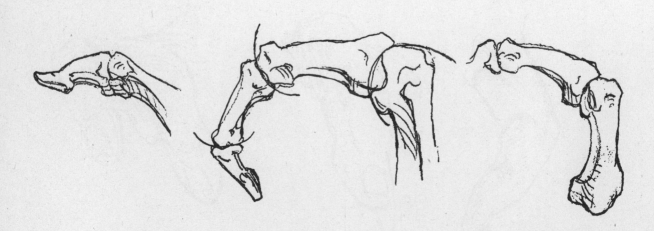

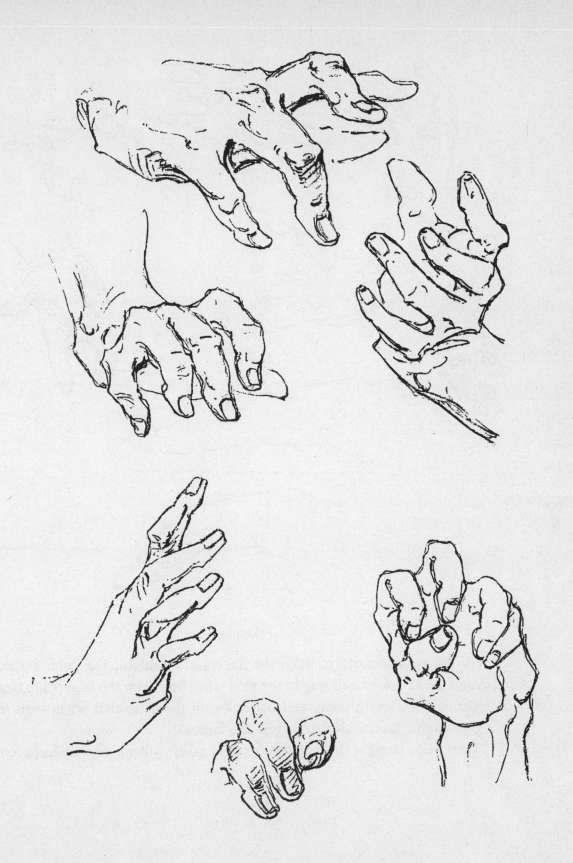

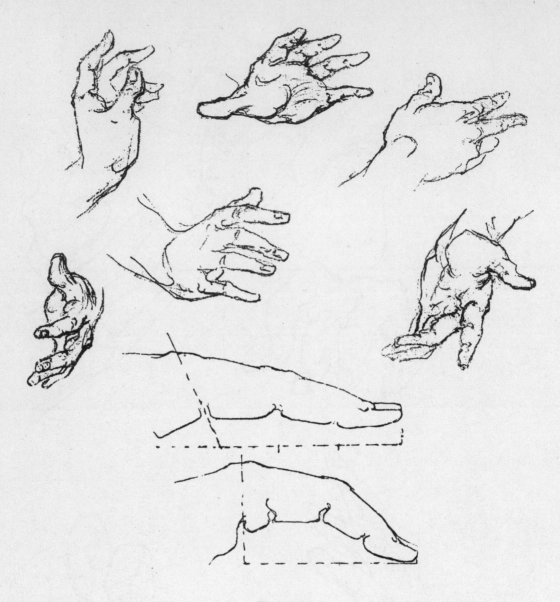

FINGERS

On the palmar surface, when the fingers are straight, the palm extends beyond the knuckles half way to the next joint; but when the fingers are bent, a portion bends with them, and belongs with them; so that when bent the fingers on the palmar side start from the knuckle.

Thus when straight the fingers have three pads; when bent they have four.

266

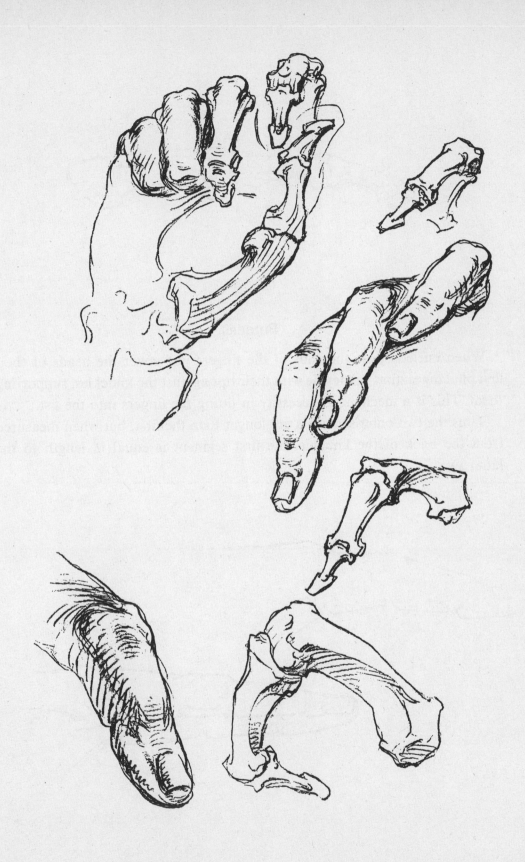

FINGERS

When curled close, the ends of the fingers just cover the heads of their first phalanges; that is, they lie with their tips against the knuckles, supporting them. This is a mechanical necessity in fitting the fingers into the fist.

Thus the two outer segments are longer than the first, but when measured from the back of the knuckle, the first segment is equal in length to the latter two.

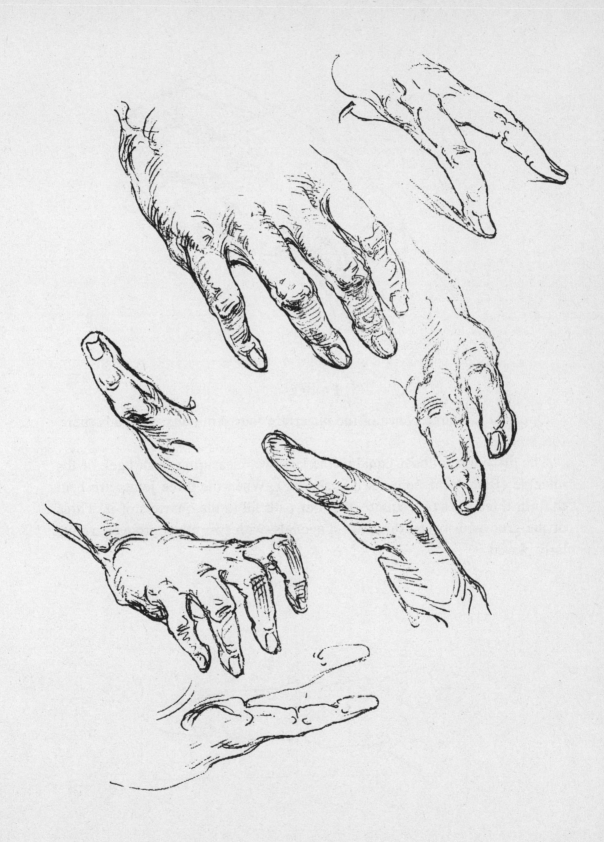

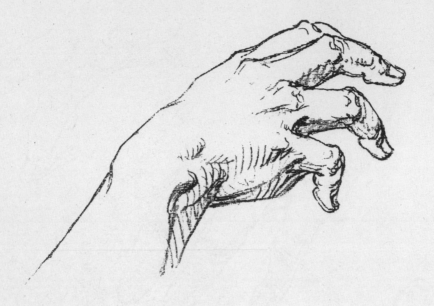

FINGERS

Opposite the three bones of the finger are four skin pads; the pads therefore smaller.

The first joint is about equal to the last two, measuring from back of the knuckle (though the bone itself is shorter). When the three joints are bent to form three sides of a square, the four pads fill in the quarters of it. Three of the grooves between them are diagonals, with two other grooves irregularly placed.

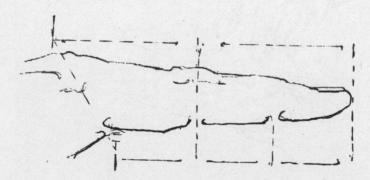

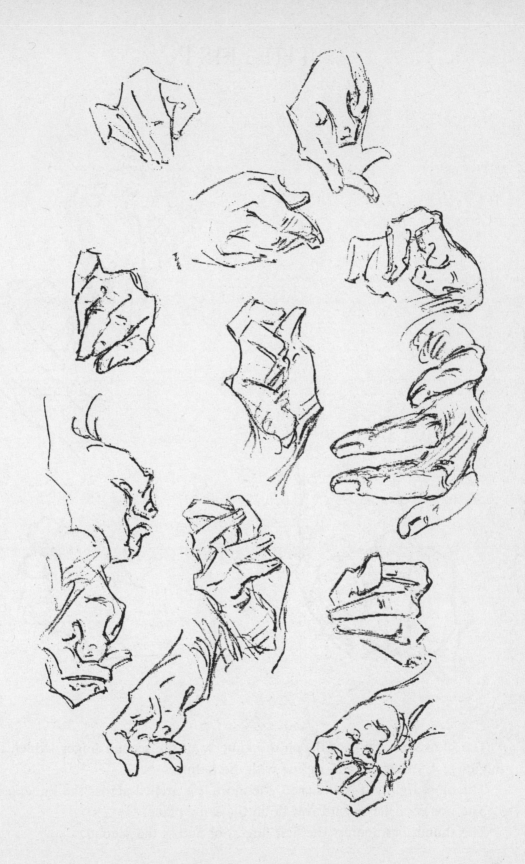

THE FIST

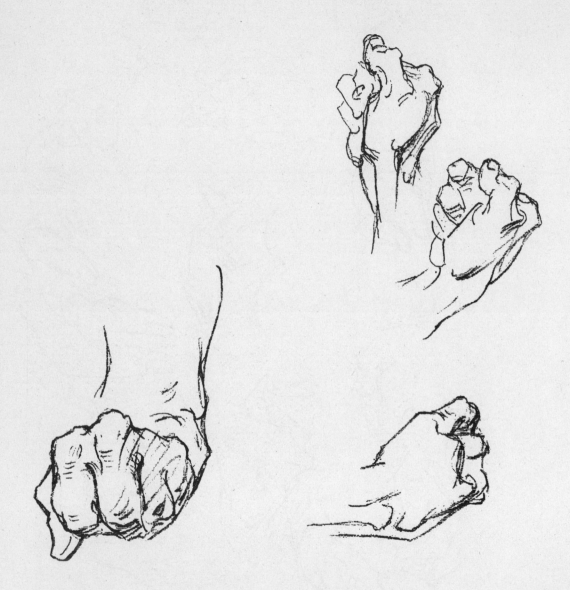

The blow with the fist falls on the knuckle of the second finger, which is the longest, strongest, and in line with the radius.

The more tightly it is clenched, the more it is arched across the knuckles.

The bones of the second row lie in the same plane.

The thumb lies against the first finger, or across the second.

272

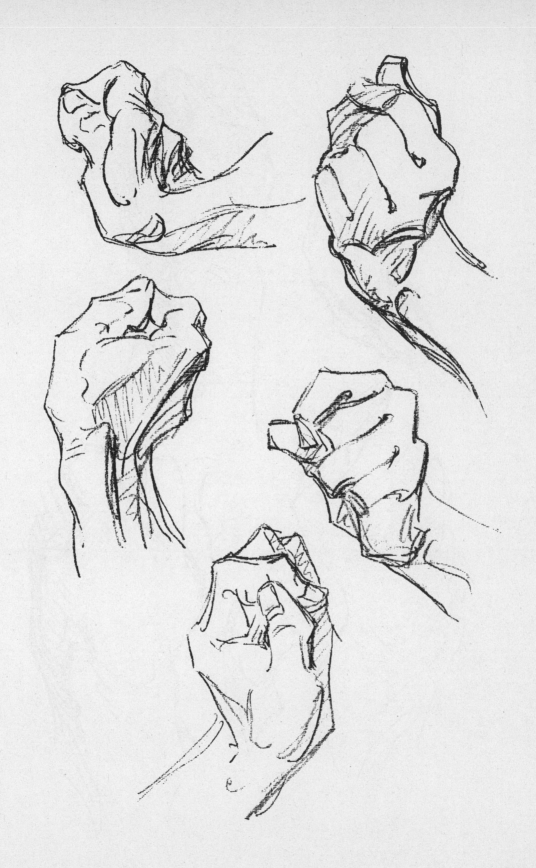

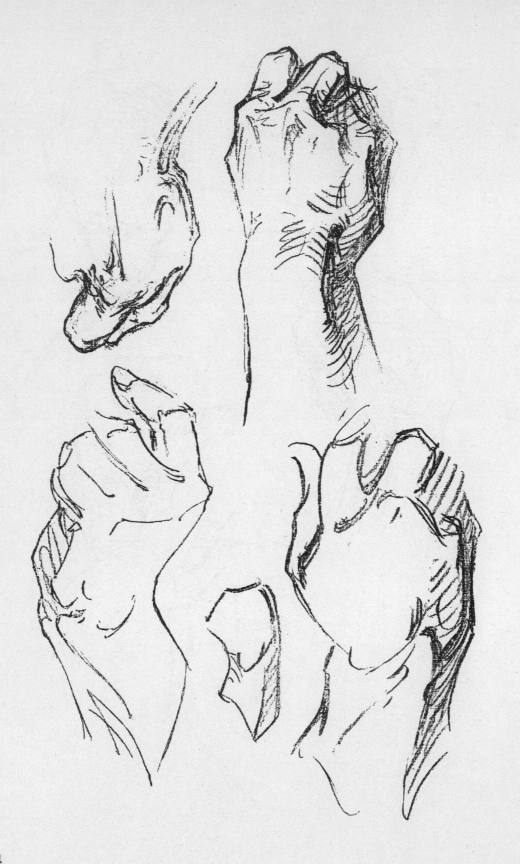

274

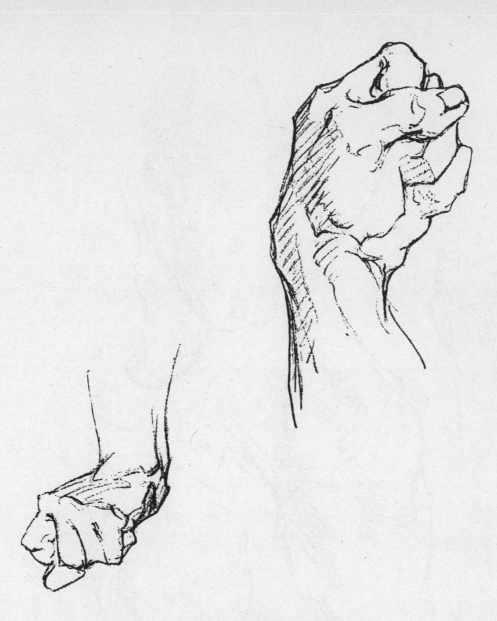

THE FIST

The hand, open, is an implement.

The hand, closed, is a weapon.

When driven forward, the second knuckle, as the most prominent, becomes the point of impact; but in clenching it is braced by the entire fist, bone, tendon and knuckle.

When driven directly forward, the second knuckle is in line with the wrist and the radius, making a straight battering ram.

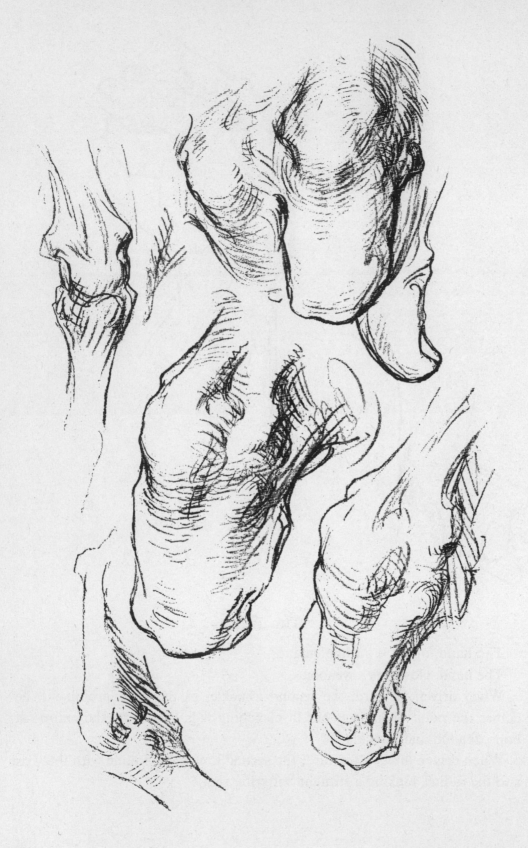

276

KNUCKLES OF THE HAND

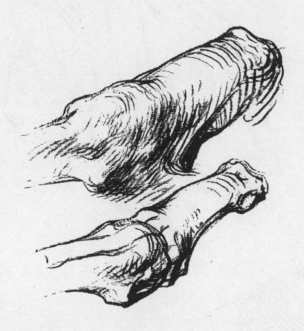

There is no muscular covering for the knuckles; only the tendons, which are half blended with them, and roughened skin.

In clenching, this skin is tightly stretched, and by contact with objects is hardened, so that in other positions it is wrinkled.

The end of the metacarpal bone is a round dome, over which fits the socket of the first phalanx. The dome is protected on the sides by square projecting flanges, which are matched by the sides of the socket. They are in the first finger set at a slight diagonal, so that there is an overhang of the phalanx, serving to protect the joint in lateral blows.

KNUCKLES

1 Tendons of the extensor digitorum communis
2 Dorsal interosseous muscles

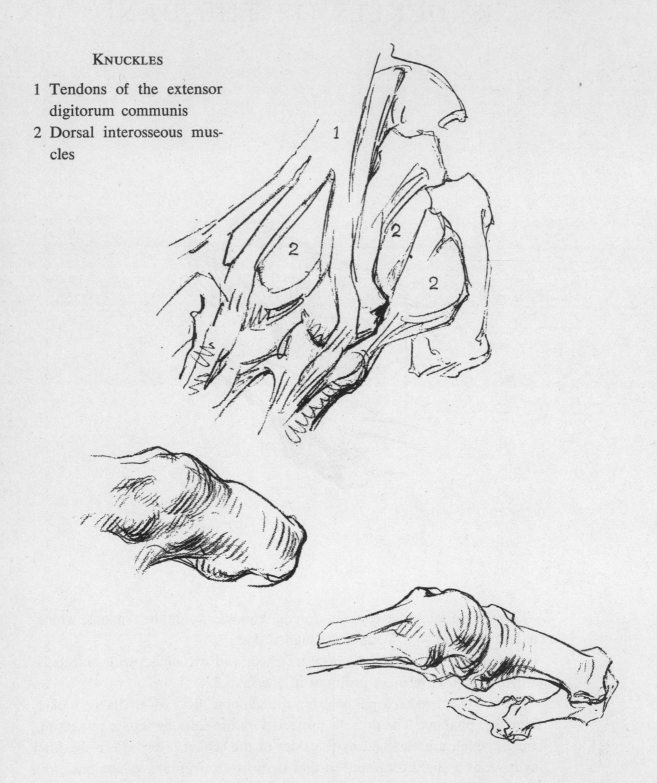

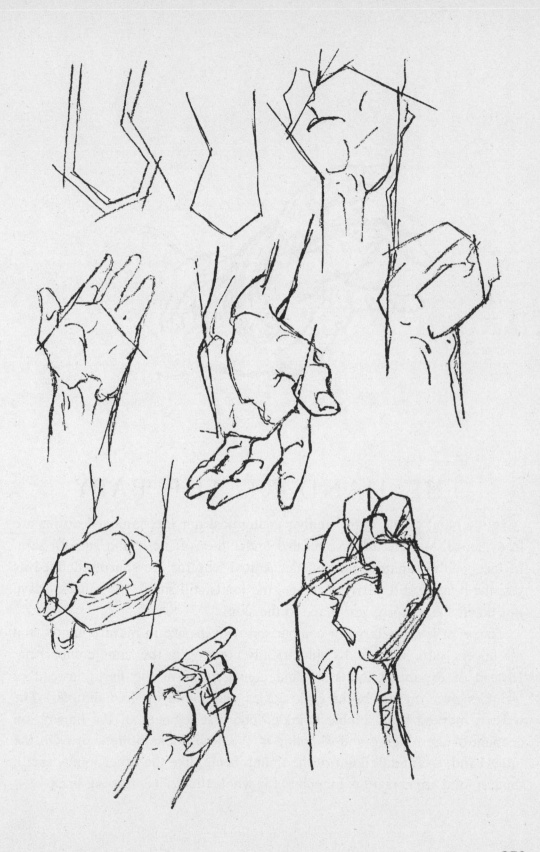

279

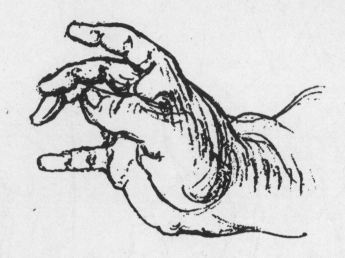

THE HAND OF THE BABY

In the hand of the baby, neither anatomical nor mechanical features are in evidence, but are alike concealed under the soft flesh and smooth skin. In fact, neither anatomical nor mechanical features are sharply defined as yet; the bone is still partly cartilage, the joints still small, the muscles have not taken shape nor given shape to the skin.

The wrist is quite large in comparison with its size in mature hands, and the fingers quite short and symmetrically tapering in the same comparison. Instead of expanded joints we find constrictions in the flesh; instead of wrinkles over on the backs of knuckles and joints we find dimples. The wrist is marked by a double wrinkle. The first segment of the fingers, on account of the bulging and dimpling of the flesh, looks quite short. On the other hand, the middle joint of the thumb being, like the other joints, small, the last joint appears quite long, and the whole thumb has flowing lines.

280

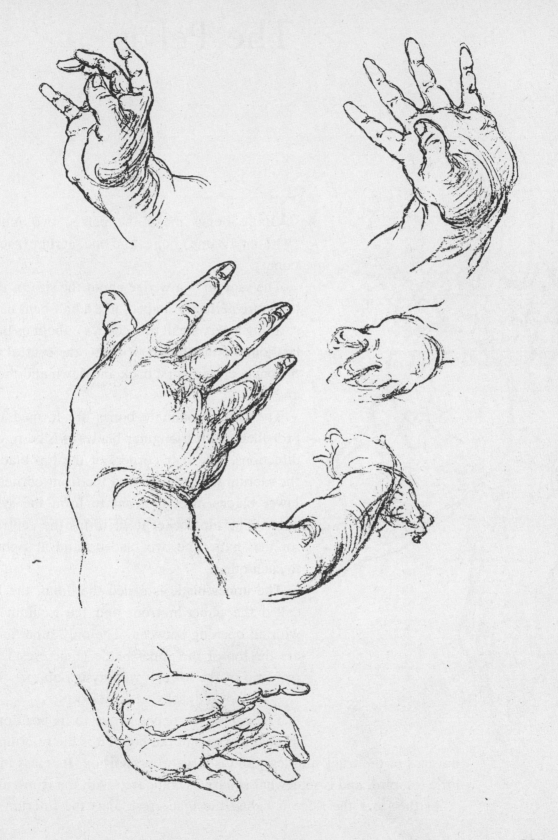

The Pelvis

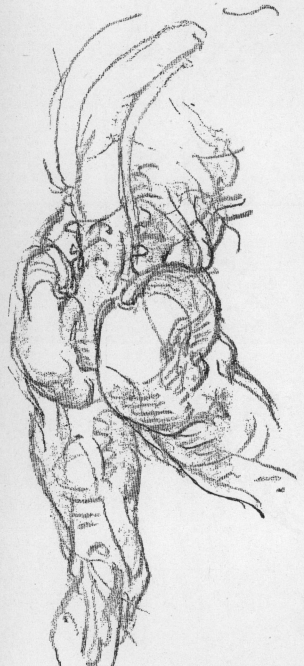

THREE bones make the pelvis; two innominate (without a name) bones and one sacrum (sacrificial) bone.

The sacrum is a wedge about the size of the hand but more perfectly shaped, like a half-bent hand, and carrying a very small tip (coccyx) about as big as the last joint of the thumb. It forms the central piece in the back, curving first back and down and then down and in.

The two innominate bones are formed like two propellers, with triangular blades twisted in opposite directions. The rear corners of the top blades meet the sacrum in the back, and the front corners of the lower blades meet in front to form the symphysis pubis. The hip socket itself forms the central point for the shaft. The two blades stand at right angles to each other.

The upper blade is called the ilium, the lower is called the pubis in front and the ischium behind, with an opening between. The only superficial parts are the top of the upper blade (iliac crest) and the front tip of the lower (symphysis pubis).

MASSES AND MARKINGS

The size of the pelvis is due to its position as the mechanical axis of the body; it is the fulcrum for the muscles of the trunk and legs, and is large in proportion. Its mass inclines a little forward, and is somewhat square as compared with the trunk above.

At the sides the ridge is called the iliac crest. It is the fulcrum for the

lateral muscles and flares out widely for that purpose, rather more widely in front than behind.

Above the rim is a roll of muscle belonging to the abdominal wall; immediately below it a groove or depression, made by the sag of the hip muscles, obliterated when these are contracted in action.

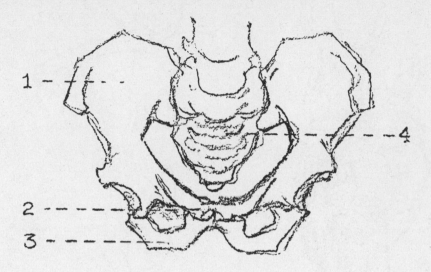

Front View

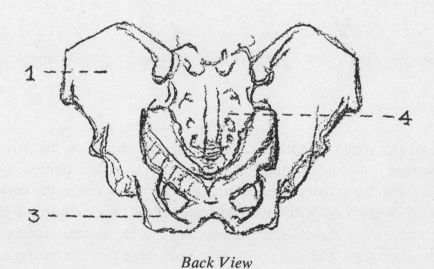

Back View

1 Ilium

2 Pubis

3 Ischium

4 Sacrum

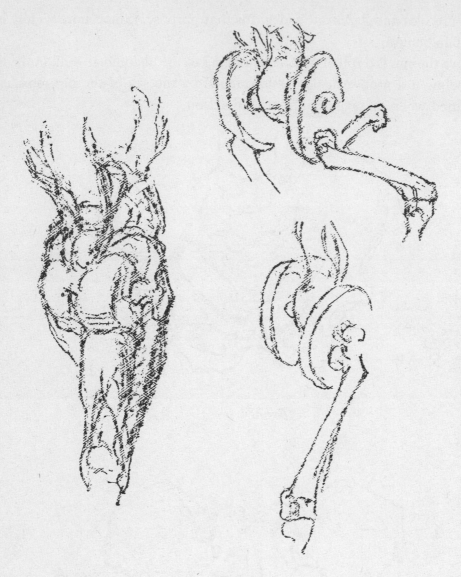

PELVIS

The greater part of the movement of a figure is based on the pelvis. Its bony basin in front supports the fleshy mass of the abdomen. Behind, a circle of bones forms the extreme lateral part, of which the sacrum is the keystone.

The muscles that are visible are all situated at the back to form the gluteal region. Only two of these are prominent; they are, the gluteus maximus and the gluteus medius. With the pelvis as a base, these two act on the femur, which acts as a crank shaft. The upper end of the femur is in the shape of a bent lever on which the whole body rests.

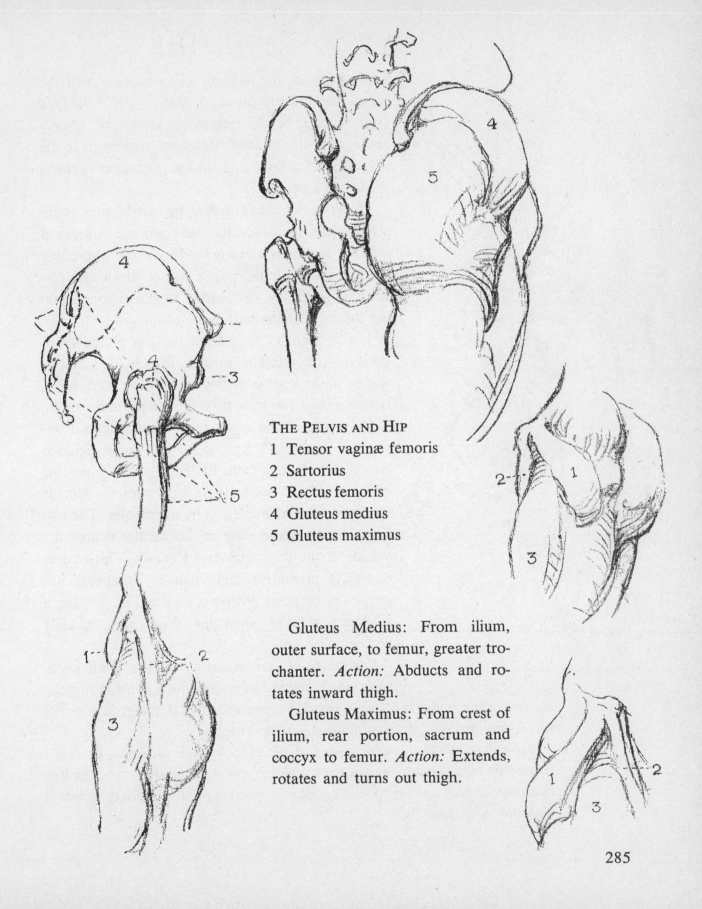

THE PELVIS AND HIP
1 Tensor vaginæ femoris
2 Sartorius
3 Rectus femoris
4 Gluteus medius
5 Gluteus maximus

Gluteus Medius: From ilium, outer surface, to femur, greater trochanter. *Action:* Abducts and rotates inward thigh.

Gluteus Maximus: From crest of ilium, rear portion, sacrum and coccyx to femur. *Action:* Extends, rotates and turns out thigh.

285

THE HIP

So great are the changes in surface form of the muscles in different positions of the hip that the iliac crest remains as the one stable landmark. It is a curve, but being beveled backward, it presents to the side view two lines and almost an angle between them at the top.

The posterior line is marked by two dimples where it joins the sacrum, and the line continues downward into the fold of the buttocks. From this whole line the gluteus maximus muscle passes down and forward, to just below the head of the thigh bone, making the mass of the buttocks and hip.

Just in front of this, from the top of the crest, descends the gluteus medius muscle, forming a wedge whose apex is at the head of the thigh bone. Between these two muscles is the dimple of the thigh.

Only part of the medius is superficial; its front portion is overlaid by the tensor fasciæ femoris muscle, which rises from the edge of the front line of the crest and descends to form with the gluteus maximus the wedge filled in by the medius. The two fasten to the dense plate of fascia that guards the outside of the thigh (ilio-tibial band). This muscle is always prominent and changes its appearance greatly in different positions of the hip, forming a U-shaped wrinkle when the thigh is completely flexed.

On the front end of the crest is a small knob, from which descends the sartorius (tailor's) muscle, longest in the body. It forms a graceful curve as it lies in the groove of the inner side of the thigh, passing to under the knee.

From just below the knob, overlaid therefore by the sartorius, descends the rectus femoris muscle, straight to the knee cap. From the knob, the line continues down and in to the symphysis, marking the boundary between abdomen and thigh.

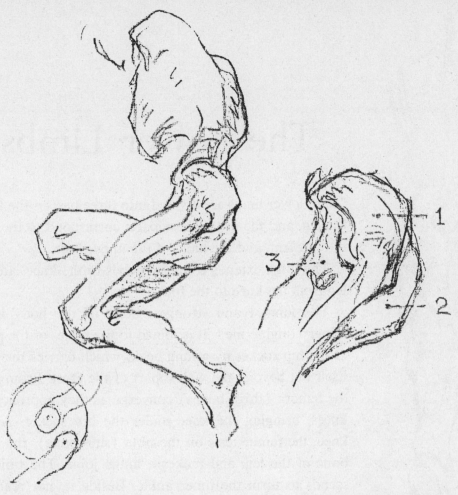

1 Gluteus medius
2 Gluteus maximus
3 Tensor vaginæ femoris

MUSCLES OF THE HIP

Nature has provided a perfect system of columns, levers and pulleys to which cords and muscles are attached. When contraction takes place, these muscles and their tendons pull, twist or turn, the movable bones. The hip joint is a strictly machine-like contrivance. It has at its connection with the hip, a ball and socket joint and a hinge joint at the knee. The muscles at the hip give a wheel-like movement. Those muscles that pass to the knee parallel the thigh bones to bend the knee.

The Lower Limbs

THE lower limbs are divided into three parts—the thigh, the leg, and the foot. These parts correspond to the arm, the forearm, and the hand of the upper limb.

The thigh extends from the pelvis to the knee, and the leg from the knee to the foot.

The longest and strongest bone of the body is the femur (thigh bone). It is joined to the bones of the pelvis at the hip socket by a long neck, which carries the shaft itself out beyond the widest part of the crest. From there the femora (thigh bones) converge as they approach the knees, bringing the knee under the hip socket. At the knee, the femur rests on the tibia (shin bone), the main bone of the leg, and makes a hinge joint. The tibia descends to form the inner ankle. Beside it, not reaching quite to the knee, is the fibula, the second bone of the leg, which descends to form the outer ankle. It is located on the outside, and is attached to the tibia at the top and bottom. These two bones are almost parallel. Above the juncture of the femur and tibia lies the patella (knee cap). This is a small bone almost triangular in shape. It is flat on its under side, and convex on the surface.

The great trochanter of the femur is the upper tip of the shaft which reaches up slightly beyond where the neck joins.

The lower portion of the femur widens to form two great hinge processes, known as tuberosities. They are on the outer and inner sides, and they are both visible.

THE THIGH and the LEG

From the head of the femur (trochanter) to the outside of the knee runs a band of tendon called the ilio-tibial band. It makes a straight line from the head of the thigh bone to the outside of the knee.

The rectus femoris muscle makes a slightly bulging straight line from just below the iliac crest to the knee cap. On either side of the latter is a twin mass of muscles. That of the outside (vastus externus) makes one mass with it, and slightly overhangs the ilio-tibial band outside. That of the inside (vastus internus) bulges only in the lower third of the thigh, and overhangs the knee on the inside.

Behind and inside of this is the groove of the thigh occupied by the sartorius muscle, passing from the ilium above to the back of the knee below.

Behind the groove is the heavy mass of the adductors, reaching two-thirds of the way down the thigh.

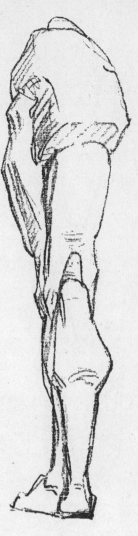

Behind groove and adductors, around the back of the thigh and to the ilio-tibial band outside, is the mass of the ham-string muscles whose tendons are found on either side of the knee at the back. It is a dual mass of muscle, dividing above the diamond-shaped popliteal space at the back of the knee, whose lower corner is formed by the gastrocnemius muscle, similarly divided.

Of the same width as the end of the thigh bone is the head of the tibia, or shin bone. Immediately below the head the shaft narrows on both sides, but on the outside and a little to the rear is the head of the fibula (which corresponds with the ulna of the forearm) more than filling out the narrowing on that side.

The ridge of the shin bone descends straight down the front of the leg, a sharp edge toward the outside, a flat surface toward the inside, which at the ankle bends in to become the inner ankle bone.

The outer bone of the foreleg (fibula) soon overlaid

289

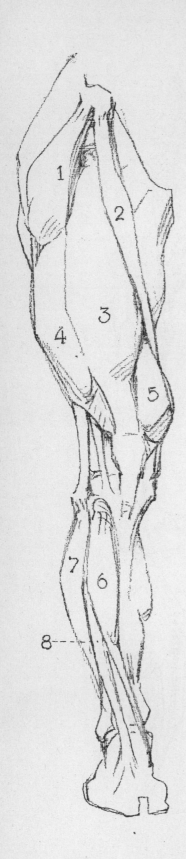

by a gracefully bulging muscular mass, emerges again to become the outer ankle bone.

On the back of the leg are two muscles. Beneath is the low, flat and broad soleus (sole fish) muscle; on top of it is the double-bellied calf muscle (gastrocnemius, frog's belly), covering its upper half, but crossing the knee joint above and helping to make the two knobs there. These two muscles unite to form the tendon of Achilles at the heel.

BONES:
Hip—Pelvis.
Thigh—Femur.
Leg—Tibia and Fibula (outside).

MUSCLES, *Front View:*
1 Tensor fasciæ latæ
2 Sartorius
3 Rectus femoris
4 Vastus externus
5 Vastus internus
6 Tibialis anticus
7 Peroneus longus
8 Extensor digitorum longus

Tensor Fasciæ Latæ (tensor fasciæ femoris): From crest of ilium, front end, to fascia lata, or ilio-tibial band. *Action:* Tenses fascia and rotates inward thigh.

Sartorius: From spine to ilium in front to tibia inside. *Action:* Flexes, abducts and rotates inward thigh.

Rectus Femoris: From anterior inferior spine of ilium to common tendon of patella. *Action:* Extends leg.

Vastus Externus: From outer side of femur to common tendon of patella. *Action:* Extends and rotates outward leg.

Vastus Internus: From inner side of femur to common tendon of patella. *Action:* Extends and rotates inward leg.

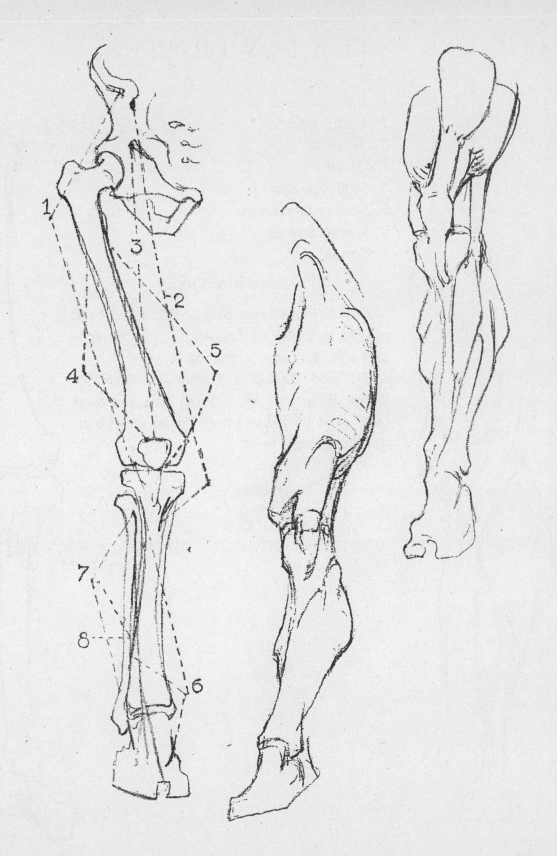

THE LOWER LIMBS

Inner View

1 Rectus femoris
2 Vastus internus
3 Sartorius
4 Gracilis
5 Semi-tendinosus
6 Semi-membranosus
7 Gastrocnemius
8 Soleus

BELOW THE KNEE

Soleus: From upper part of fibula and back of tibia to tendon of Achilles. *Action:* Extends foot and lifts body in walking.

Extensor Digitorum Communis (extensor longus digitorum pedis): From tibia and front of fibula to second and third phalanges of toes. *Action:* Extends toes.

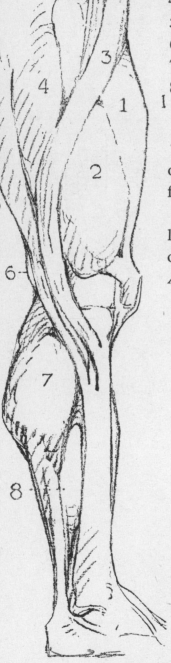

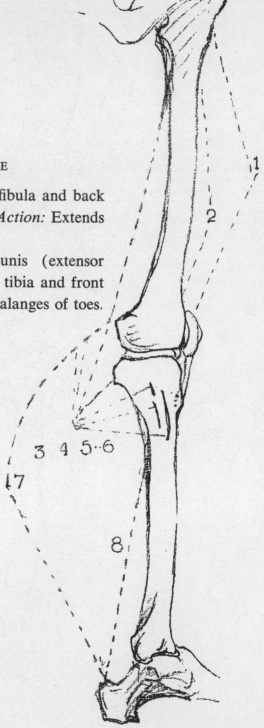

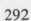

292

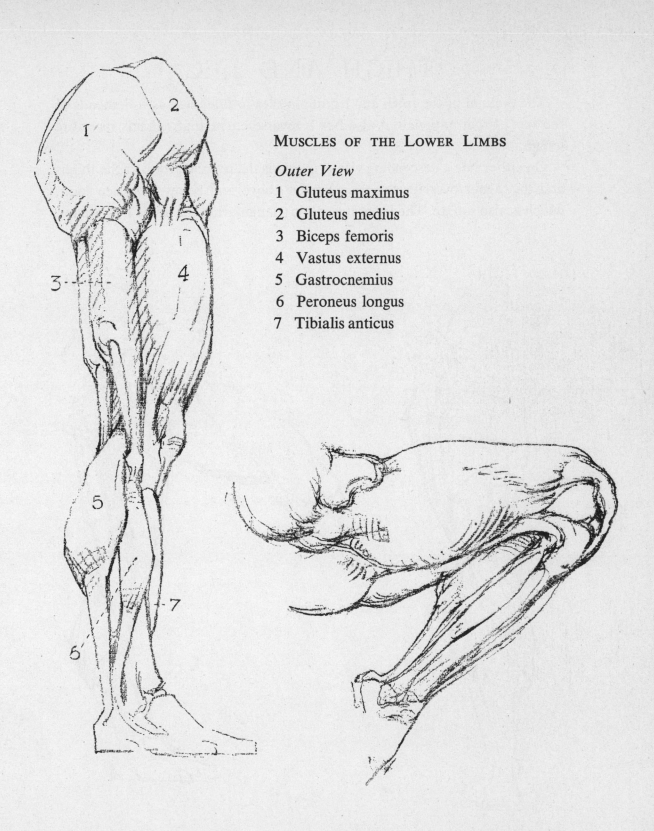

Muscles of the Lower Limbs

Outer View
1 Gluteus maximus
2 Gluteus medius
3 Biceps femoris
4 Vastus externus
5 Gastrocnemius
6 Peroneus longus
7 Tibialis anticus

293

THIGH AND LEG

The column of the thigh and leg diminishes in thickness as it descends to the foot. From any view it also has a reverse curve that extends its entire length.

On either side a descending wedge overlaps the rounded form of the thighs and this again overlaps the square form above and below the knee joint, which is also square. The leg at the calf is triangular; at the ankle it is square.

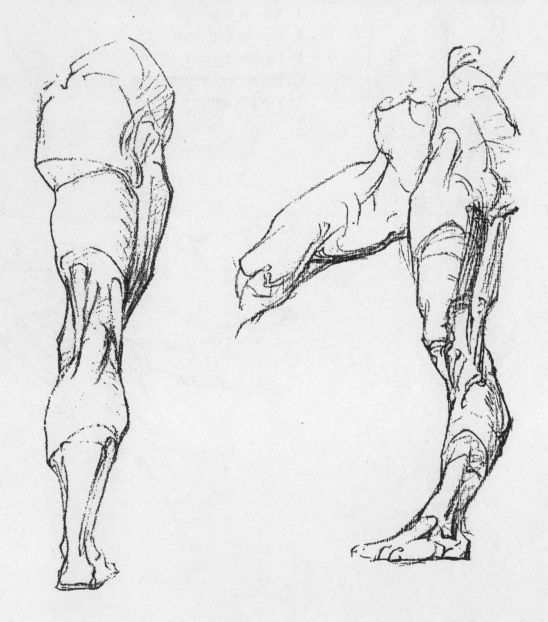

294

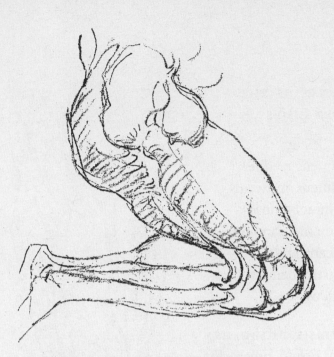

MUSCLES BELOW THE KNEE

Gastrocnemius: From tuberosities of femur to tendon of Achilles. *Action:* Extends foot, raises body in walking.

Peroneus Longus: From head and upper part of fibula passes beneath foot from outside, to base of big toe. *Action:* Extends ankle and raises outer side of foot.

Tibialis Anticus: From upper and outer two-thirds of tibia to inner side of foot. *Action:* Flexes ankle and raises inner side of foot.

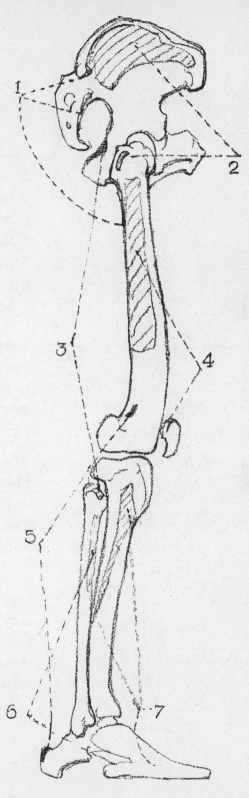

295

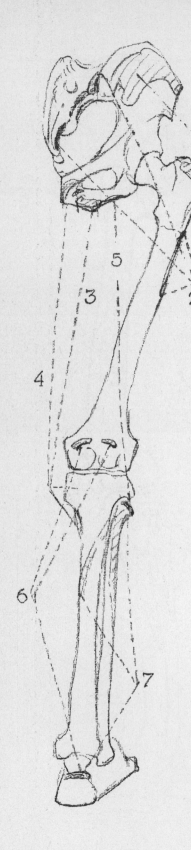

MUSCLES OF THE LOWER LIMBS

Back View:
1 Gluteus medius
2 Gluteus maximus
3 Semi-tendinosus
4 Semi-membranosus
5 Biceps femoris
6 Gastrocnemius
7 Soleus

Semi-tendinosus: From ischial tuberosity to tibia. *Action:* Flexes knee and rotates inward leg.

Semi-membranosus: From ischial tuberosity to tibia. *Action:* Flexes knee and rotates leg inward.

Biceps Femoris: Long head from ischial tuberosity; short head from femur, to head of fibula. *Action:* Flexes knee and rotates thigh outward.

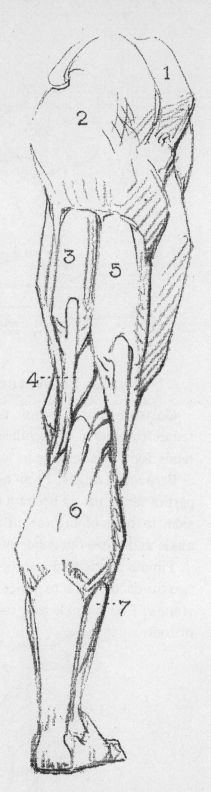

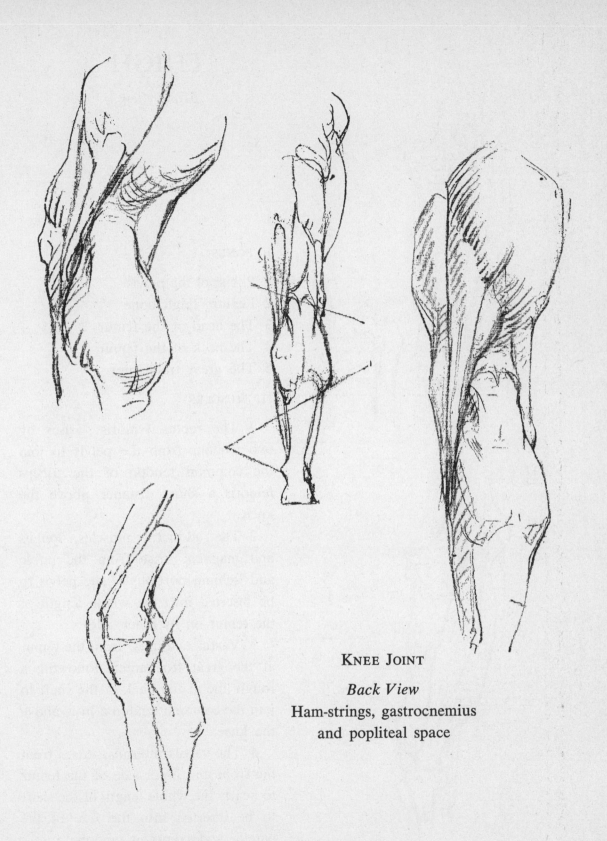

Knee Joint

Back View
Ham-strings, gastrocnemius
and popliteal space

THIGH

Front View

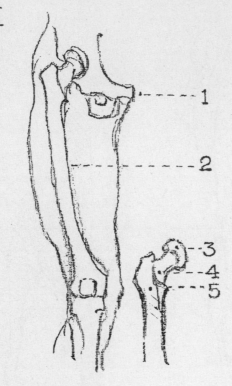

I. BONES:

1 Pubis: of the pelvis
2 Femur: thigh bone
3 The head of the femur
4 The neck of the femur
5 The great trochanter

II. MUSCLES:

1 The rectus femoris: arises by two tendons from the pelvis to join the common tendon of the triceps femoris a short distance above the knee.

2 The adductor muscles, longus and magnus: arise from the pubic and ischium portions of the pelvis to be inserted into the whole length of the femur on its inner side.

3 Vastus externus: from the femur at the great trochanter; following a rough line at the back of the shaft to join the common tendon a little above the knee.

4 The vastus internus: arises from the front and inner side of the femur to nearly the whole length of the shaft to be inserted into the side of the patella and common tendon.

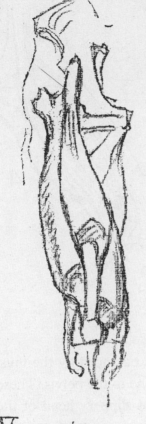

III.

The triceps of the thigh comprise the rectus, vastus externus and internus, adding the crureus, a deep seated muscle, which makes four in all. These four are together called the quadriceps extensor. They all meet above and around the knee to a common tendon that is inserted into the patella and continued by a ligament to the tubercle of the tibia.

The rectus is seen above as it emerges from between the tensor vaginæ femoris and the sartorius. From here it descends vertically on the surface of the thigh to join to its tendon above the knee. The rectus muscle bulges out at a much higher level than the muscles on either side. The outer muscle ends as a triangular tendon to enter the patella above the knee. The inner is placed quite low on the thigh and seen distinctly at its lower margin. It passes round the inner side of the knee to its insertion into the patella.

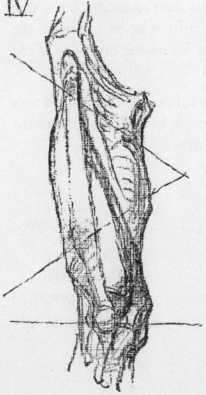

IV.

The human body is provided with a system of levers and pulleys by which muscles pull on the movable bones. The thigh swings backward as well as forward. When in action, all the muscles that surround the hip joint are geared and set in motion. The triceps of the thigh like the triceps of the arm is composed of three muscles that act together. When they pull they extend the leg on the thigh.

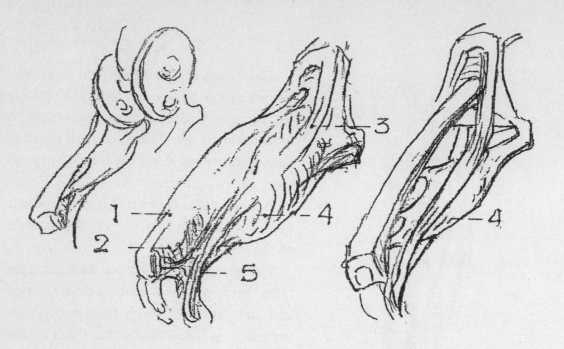

The thigh bone is the most perfect of all levers, it is balanced by the muscles that pass up from the "crank shaft" of the thigh bone to the pelvis. These muscles work against one another in turning the round slippery head of the thigh bone in the socket. The muscles parallel the shaft to control the action of the knee joint. The extensors of the leg are in front or on top when the thigh is drawn upward, while those that flex the leg on the thigh are at the back.

The sartorius arises from the crest of the ilium. It sweeps downward in a sinuous curve across the thigh, in a flattened tendon as it wraps around the inner surface of the knee to its insertion on the tibia.

INNER VIEW

1 Rectus
2 Vastus internus
3 Sartorius
4 Adductor
5 Hamstrings

OUTER VIEW

1 Hamstrings
2 Rectus femoris
3 Biceps femoris
4 Vastus externus

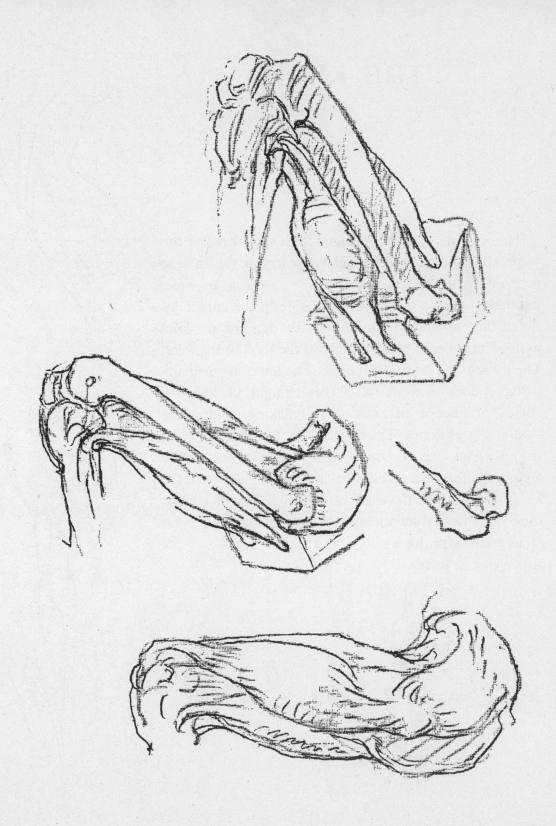

301

THE KNEE

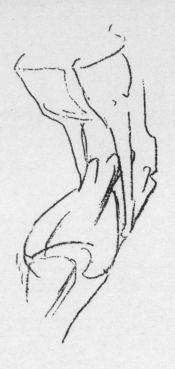

Think of the knee as a square with sides beveled forward, slightly hollowed in back and carrying the kneecap in front. When the knee is straight its bursa, or water mattress, forms a bulge on either side in the corner between the cap and its tendon, exactly opposite the joint itself. The kneecap is always above the level of the joint. The back of the knee, when bent, is hollowed by the hamstring tendons on either side. When straight, the bone becomes prominent between them, making, with these tendons, three knobs. The inside of the knee is larger, and the knee as a whole is bent convex toward its fellow. The hip socket, the knee and the ankle are all in line when the leg is straight, but the shaft of the thigh bone is carried some distance out by a long neck, so that the thigh is set at an angle with the leg.

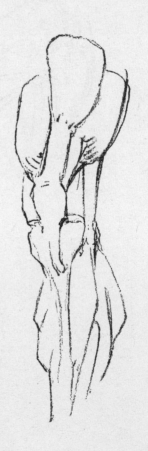

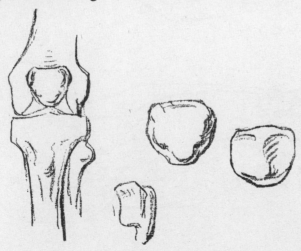

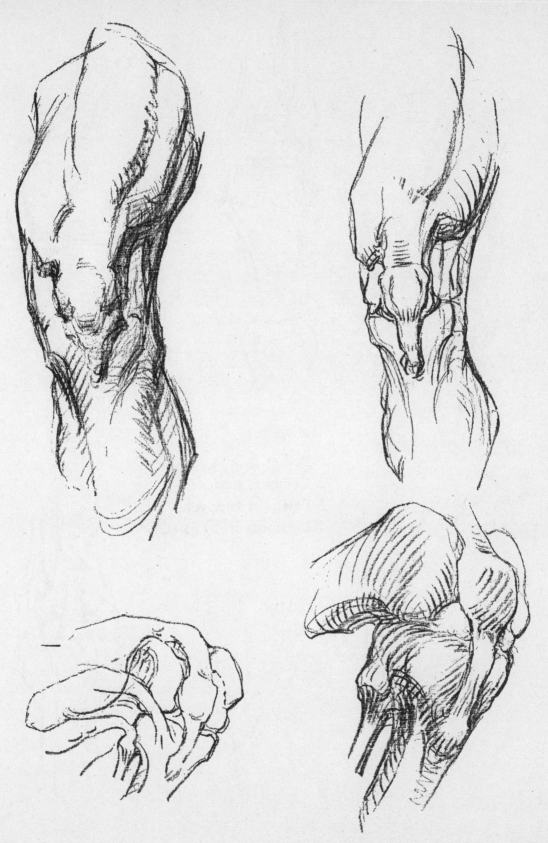

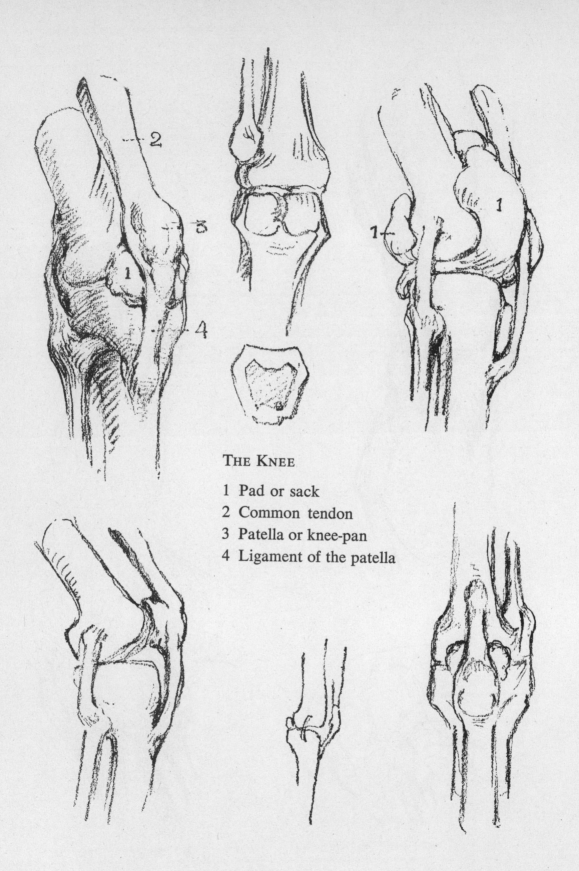

THE KNEE

1 Pad or sack
2 Common tendon
3 Patella or knee-pan
4 Ligament of the patella

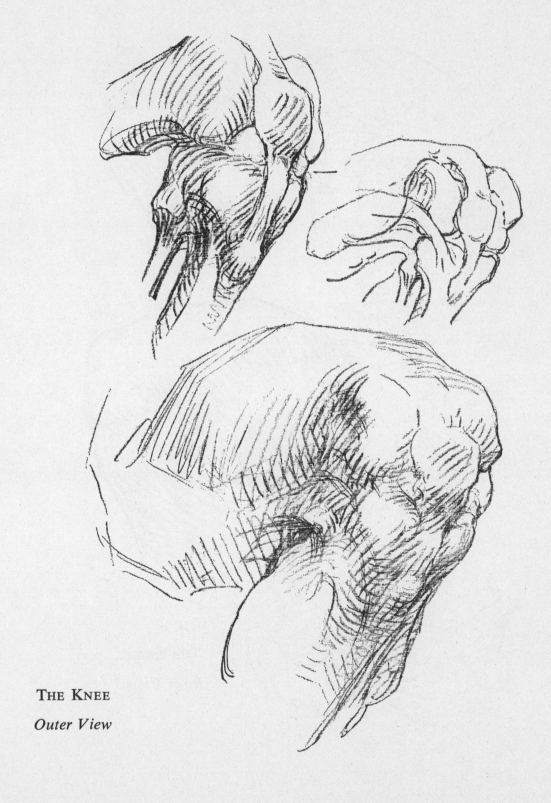

THE KNEE

Outer View

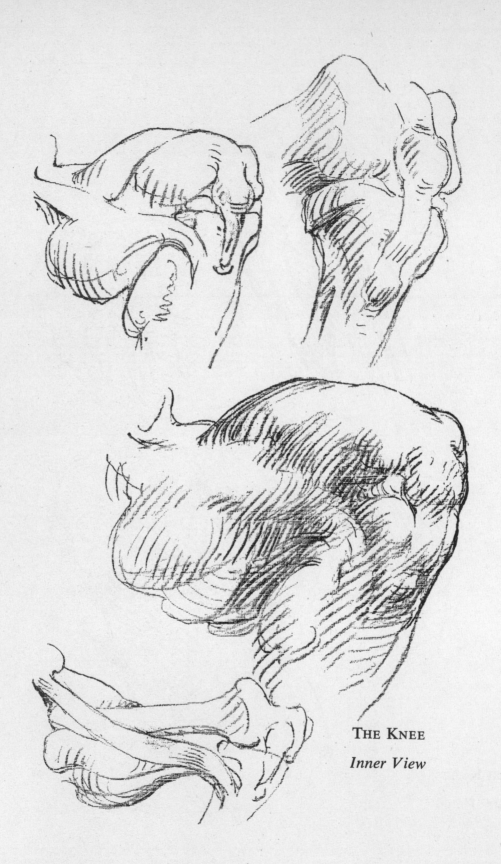

THE KNEE

Inner View

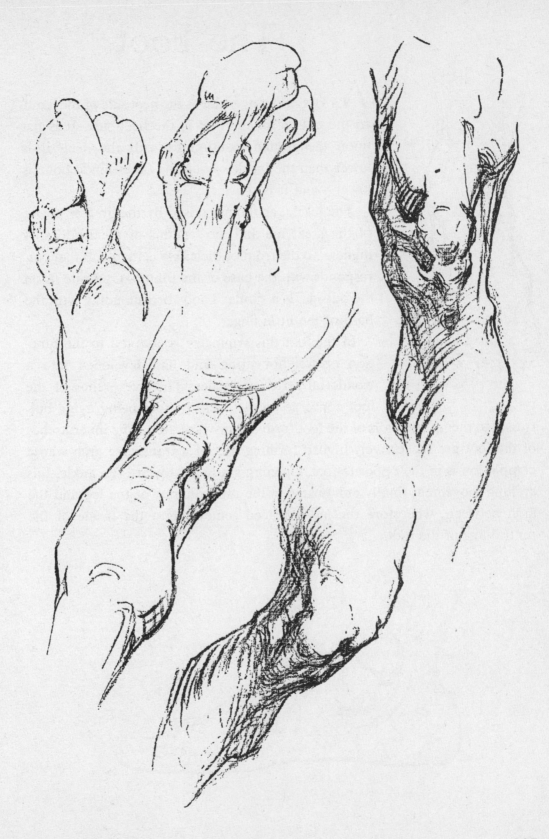

The Foot

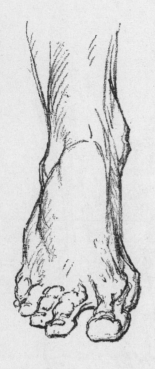

As the little finger side is the heel side of the hand, so the outside of the foot is the heel side. It is flat upon the ground, continuous with the heel; it is lower than the inside—even the outer ankle bone is lower—and it is shorter.

The inside, as though raised by the greater power of the great toe and the tendons of all the toes, is higher. To the front of the ankle is the knob that corresponds with the base of the thumb. Opposite it, on the outside, is a similar knob corresponding with the base of the little finger.

In the foot this symmetry is adapted to the function of weight-bearing and has developed into a wonderful series of arches. The five arches of the foot converge on the heel; the toes being flying buttresses to them. The balls of the foot form a transverse arch. The inner arches of the foot are successively higher, forming half of a transverse arch whose completion is in the opposite foot. Opening gradually toward the ankle, this arching movement finally culminates in the two columns of the leg and the arch between; wherefore the leg is placed somewhat to the inside of the central line of the foot.

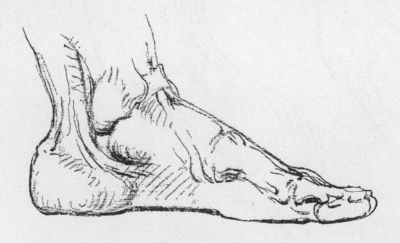

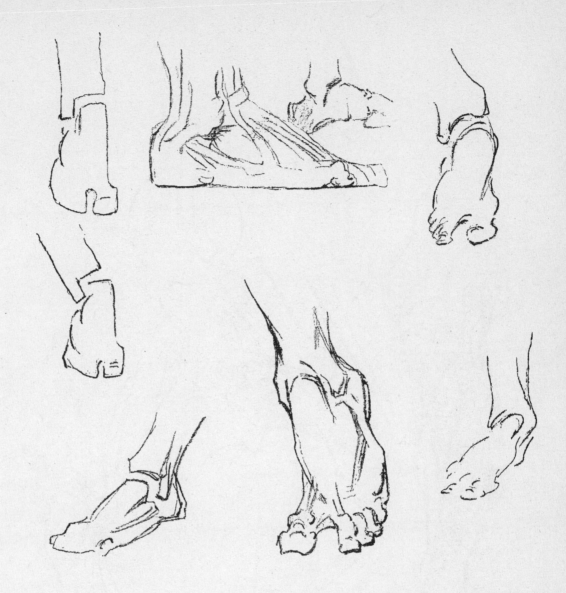

Movements

In all positions, the foot tends to keep itself flat with the ground, the arches of the foot changing accordingly. In action, the foot comes almost into straight line with the leg, but when settling upon the ground, the outer or heel side strikes first and the whole foot settles toward the inside.

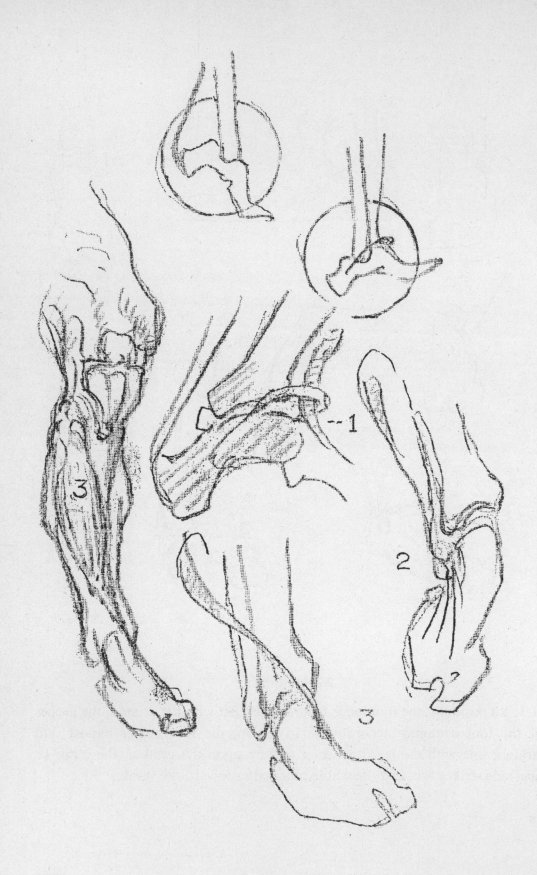

ABDUCTION AND ADDUCTION

Turning the foot inward toward the body is called adduction. Abduction means turning away. Abduction and adduction are controlled by the tendons that pass round the inner and outer ankles. The tendons that pass round the outer ankle bone pull the foot in an outward direction. The tendons that pass round the inner ankle bone turn the foot in.

The foot is also capable of turning and elevating its inner border. The muscle that causes this movement passes from the outer to the inner side of the leg. The tendon passes over the arch of the foot to the base of the metatarsal of the great toe and is called the tibialis anticus.

1 The extensors as they pass under the annular ligament.

2 Tendons of both the long and short peroneals pass round the outer ankle to the outer side of the foot.

3 The tibialis anticus passes in front of the inner ankle to be inserted into the base of the great toe.

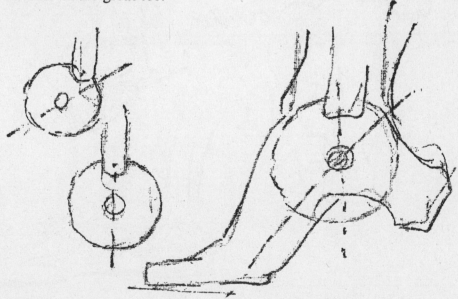

THE FOOT

Inner View

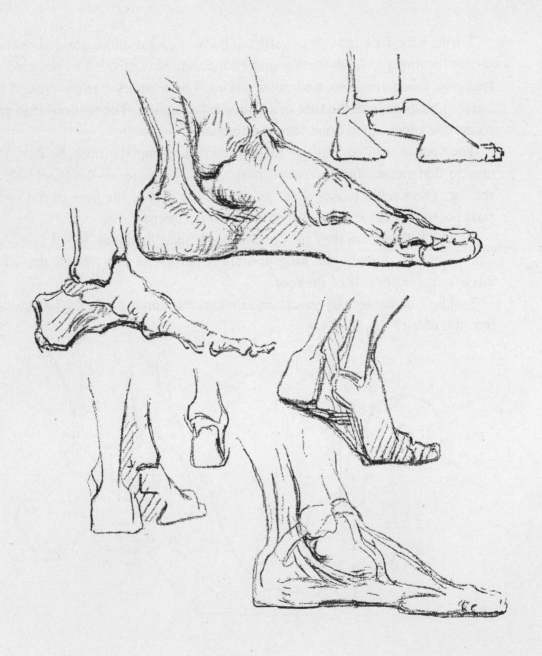

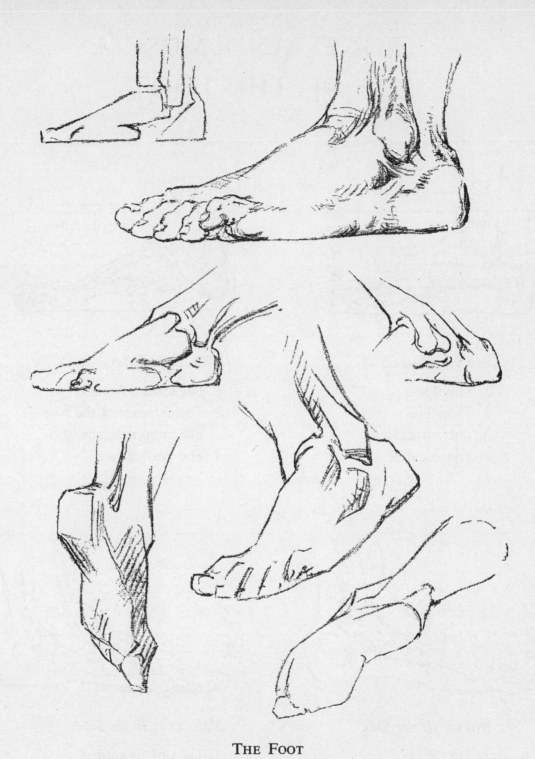

THE FOOT

Outer View

Interlocking of the ankle with the foot

BONES AND MUSCLES
OF THE FOOT

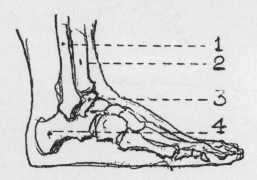

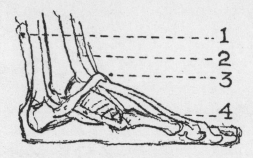

BONES: *Outer Side*

1 The fibula
2 The tibia
3 The astragalus
4 The oscalcis

MUSCLES: *Outer Side*

1 The tendon Achillis
2 The extensor of the toes
3 The annular ligament
4 The peroneus

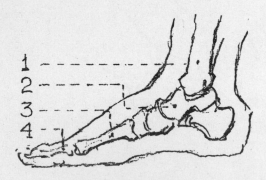

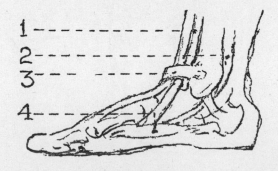

BONES: *Inner Side*

1 The tibia
2 The astragalus
3 The metatarsal
4 The phalanges

MUSCLES: *Inner Side*

1 The tibialis anticus
2 The flexor pollicis
3 The annular ligament
4 The abductor pollicis

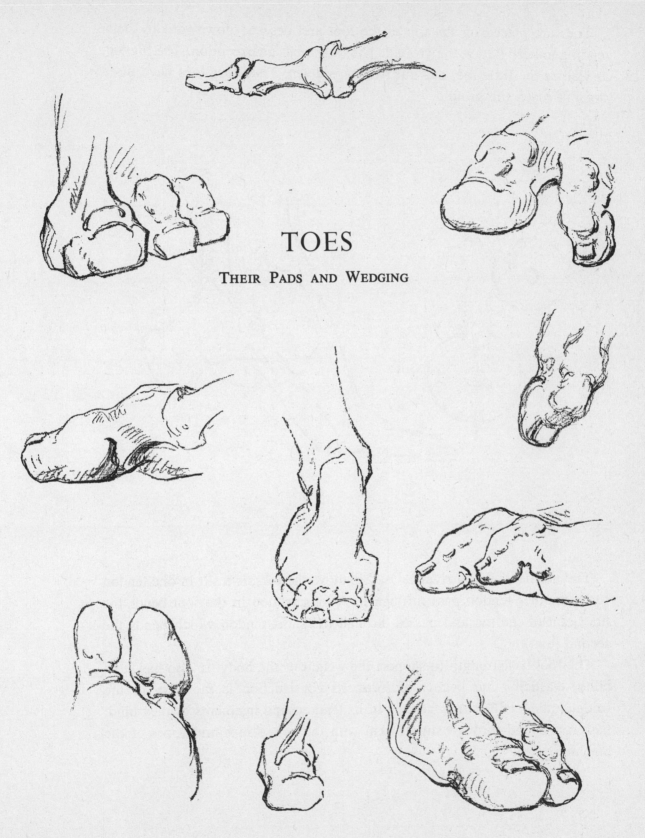

TOES

Their Pads and Wedging

Toes are placed on the top of the foot and descend downward by steps tending to keep flat on the ground. The little toe is an exception. The big toe, as well as the little toe, has but two steps down. The other toes have three steps to reach the ground.

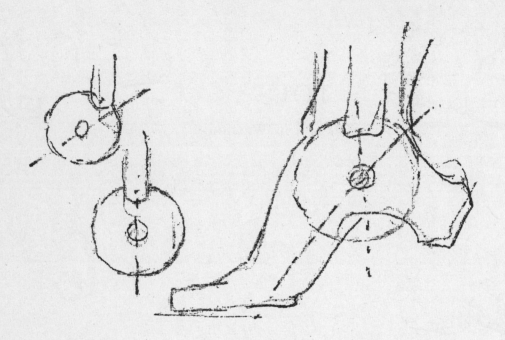

The mechanical contrivance used to move the toes, is a slit in one tendon to let another tendon pass through it. A long tendon in the foot bends the first joint of the toe and passes through the short tendon which bends the second joint.

The foot has strength to support the weight of the body. It also has flexibility, elasticity and beauty of form. Its construction is the envy of the bridge builders. The arrangement of its tendons and ligaments as they bind, pass round and through slits is akin with the belt, straps and ropes of the machine.

The arch of the foot is curved from heel to toe. The arch plays freely between two bones, the inner and outer ankle. From the two ends of this arch at its base, a strong elastic ligament extends that sinks or rises as the weight of the body bears upon the arch. The foot is also arched from side to side as well as forward, across and horizontally. The bones of the foot are wedged together and bound by ligaments. The leg bones rest on the arch where it articulates with the astragalus, the key-bone or keystone of the arch. This keystone is not fixed as in masonry, but moves freely between the inner and outer condyle. The heel is on the outside of the foot. The ball of the large toe is on the inside, giving it the rotary and transverse movement already mentioned.

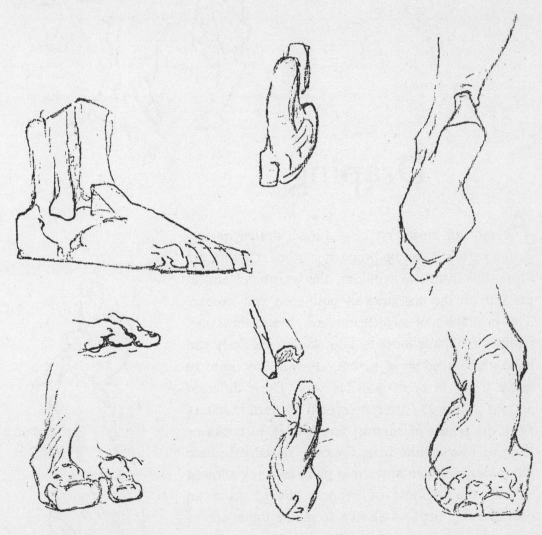

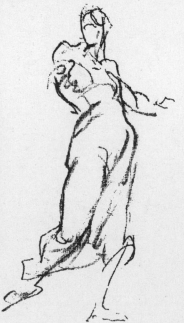

Draping

A FIGURE must first be outlined, drawn or suggested before it can be properly clothed. Clothes are supported from the shoulder, the waistband and at the hips in the costumes of both men and women. The principles of suspension are always the same. Clothes are made loose enough so that the body can have great freedom of action, allowing the limbs to move freely in every possible way. These different actions in drapery are represented by lines radiating from the points of support terminating in hooks or hanging festoon-like from opposite systems. In case the folds are drawn upward in place of being allowed to fall, the surfaces of support change from an outward support to a stretch from the underside of the mass.

318

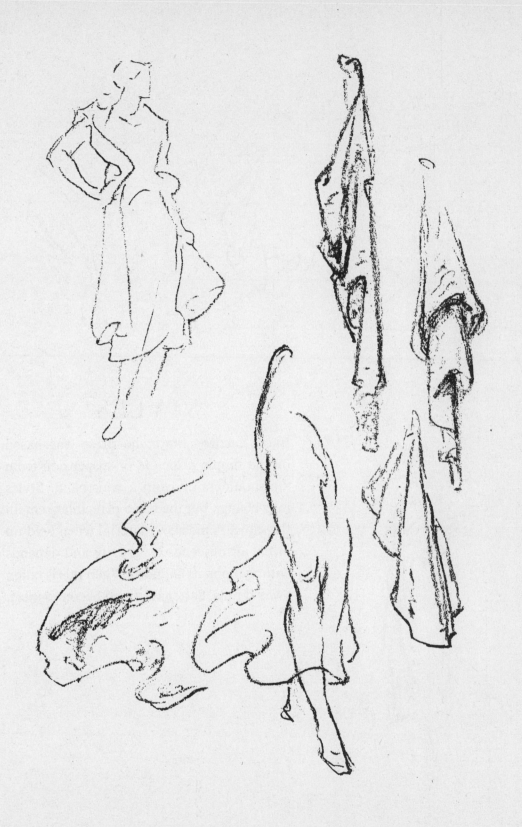

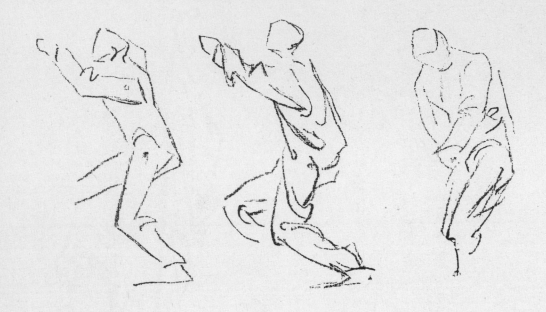

STYLES

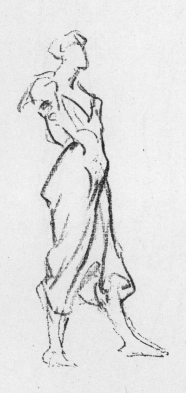

From ancient times the dress was based on the simple principle of suspension from the shoulders or from a waistband. Styles may change but the basic principles remain the same. A piece of material when held up in the air descends by gravity and depends entirely upon its support. When this is taken away it falls, flattens out and becomes inert.

The character of drapery has followed the different periods in art, as well as distinguishing the work of some particular master. Therefore, it must be realized that the object could not have been a servile imitation of folds. These periods varied from V-shaped kinks at one time to long rounded festoons at another. The costumes of classic times were more suited to the study of the laws of folds than those of the present time. The Greek paintings on pottery kept to long, flowing or sweeping lines that terminated in hook-like forms; the Gothic changed from round to angular; the Renaissance period shows a radiation of line that follows the figure allowing the plain surfaces to cling or lie close to the form, thereby accentuating the figure beneath.

COMPOSITION

THOUGH one can copy a piece of drapery by noting every fold or crease, it will be observed that every time the model moves, the folds seem to take on a different aspect. Therefore, some underlying principle must be thought out or there will be little harmony as a whole.

Cloth revolves itself into drapery but the thought that must be carried out is the idea of a figure draped with a body underneath. This fact must always be uppermost. Next, the art is in the arrangement which comprises line, rhythm, distribution and subordination, grouping and balance, and the joining of all these essentials into a harmonious whole.

The design of a draped figure must first be good in proportion and each portion be relevant to the whole. The detail must have a relation to the main design and not be plastered over with meaningless zigzags and sagging folds that do not contribute to the real form of the body which must be preserved and not broken up by minute detail. To arrange these details comes under the head of composition. In composition there must be rhythm, charm, and if the subject calls for it even beauty, a word for which no one can give a satisfactory definition, yet all this enters into a composition. The draped figure must be a complete pattern in itself.

DRAPING THE FIGURE

WHEN drawing folds that occur at the bending of a limb, it must be understood that drapery is either attached to, or supported at some fixed point. If the material is limited as to volume, such as the bending at the knee, the folds radiate in size and number from the fixed point of attachment as well as a point of resistance. The lower limbs vary greatly as to shape. Below the hip the thigh is round; at the knee the form is square with its sides beveled forward; and the broad double-bellied calf muscle covers the upper half of the leg.

When the leg is bent upon the thigh at the knee, the two opposing masses that are above and below the knee need little detail, but when bent at the joint, the folds become bunched up and take on both spiral and acute angles. To memorize the direction and meaning of one or two of these folds gives a plan to work upon. It takes both theory and close observation to find a fold that occurs again and again.

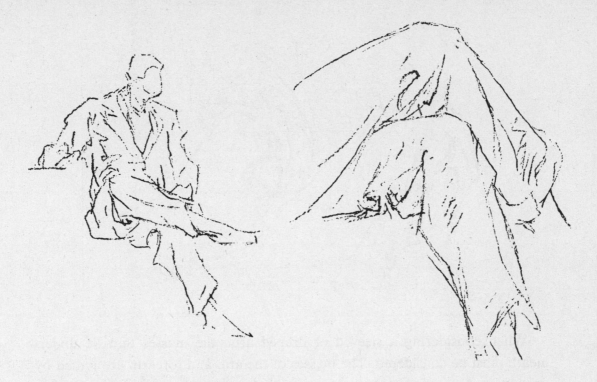

In drawing folds watch for forms that happen and then happen again. Using this as a background, one can put in the really important things that are essential to the story and not just a series of still life studies describing things that are not worth describing. In studying the character of these different folds, the quality of materials should be tried out to study their comparative relationship, such as: the difference of weight and tension; heavier materials as compared to light or more pliant materials. Try to remember the folds that happen and then happen again and you will find a family resemblance in all materials no matter what the weight or texture.

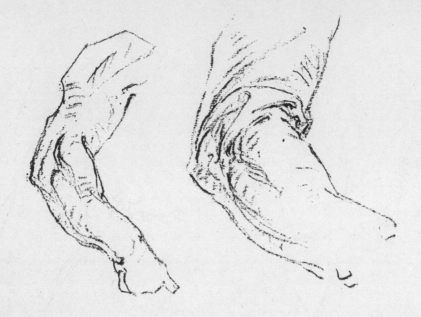

When considering a sleeved or draped arm, the masses that lie underneath must be considered. The masses of the arm and forearm are joined by wedges and wedging movements that overlap each other at various angles. The shoulder slopes down and out, its broad side facing outward, the upper arm flattened at the sides. The mass of the forearm overlaps the end of the arm on the outside by a wedge that arises a third of the way up and tapers toward the wrist. Whether the arm is straight or bent, this wedge, this underlying form, must be kept in mind. The folds pass over and around it; the creases alternate between round, zigzag or locked yet seldom parallel one another.

The mass of the upper half of the forearm is oval in shape when the thumb is turned away from the body and more round when the thumb side of the hand is reversed. The forearm as it approaches the wrist becomes flattened out to about twice as wide as it is thick. As material has no form in itself, these round and wedged forms must be shown or felt under the material that covers the arm. The folds at the elbow under certain conditions can be looked upon and copied as a piece of still life, but if the points of attachments and resistance, as well as their radiating lines are understood, the translation of the form beneath is clearer and better understood.

326

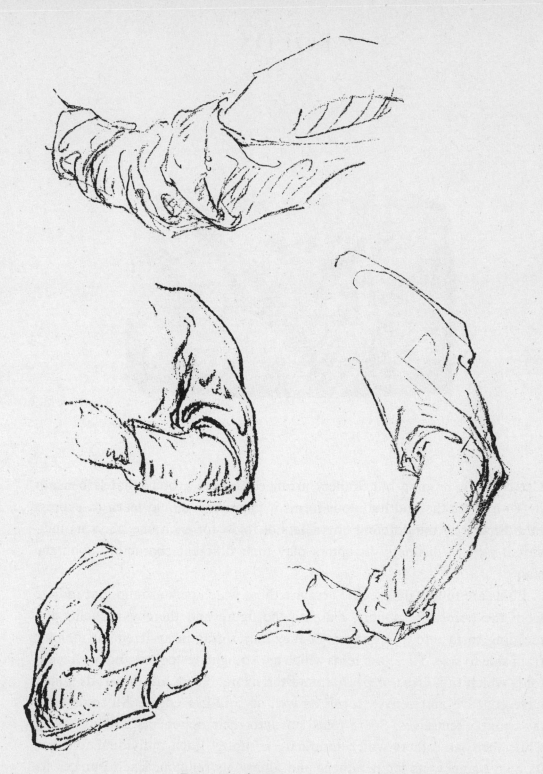

DRAPED ARMS

FOLDS

CLOTHING is nothing but drapery arranged around a body that is beneath it. To express the multitudinous forms it takes, one should learn to express in a direct way the different characters of folds, for each one plays its individual part as distinctly as actors play their different characters upon the stage.

Folds are totally different. There are those which pass around and radiate from the points of support, clasping the figure and thereby reducing the receding surface to a minimum; or they may zigzag in an irregular manner from side to side. There are folds which are straight, festooned and V-shaped; folds which fall, cross or pass around the figure. There are materials which have concave and convex forms as well as cord-like edges. All folds have laws unto themselves. Some folds run into their opponents and die away while there are others which terminate abruptly. Each individual fold has its own manner, its temperament and almost its religion. Each pursues its

function so that each must be studied apart as a fixed law, a thing entirely apart, without connection, yet held throughout by the unforeseen laws of rhythm.

As you would study the surface of an arm and forearm, or a thigh and a leg, and their connection at the elbow or at the knee joints, these folds must come together, linked as they pass around or into one another. To do so, a name indicating a function must be given to each:

1 Pipe or Cord 5 Diaper Pattern
2 Zigzag 6 Drop or Flying
3 Spiral 7 Inert
4 Half-lock

TYPES OF FOLDS

Dress materials in themselves have no form. When lying on the floor they conform to the floor; thrown over a chair they take the contour of the chair; on a hanger or hook, the folds descend from their support. Drapery may encircle, it may fall or it may be drawn upward. To realize this is the first step to the understanding of drapery. There is no sameness, no monotony; every fold has a distinct character of its own.

To show this vast difference in folds take the figure of Victory as an example. First, the diaper pattern which in this case falls from its fixed points of support at the shoulders is the simplest of all folds to understand. Next, a spiral fold is drawn around the receding hips; opposed to this spiral is a fold of a totally different character. It is irregular and zigzags from side to side. Below this another distinct type of fold appears, known as the pipe or cord fold. Beneath this another type emerges, called a half-lock. This in turn shares its form with that which lies prone upon the floor and is known by the name, inert. There is also the fold that is carried away from the body by its movement or by the air and is known as the drop fold or a piece of flying drapery.

INERT

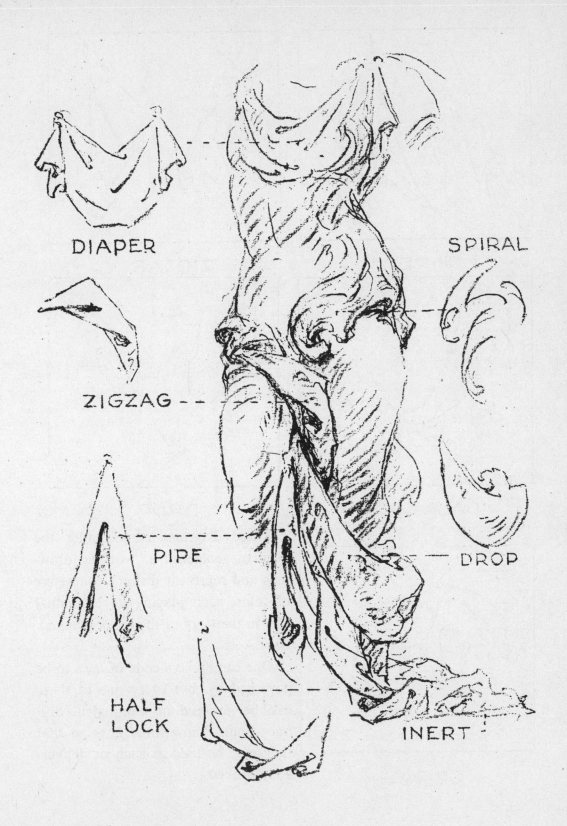

DIAPER

SPIRAL

ZIGZAG - -

PIPE

DROP

HALF
LOCK

INERT

PIPE

ZIGZAG

HALF LOCK

DROP

These diagrams come under the head of geometric or working drawings and represent distinct characters of folds, each playing its individual role in the story of the draped human body.

One can make a code of laws to be governed by, but every one of these can be changed or eliminated. Still one should know these laws so that they may be used as such or deliberately broken.

SPIRAL

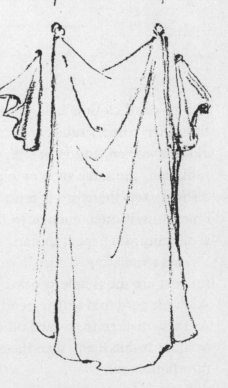

DIAPER PATTERN

Every fold must have its support. It either pulls or is being pulled; it clings or it folds; it encircles or it is festooned, but in every case it must be supported. It does not become drapery until it is supported by something.

Take a yard or so of plain material in both hands; hold it by the two upper corners and allow the center to sag. It shows how the folds festoon and lock into each other toward the center. Try both light and heavy materials until you note the relationship in the radiating lines. Trace the fold or crease from the point of support by which it is being held. Follow to where the two sagging opposing forces meet and study carefully how they interlock. Still holding the two corners at arms' length bring the ends nearer together and note the changes that take place and note the way they repeat themselves. After you have the idea as to how the festoon locks, the goods may be thumb-tacked to a board or to the wall or placed on a lay figure.

333

PIPE OR CORD FOLDS

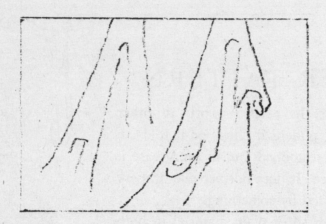

If a piece of cloth is held up or nailed by one corner and then pulled from the other corner, tubular forms radiate from its fixed point. Whether the cloth is woolen, cotton or silk; whether it is thick, thin, old or new, the same radiation, the same tube or pipe-like forms are always prevalent. This is a distinct fact, therefore it must be recognized as a law; it is something that repeats itself often enough to be recognized as such, something to look for, something you expect to find.

These radiating cords or summits as they descend from their points of support are the simplest forms in drapery and are the first to be understood. A simple cord fold will descend and then divide into two or three other cords. As these diverge from each other, the original cords may make room for two or more within them, then these may again divide, making two or more until they flatten out.

334

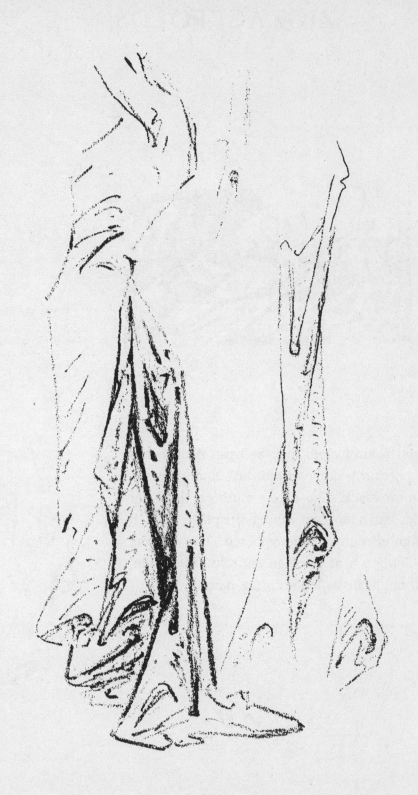

ZIGZAG FOLDS

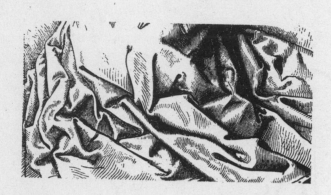

A tubular fold of cloth may be bent. As it bends the outer portion becomes rigid, and underneath it becomes more slack. The excess cloth on the inner side buckles into a more or less definite pattern which must be figured out and remembered. The twisting of this fold when bent gives an entirely new design, one which might be called a zigzag pattern.

337

Here the pull is uneven in character. It is quick and jerky. To demonstrate this, take six single sheets of newspaper, roll them into a two-inch cylinder, bend the roll in the middle, now grasp the roll near each side of the bend and give it a sharp twist from side to side. Note the pattern and the design.

You can reason out why these bendings and twistings so consistently repeat themselves. Try it out on a piece of stiff cloth and you will find a familiar resemblance. It is this repetition that must be stored away in your mind so that you may check your knowledge with what you see on the model. Remember at all times that each fold has a character apart from every other fold. Remember that you will have a preference as to folds, that some folds will appeal to you more than others, making your drawings different from other drawings. Remember that the things you know and leave out are the things that give the power and simplicity to your drawings.

Students gain much by making a number of drawings to tell the story of an interlocking zigzag fold. Do not copy the drawings on these pages, start with a straight or curved line and try to lock the ends with other lines that will account for bringing together the two opposing forces.

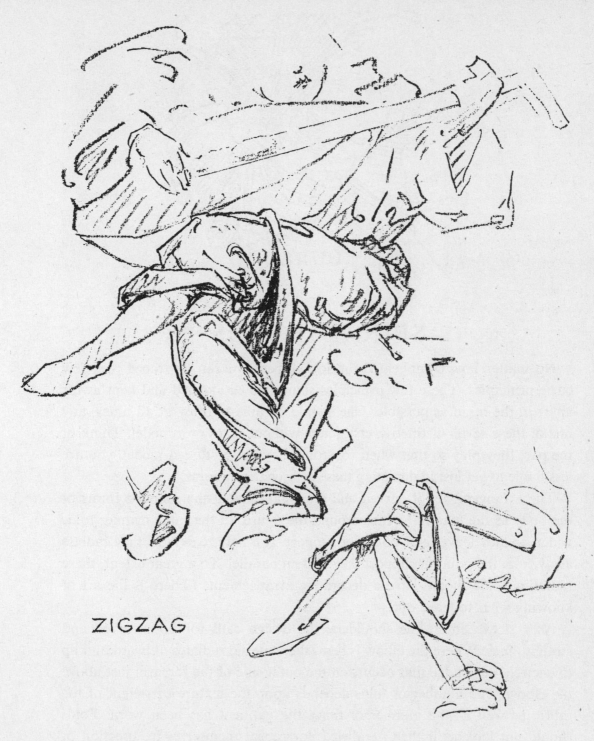

ZIGZAG

After Carpaccio

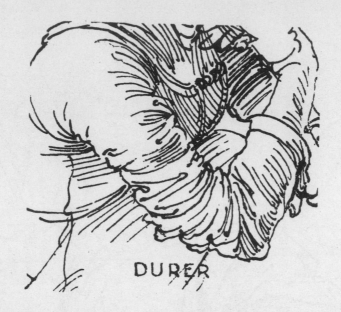

DURER

SPIRAL FOLDS

No matter how complicated the fold appears, it can be traced to a few basic principles. These few principles should be catalogued and kept as far apart in the mind as possible. One should be able to draw at all times, any one of these seven distinctive characters without notes or a model. Think of the part they play so that when confronted by the costumed model, you are less liable to get lost in depicting these ever changing folds.

The arrangements of curved and diagonal lines fit the rounded forms of the body as the material wraps around the figure. In the same manner folds widen as they leave their points of support. It is safe to say: as they radiate away from the point of support they seldom parallel. To a great extent, these radiating folds should have a decorative arrangement. (There is the art of knowing what to leave out.)

As a sleeve enters the shoulders, the design calls for both curved and straight lines. Where the elbow is bent, the material radiates outward and up to encircle the wedge that occurs on the outer side of the forearm just above the elbow. The number of folds depends upon the texture or weight of the fabric as well as the number of times the garment has been worn. Folds should not look as if they paralleled nor repeat themselves in direction or volume. Your drawing should show an understanding sense of design and pattern.

340

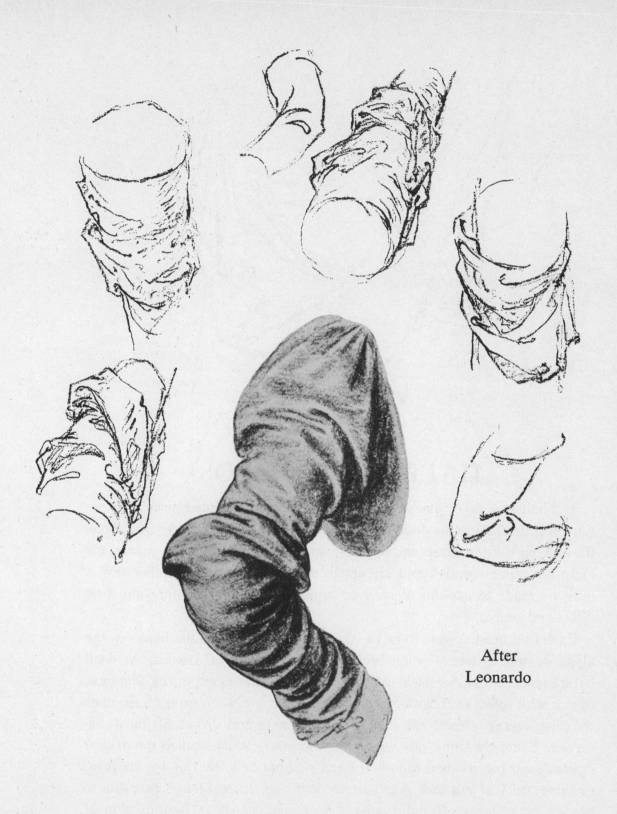

After
Leonardo

341

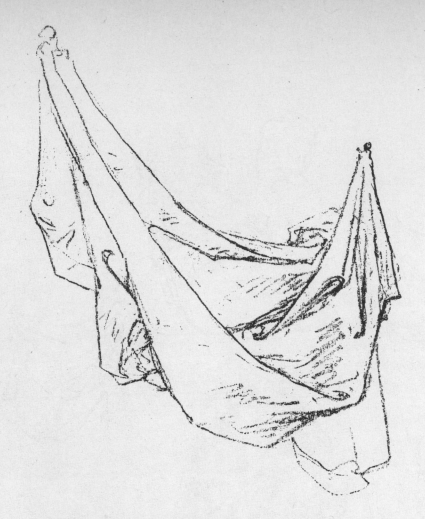

HALF-LOCK FOLDS

The half-lock takes place every time a tubular or flattened piece of material abruptly changes its direction. When the turn is at or near a right angle, the locking is more sharp and angular; when it falls in sweeping curves, the locks are more rounded and are apt to dissolve one into the other. Folds must be made to explain themselves without difficulty, therefore, must be direct and simple.

Each fold must appear to be as far apart in character as the letters of the alphabet and as letters when brought together to form a word. As each letter seems to dissolve itself into that word and that again into a sentence, so it is with folds, each with a distinct character, yet when brought together the pipe, zigzag, spiral, half-lock, diaper, festoon and drop-folds must dissolve one into the other making one harmonious element called the draped figure. Each has its own function. Each is supported from or by the form underneath. The half-lock is more prevalent in a sitting down figure due to the greater number of angles causing a greater change in the direction of planes.

342

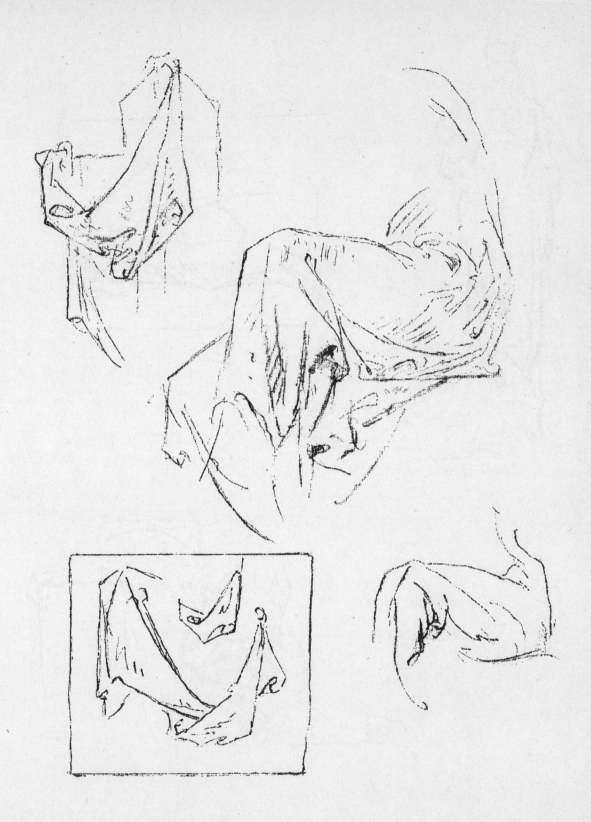

343

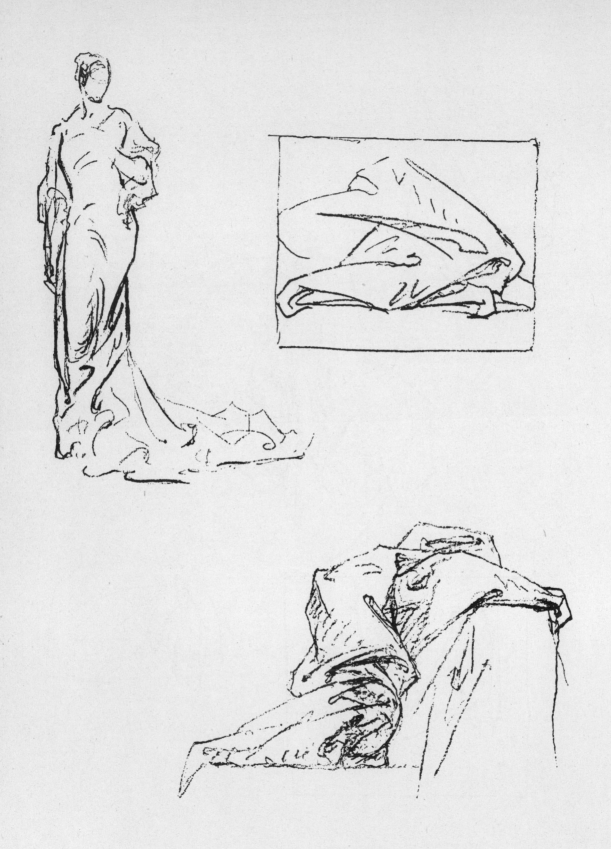

344

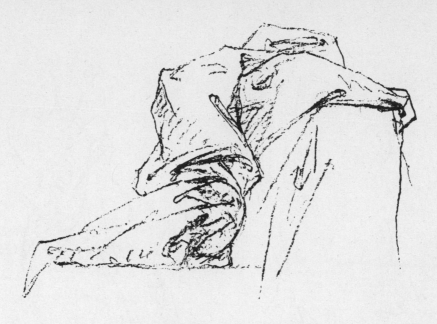

INERT FOLDS

It is understood, of course, that cloth no matter how thick or thin has in itself no given form. A piece of cloth when thrown or dropped on the floor either flattens out or crumples up and takes on a character distinct from any other form. This crumpled up piece of cloth is not static; it changes as it keeps settling; in an hour's time its vigorous angles become more subdued and flattened. Still it remains a fallen piece of goods with a character distinct and apart from any other, and this positive character must be the abstract idea back of the drawing to make it obvious to the onlooker that this fallen piece of cloth is inert and dead.

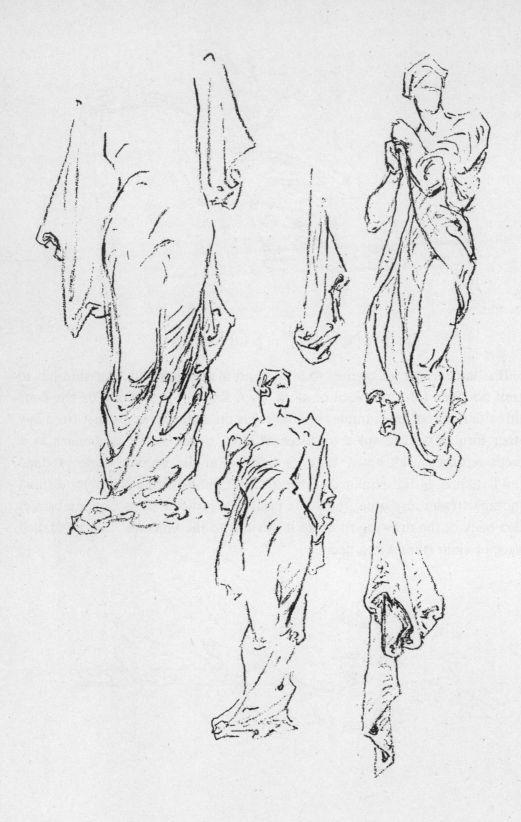

346

DROP FOLDS

As this particular class of fold leaves its support, being free, it takes a swinging rhythmical motion down the whole length of the material to its selvedge. When these folds hang straight they add dignity to the figure but when the outline is curved such as in movement and the lower borders are suspended in space, they usually twist, turn or take a spiral form at their inner or outer edges. The drop fold is a distinct opposite to any other character of fold. No other fold must encroach upon its territory. It is used chiefly in figures that run, dance and perform other decorative movements. Its outline sways in weaving curves when the figure is in motion and with dignity when in repose. Whether in movement or static, all folds follow the laws of gravity when away from a fixed point. Only the details of these laws vary. A great deal depends upon the materials used when they are cut straight across or warp-wise. They then behave differently in detail.

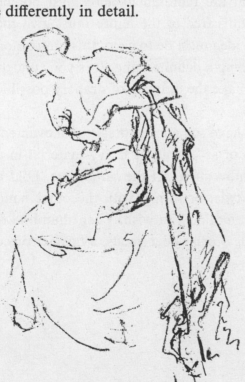

DROP AND FLYING FOLDS

Folds must be arranged and regulated to the lines of the figure. Folds that fall some distance from the source of support shake or wave irregularly as they leave the figure. These may be seen as concave or convex according to the way they are connected to the cordage of the material. The upper portion may have the same width or bulk, but having less space may give a pipe-like appearance above. As it descends it widens out and becomes more free at the lower borders.

These descending folds must have the appearance of falling from their support above, such as the shoulder, sleeve or girdle. In drawing a drop or flying fold one must sense and force it to drop. No camera can give these qualities; they are personal, individual. A photograph may be useful in studying the details of parts, but can scarcely be of use in arrangement of, we will say, two figures or more. A camera may be as accurate as the human eye, but it cannot render the beauty of line or the arrangement that enters into the expression demanded by the many factors that go to make a composition. A photograph does not eliminate the petty details that go to make folds convincing.

The different characters of folds that are represented here must not be looked on as a novelty. Drapery that falls free of the figure must give the impression of descending or flying. The idea must be to carry this impression to others, that this piece of drapery is doing a definite thing. It is your understanding of these simple laws that will make the drawing of drapery possible and convincing.

To get an idea of drapery in motion, have someone express the movement you have in mind by swinging a length or so of thin or heavy material in a backward, a forward or a rhythmical movement. At the same time, hold a piece of tissue paper in one hand and twist or turn it with the other hand until it is given somewhat the duplicate motion you wish. Then thumb-tack the tissue to a board and copy the details. For heavier goods, a heavier piece of paper should be used.

VOLUME

The treatment of heavy materials is a problem, for the reason that it is difficult to preserve the real form of the body beneath and make it apparent that it represents a human figure and not just a mass of cloth and folds. Assuming that the principal supports of a sitting figure are from the knees, and that these supports are on a level horizontally and not too close together, the descending folds would festoon toward the center following the weight of the material, causing the lower border to fan out and become more pointed below and lower down than at the sides. Should one foot be resting on a stool or cushion then one support would be higher than the other causing a large festoon above and a smaller one below to interlock much nearer the lower knee than at the center. In this case, the folds would not be continuous from one support to the other but would meet at a more acute angle.

When drapery hangs in loose folds the opposing festoon and cones do not interlock at acute angles but intermingle and fade into each other. The thought must be to carry the idea that a fold is doing a definite thing. It is your understanding, as well as copying, that makes the drawing of drapery possible.

349

RHYTHM

The arrangement of line and volume of folds is not complete or harmonious without a hidden and subtle flow of symmetry. Nature has supplied both line and form that are symmetrical and harmonious. These laws of rhythm exist and are recognized as undefined laws.

In drawing and painting there is rhythm in outline, color, light and shade. So to express rhythm in drawing a figure we have in the balance of masses a subordination of the passive or inactive side to the more forceful and angular side in action, keeping constantly in mind the hidden, subtle flow of symmetry throughout.

COMBINED INDEX
AND GLOSSARY